Among the Silent Giants

A Young Girl's True Adventures and Survival in a Wild Country

Maxine: I remember the days when we worked together. I miss them.
Sharon Porter Moxley

Sharon Porter Moxley
with Susan Dregéy

iUniverse, Inc.
Bloomington

Among the Silent Giants
A Young Girl's True Adventures and Survival in a Wild Country

Copyright © 2012 by Sharon Porter Moxley with Susan Dregéy

All rights reserved. No part of this book may be used or reproduced by any means, graphic, electronic, or mechanical, including photocopying, recording, taping or by any information storage retrieval system without the written permission of the publisher except in the case of brief quotations embodied in critical articles and reviews.

The names of all non-family members who appear in this memoir have been changed to protect their privacy. Names of family members remain unchanged.

iUniverse books may be ordered through booksellers or by contacting:

iUniverse
1663 Liberty Drive
Bloomington, IN 47403
www.iuniverse.com
1-800-Authors (1-800-288-4677)

Because of the dynamic nature of the Internet, any web addresses or links contained in this book may have changed since publication and may no longer be valid. The views expressed in this work are solely those of the author and do not necessarily reflect the views of the publisher, and the publisher hereby disclaims any responsibility for them.

Any people depicted in stock imagery provided by Thinkstock are models, and such images are being used for illustrative purposes only.

Certain stock imagery © Thinkstock.

ISBN: 978-1-4759-2959-1 (sc)
ISBN: 978-1-4759-2960-7 (hc)
ISBN: 978-1-4759-2961-4 (e)

Library of Congress Control Number: 2012909462

Printed in the United States of America

iUniverse rev. date: 6/11/2012

For my family

Contents

Acknowledgments . ix
1. 1947—Bull Creek Days and Eureka Nights 1
2. Road to Whitethorn 14
3. Bar People and Church People 24
4. The Importance of the Outhouse 39
5. Stardust: A Tale of Three Horses 46
6. Family Circus and Visit to Arcata 58
7. A Mysterious Sickness 71
8. Winter Dreams: Fishing, Hunting, and Gathering 86
9. Night Ride . 94
10. Wild Berries . 100
11. The Shoelace Salesman 106
12. Trouble with Chipmunks 113
13. Johnny Johnson . 120
14. A Cat's Tale . 132
15. Loggers and Indians: Trick or Treat 136
16. I Can Ride Anything 144
17. I Never Forgot the Bomb 157
18. Mr. Smith Goes to Whitethorn 162
19. The Last Match . 175
20. The School Bus Driver 181
21. Leaving Whitethorn 190
Afterword . 199
About the Author . 201
Endnotes . 209

Acknowledgments

My gratitude to Ms. Suzanne Sherman—writer, editor, and writing instructor—and participants in her memoir writing groups, for their enthusiastic support, encouragement, and perceptive critiques during the writing of *Among the Silent Giants*.

Special thanks to Joyce Harr for her technical assistance with family photos.

Many thanks to the daughters of Barbara Coffey, Linda and Lisa, for providing the photo for the back cover.

1. 1947—Bull Creek Days and Eureka Nights

Bull Creek is a small logging camp in the giant redwoods. A funny little creek and a single road run through it, and mountains with high prairies and tall trees look down on us folks as we go about our daily doings. My mother, Ruby, told me that Bull Creek got its name from a time, long ago, when Indians killed a white man's bull and cooked it beside the creek. She said the white man got mad, and he and some of his friends killed the Indians. I like stories about Indians but not about them getting killed.[1]

Bull Creek has one store, a school, a graveyard, and a mill. Next to the mill is a pond filled with logs waiting to be sawed into lumber. For everything else, folks have to drive through Bull Creek Flats, where the tallest trees in the world line each side of the road, onto Highway 101 and north to Eureka. Eureka is a big port with docks and ships and lots of noisy bars lining the waterfront.

Although I was born in Eureka, I hate the place. It's only a couple hours' drive from sunny Bull Creek, but the weather in Eureka is foggy, wet, and slimy most of the year. Moss and all sorts of green stuff grow on the north sides of the moldy houses, making them look like they're going to rot soon. The only thing

that saves them from crumbling is their redwood frames, which are supposed to last forever.

I've had some awful things happen to me in that ugly town.[2]

For the past few months, Ruby and I've been staying here in Bull Creek with her sister, Maude, and Maude's husband, Gene. A couple of days ago Ruby took off for Eureka. She's often up and disappearing on me, and I don't much like it.

My aunt and uncle's teeny house looks like most of the houses around here. The outside walls are made of wood gone gray with age. The inside walls are an even darker gray. Wood smoke and cigarette smoke are always swirling and mixing in the air and settling on the old walls. I cough a lot when I'm inside.

This morning I'm awakened by voices drifting from the kitchen. Feeling dopey, I crawl out of bed and stumble toward the voices. There's Ruby, sitting at the kitchen table with a strange man. My eyes are half shut and strands of hair hang over my face. Ruby grins and brushes them away as I slouch in a chair.

"Good morning, sleepyhead. I want you to meet Al Sharpe. He lives in Whitethorn."

Well, good for him, I think. I've never heard of Whitethorn. I mumble hi to this strange guy. Who needs him, anyway? Just when Ruby finally shows up.

"Nice to meet you," he replies. We both slip into silence. *He's not much of a talker,* I think, feeling thankful at least for that.

"I've a surprise for you," Ruby says. "Let's go back to your bedroom."

I drag myself off the chair and follow her.

Once we're in the bedroom, she whispers in my ear, "Al and I were married yesterday."

I squeeze up my nose and croak, "You married him?"

"He's a real nice guy, and I'm sure you're going to like him," she says quickly. We sit down on my bed, both quiet, each in our own thoughts. "He's your stepfather now," she finally adds.

Oh joy. Just what I need, a stepfather. I already have a dad—George. I can't remember why, but I've always called him and my mother, Ruby, by their first names. I don't get to see George much

because he lives in Arcata, across the bay from Eureka, and Ruby and I are always moving around.

After the big news, Ruby and I head back into the kitchen. Soon after, I follow her and the new "dad" out of the house.

We cross the dirt yard and head for a green GMC pickup. Ruby looks real pretty today. She has on the cotton dress with the polka dots that she made and fancied up with stockings and high heels. Her curly red hair is rolled up in front, covering the hair rats that make her hair look smooth and round on top. Ruby makes her "rats" from the loose hairs in her hairbrush. When she has enough hairs to make a nice ball, she splits it into two long lumps and wraps each lump in a hairnet. Everyone's wearing them these days, including Aunt Maude.

When we get to the pickup, Ruby looks down at me with watery eyes. "I'm sorry you can't come with me now. Al's friends Mike and Norma are staying at his house, and there's no room for you. They're going to move soon, and when they do, I'll come back and get you."

"When will they move?" I ask, stirring the rocks on the ground with my bare foot.

"It might not be until the end of summer. They're trying to find a house, but there are not many houses in Whitethorn."

"What about school?"

"You have only a few more weeks at Bull Creek School before you finish second grade. I hear they have a nice school in Whitethorn and you can start third grade there."

"That's a long time," I choke out tearfully.

"For now you need to stay with your Aunt Maude and Uncle Gene," she says, her voice getting tougher. "You'll have lots of fun with Maude. I know you like her a lot."

"Yes, but I want to go with you."

"The time will fly by before you know it, and I'll be back to get you." She hugs me, kisses me on the cheek, and climbs into the pickup. "Be my brave little girl," she calls out the window as the pickup rumbles off.

As I stand in the yard with Maude, watching the pickup drive away, an old feeling starts creeping up on me. *Why does Ruby do things like this?* I wonder, squeezing back some more tears.

Now she's gone off with a new husband, and she's not coming back to get me until I start third grade. I can't even call her because she doesn't have a phone.

She's always parking me somewhere. Now I'm parked here. I think of those awful times I sat parked in front of bars in Eureka, bored stiff and scared while my mother and folks were inside, drinking and whooping it up.

As I stare down the dusty road where the pickup disappeared with Ruby, I try but can't stop memories flooding my head of sitting in cars in front of bars. One of those times was in a place called Fields Landing on the outskirts of Eureka. This bar was named Volpie's, and Highway 101 breezed past just a few feet from the back of my little dark hole. Oh, they'd come out to the car once in a while and bring peanuts, jerky, and Coke. But most of the time, alone and with nothing to do, I would be slouched down in my seat, my mind drifting off into nothing I could get hold of, or ever remember, except for feeling scared or bored.

The songs from the jukebox did sometimes bring me 'round. I was parked at Volpie's so many times, I could wail out "Heartaches, Heartaches," and many other sorry jukebox tunes drifting out of the bar and slipping through the cracks of my car window. I 'specially liked a peppy tune about smoking that played a lot and perked me up. Whenever it drifted in, I would hop up and down in my seat, bang the beat on the dashboard, and sing along at the top of my voice.

The very worst night I spent in a car happened on Two Street in Eureka. It's really called Second Street, but my family calls it Two Street. It's a horrible place, close to the waterfront, with bars on both sides of it. There are lots of winos, men who work on the ships, and lumberjacks who come to the bars to drink. All is gloomy and gray, even the men. But after dark, red and blue beer signs light up the foggy night and spread a spooky glow over everything.

On that awful night, Ruby, Aunt Maude, Uncle Gene, Aunt Doris, Uncle Max, and I all drove in three separate cars to their favorite bar on Two Street. They left me sitting in one of the cars. When the bars closed, lots of people began pouring out onto the street, and I was hoping to see my family. They never came.

I waited and waited as the bars emptied, the people on the street staggered off, and everything went dark and quiet. A few minutes later, a bunch of men arguing and yelling broke into the quiet. They came closer and closer, finally swarming all over my car. I dived to the floor and scrambled under the dashboard, my head pushing into the wires. I could hear the sounds of punches and grunts as the whole gang battled on top of the car, shaking it like an earthquake. I was afraid they would kill me if they found me. Gradually they stumbled away into the night.

A few hours later, Ruby and Uncle Max came to get me. They had forgotten me and gone back to the ranch in the other two cars. They finally figured out I was still sitting in the car on their wonderful Two Street.

"Now Sharooney, we're goanna have ourselves a real good time." Maude's voice breaks into my gloomy thoughts and brings me back to where we're standing in her yard. I'm still looking down the road where Ruby and new stepfather drove off. I can't help worrying—will she come back to get me?

My aunt puts her arms around me and pats me on the back. "It's going to be okay. You and I can cook pies, chicken and noodles, and all sorts of good stuff."

The talk about food makes me hungry. I haven't had anything to eat today. "Could we make fried chicken for lunch?"

Maude frowns and shakes her head. "We can't have chicken. Uncle Gene isn't here to cut its head off for us. He'll be working on the Donkey unloading logging trucks and dumping the logs in the log pond all day. He won't be home until after dark."

"That's too long to wait," I wail. "Can't you chop the chicken's head off?"

Maude shakes her long blonde hair and makes a face. "I've never cut a chicken's head off in my life. I just couldn't do it."

I wipe my runny nose on the sleeve of my shirt. I'm so hungry I can hardly stand it, and I know there's nothing in the house to eat except stale bread. I've got to have fried chicken right now!

Maude's backyard is filled with chickens and there's a chopping block by the woodpile. I'm pretty sure the two-bladed axe is lying around there somewhere.

"I'll cut its head off!" I cry.

"But Sharooney, you couldn't do it. You're only seven. You're too little."

"I can too! I've watched Uncle Gene do it a whole bunch of times."

"You really think you could do it?" Maude must be hungry for fried chicken too.

"I know I can. You hold the chicken and I'll cut its head off."

"Well, first we have to catch the chicken."

I lead the way out to the backyard. My aunt tightens the belt on her bathrobe and follows me. I look over the flock and spot a young rooster. We need a young chicken if we're going to make fried chicken. An old one is so tough you can't eat it unless you boil it.

After chasing the squawking bird all over the yard, I tackle him and haul him over to the chopping block. My aunt makes a face, but she comes over to me. I hand her the chicken. "You hold its legs and I'll lay its head on the block."

"Okay," Maude says, holding the chicken and turning her head away. She has her eyes shut too.

I pick up the big axe, being careful not to raise it so high that the top blade whacks me in the head. It's very heavy and hard to lift. Although the axe is wobbling in my hands, I take a big whack at the chicken's head.

"Did you do it?" Maude asks.

I look down at the chicken, who is now missing the tip of his beak. "I almost did it," I tell her, hoping to keep her calm. If I upset her she might call the whole thing off.

This time I hold the axe even tighter and when I bring down the big blade, it cuts straight through the chicken's neck and his head falls to the ground.

"I did it!" I shout. "You can turn him loose now."

Maude, eyes still closed, lets the chicken go and it runs off headless, splattering blood all over the yard. It's funny how chickens run all over the place after their heads are cut off. We wait until it drops to the ground and sprawls there dead. As I bring the fat rooster back to my aunt, I'm sure my eyes must be shining with success.

An hour later, Maude and I feast on golden fried chicken.

By the time I finish eating, I know what I have to do. I stand up, shove out my chest, square my shoulders, and feeling tall and tough like an army soldier, I march straight back into my bedroom and begin packing up my Teddy bears.

I pick up my favorite bear, Mr. Darby, first and drop him, flip-flopping, into the bottom of a big cardboard box. I don't say good-bye. I just turn and reach for another bear. This time it's the little blue and white bear I've had since I was three years old. He plops down on top of Mr. Darby without saying a word. I grab the orange one and the brown one with the bright blue eyes and big smile. Next I toss in the black, the white, and the pink bear. I'm not sure but I think I hear tiny sobs. I don't stop to listen; I just keep on yanking bears off my bed and tossing them into the box. The last one is a girl bear with a bright red dress and a flower on her head. She doesn't say anything, but she looks scared and kind of sad.

After the bears are all in the box, I slam it shut and swear to myself, "I will never open this box again. I'm too old for Teddy bears."

Just then Maude comes into my bedroom and watches me looking at the box on the floor. "What are you doing, Sharooney?"

"I'm putting my Teddy bears away. Could you help me put them up on that tall shelf?"

Maude has no trouble putting the box on top of the shelf because she's almost six feet tall. She looks a lot like my mother. They're both very pretty and their eyes are a greenish color. The biggest difference is their height and the color of their hair. Ruby is only five feet four and she's a redhead. Maude is a blonde. Today, as on most days, Maude is in the bathrobe and slippers that she will wear all day. My folks think she never gets around to putting her clothes on because she moves so slowly.

Although the summer seems long, I've plenty to do. I do a lot of fishing in Bull Creek. My Great-Aunt Midge and her husband own the town's general store and gas pump and right beside it is a good fishing hole where I can hook big catches to fry up at home. I also pick the wild berries growing everywhere and help Maude bake berry pies.

The redwood forest by my grandma's house, just across the apple orchard from Maude's, is a magic playground for us kids. We run across the brown carpet of redwood needles dropped from above and hide among the lush, green ferns and inside secret tree houses, burned and hollowed out by lightning. Sometimes I find a hiding place under the bulging burls that grow on the trunks of the trees. In the springtime, pink lady slipper orchids and white trilliums proudly decorate the redwood world. It's so quiet in these woods. The stillness is like a prayer from heaven. When I stop running and listen, I can tell this land is holy.

Although I love all the redwood giants, my favorite tree is called the "flat iron" tree.[3] The lower part of its twenty-foot-wide trunk isn't round like its neighbors'. It's flat. As the trunk rises, it naturally narrows; but up to its first branches, the tree gives the impression of having been flattened by a giant iron.

I visit with my grandma most every day. Her house is a tiny, weather-worn redwood cabin that sits in a big grove of redwood trees. I also love visiting her because she keeps it so neat. The dishes are always washed; things put away; floors swept and clean—not like the way Ruby keeps house.

When my Uncle Allan works in Bull Creek, a big brass bed is set up for him in the living room at Grandma's. When he's

there, he drives a logging truck from up the mountain down to the sawmill in Bull Creek. Uncle Allan got real skinny during the War, but now he's back to being straight and tall and strong like other loggers. He's got light skin with freckles, like Ruby, and fine, sandy hair tops his nice-looking face. He's real good-natured and folks like him and like to be around him, including me.

Nobody can tell stories and make people laugh like Uncle Allan. Grandma says he's the same as his father, Guy Doers, who could capture a bar full of people when he told a tale and have them roarin' off their stools and spittin' in their beers. She said Grandpa's telling of the story about finding a big ball of rattlesnakes back in Wisconsin was so funny it became famous around the county and made the local papers.

I think Uncle Allan's telling and acting out the scary story about the time his brakes gave out just as he was driving a big logging truck down a winding road could match Grandpa's in making folks split their sides around here and elsewhere.

My grandma, on the other hand, is a different sort altogether. She's almost six feet tall and carries herself so straight and royal-like, I'm reminded of the grand old redwood trees that shoot up to the sky everywhere around us. I can only hope to be as tall and grand as my grandma when I grow up.

Now her looking so grand, you would think people wouldn't ever call her "poor old Ma" when they talk about her. But anyone who's familiar with her regular complaints of "I'm so blue, I'm so-o-o blue" does. We know it must be bad for her because my grandma is generally looked on as a strong woman on the quiet side. When folks want to let each other know her sad condition, they say, "Ma is hanging her nose again."

One day I asked Grandma about it, and she said she's blue on account of the redwood trees that grow around her cabin shutting out the sunshine and making everything dark and gloomy. I wonder if it's also because she's lonely since my Grandpa Guy Doers died of a heart attack a few years ago.

To make a little money, my grandma strips bark off cascara trees. Then she dries it and sells it to a place that makes laxatives.

One day I'm helping her peel bark when three cows and a bull came over to see what we were doing. I scooted straight up the tree I was peeling. But Grandma just planted herself like a giant redwood and glared at the bull. I guessed the bull decided she was too big for him because he and his cows turned and walked away.

Grandma loves to talk about the good old days on their farm in Wisconsin. One day I finally asked her, "Then why did you leave and come to California?"

"Well, Sharooney, it's a sad story that happened to many folks besides us. The land dried up and farms failed. We became so poor that even in the bitter Wisconsin winters we didn't have money to buy shoes for the children—your mother, Doris, Maude, and Allan."

"What did you do? You can't go barefoot in the snow."

"You sure can't. Your grandpa had to make shoes by cutting up old Model-T inner tubes. He cut a piece of rubber to each little foot's measure, tied both ends, and cut a hole in the top for the feet to slip into the inner tube. Your mom and her sisters and little brother also had to sleep on beds of straw we got so poor.

"One day, in 1925, we packed up the old car and left the state hoping to find better times in California. The trip took many hard weeks. We often had to stop to work on farms for food, shelter, and gas. We kept on to Northern California, where we heard there was work to be had in the logging towns. When we got to Bull Creek, we rented a small cabin and your grandpa got work in the woods. Other families followed from Wisconsin, and while none of us made our fortune, the logging business, thank the good Lord, has kept food in our mouths, a roof over our heads, and clothes on our backs ever since."[4]

From time to time, Grandma also tells me bits of what happened during the Big War. That day she remembered the time when the three of us lived together in Eureka and Ruby helped build the first dry dock in the country by welding rivets.

"'Ruby the Riveter,' folks used to call her then," Grandma said. "But she didn't last long. Her hands swelled up and her fingers turned white, and they put her to making parachutes instead."

So the summer slowly crawls to an end while I'm waiting for Ruby to show up. Except for the redwoods, the leaves on the trees start to turn yellow, orange, and red, and I watch the road from the kitchen window for the old GMC pickup.

One morning, gazing down the road as usual, I turn to Maude, who's lounging at the kitchen table, the usual cigarette dangling from the side of her mouth. "Have you ever been to Whitethorn?"

"I sure have."

"Where is it, anyway?"

"Well, it's down south a ways, clear up in the mountains."

"What's it like?"

"It's a lot like Bull Creek, 'cept it's near the Pacific Coast. Most folks are loggers and lumberjacks, but most of the road is gravel. Here in Bull Creek, you know, we have a paved road that runs out to the highway."

"Well, you might have a paved road but it's got so many curves, lots of kids get carsick before they get to the highway."

"Old timers say the road was built by a snake because it curls 'round and 'round the big redwood trees."

Between thick billows of cigarette smoke, Maude continues, "We have electricity here and there in Bull Creek and most people have running water. But folks in Whitethorn live so far up in the mountains they have to use lamps for light, and they carry their water from the creek, and 'course they have to go to outhouses just like us folks here."

One day when I'm standing guard by the window as usual, wondering if Ruby will ever show up, and watching the pretty leaves take turns floating to the ground, I hear the rumbling noise of a motor and see a thick haze of dust swirling down the road toward us. It couldn't be Gene because he walks to work. And no one usually drives down this road to our house.

Even as I shout, "It must be Ruby," the old GMC pickup comes rumbling into the yard.

I tear out of the house and jump into my mother's arms. "I thought you would never come!"

"Well here I am." She smiles. "Ready to go?"

"I'm ready!" I cry, jumping out of her arms, and running to the house to grab my clothes.

A few minutes later, I charge out of my bedroom into the kitchen where they're all sitting around drinking coffee. It looks like we won't be leaving for a while. I throw down my pile on a chair and try to calm down.

Although I'm itching to get going, I grab a chair and look over my new stepfather. He doesn't look much like a logger. He's wearing a felt gray hat I've never seen anyone else wear. It looks like a going-to-town hat, a hat a boss would wear or someone who has lots of money. He's gripping a big pipe between his teeth. The smell of the burning tobacco is sweet and pleasant. He's dressed in a green gabardine shirt and brown cotton pants, too fancy for working in the woods. His eyes are hiding behind big, thick glasses. I wonder if he's blind or something.

As usual Maude talks a blue streak as she puffs away on her cigarette and sips her coffee. The whole kitchen quickly fills up with a blue haze.

"Sharon has been a good little girl the whole time she's been here. The only bad thing she did was filling the new coat I bought her with berries, getting berry juice all over the inside of it."

Ruby gives me a strict look. "You know I've told you not to wrap berries in your clothes or put them in your pockets."

I hunch up my shoulders and tip my head down. "How else was I going to get all those berries home?"

"Not in your new coat!"

"I know." I look up and smile. "Aunt Maude made two big pies with the berries."

Chuckling, my new stepfather turns to Ruby. "We gotta get going now. I have things to do when we get home."

"And we still have to look in on Ma before we take off for Whitethorn," Ruby adds.

I'm so excited, I'd almost forgotten about Grandma. "When is Grandma coming to Whitethorn?"

"Soon as there's a vacancy in one of Al's rentals," Ruby replies.

When we get to the pickup, Ruby gets in the driver's seat. This is a surprise because men do the driving, not the wives. There's something really wrong with his eyes or he'd be driving.

I hop in the middle of the cab and straddle the long skinny gear shift. Just as we start rolling out of the yard, Maude comes running from the house, carrying a box.

"You forgot your Teddy bears!" she yells.

"You keep them," I yell back. "I don't need them any more."

2. Road to Whitethorn[5]

My mother wheels the pickup off Highway 101 and turns down a narrow paved road. I'm squeezed between Ruby and the new stepfather, Al, with the long stick shift scraping against my legs.

"We're on our way to Whitethorn, Sharooney," Ruby announces cheerfully.

It looks to me like we're on our way to nowhere. I see nothing ahead but trees and mountains. The pavement lasts for a mile or so until we come to a few buildings folks call Redway. A while later our road to Whitethorn turns into gravel and chuck holes. I watch as dust whirls up around our tires, swallowing us in a thick, choking cloud.

"I think you're going to love it in Whitethorn," Ruby keeps on.

"Why's that?" I ask, anxious to hear anything good about the place.

"Whitethorn is open-range country."

"What's open range?"

"Open range means there are no fences, and cows and horses can be turned loose and go wherever they want."

"Can people go wherever they want too?"

"They sure can," she says. "There's also a river and a creek right by our house. You can go fishing anytime you want."

Things are looking up. I can run free, and I sure do like to fish. The first thing I'm going to do when we get there is cut a fishing pole.

In the meantime, we keep on bouncing along until we come to a grimy little town called Briceland. As we pass through town, I can make out a grocery store and a bar ... everything a logger needs. Although I can't see much else, the drive through tells me the town is just big enough to need a school and a church. They're probably out there somewhere in the haze.

Back on the open road, Al sucks on his pipe and takes it out of his mouth. Although he has quit puffing, the smoke mingles with the dust and hangs heavy in the air, making me hack away. I do like the sweet smell of the tobacco, though.

"A long time ago," he begins, "Briceland had one of the biggest fights ever seen in these parts."

Looks like this guy can talk after all, I think. That's a relief. So far he hasn't said a word during the whole trip.

"One night, the Hoopa Indians were having a dance at the Briceland Bar. When the loggers got wind of it, they hustled over to beat up the Indians. A pile of redwood grape stakes was stacked outside the bar, waiting to be sold and hauled off to places like Eureka. As the loggers charged in, some of them grabbed grape stakes and started smashing away at the Indians. It was quite a brawl."

Boy, this doesn't sound too good. Loggers and Indians fighting just like they did in the Old West. I wonder if it's going to be safe up there in Whitethorn.

"A few loggers got pretty cut up and they had to be taken to Garberville to get sewed up by a doctor."

"What happened to the Indians?" I ask.

"They packed up their women and crawled back to wherever they came from," he says, sticking his pipe back in his mouth.

I kind of liked hearing about fights in the Briceland Bar. *Looks like this quiet guy has some great stories up his sleeve,* I think, looking at him with new interest. But it's clear he doesn't much

like Indians himself. I would just as soon the white loggers got beat up and crawled off somewhere instead of the Indians.

"Let's tell Sharon the nice things about this country, Al," Ruby cuts in as she cranks the pickup around another narrow curve. "You're going to have her scared to death if you keep on talking about Indians and fights."

"This kid doesn't look like she scares that easily," he replies, now puffing away on his pipe.

"That's right," I agree, nodding. "But I wish the Indians wouldn't always get beat up," I add, turning my head on purpose to look at Al, who just looks back at me with raised eyebrows and keeps on puffing.

After Briceland, we start climbing into the mountains. The country looks pretty bare except for a few scrubby bay trees and manzanita brush. I crane my neck looking out at tree stumps and dead branches scattered all over the mountains.

I turn to Al. "Why are all the trees cut down?"

He pulls his pipe out of his mouth. "When I moved out here, most of this country was filled with trees. Giant redwoods, fir, and tan bark trees. The redwoods and fir trees were cut for lumber and the tan bark was stripped from the trees and used for tanning leather. What's left on the mountains out there's called 'slashings.'"

"Slashings sure is the right word," I say. "It looks like a giant pirate ran all over the place swinging his sword and slashing everything in sight." I spend a few minutes imagining a wild pirate swinging his gleaming sword at all the trees.

For the next couple of miles the road is so rough I have to hang on to my seat. I wonder why anyone would want to live way out here. "Why did you come to Whitethorn?" I ask Al.

"I wasn't born in this country," he says. "I was born in Canada."

"Where is Canada?"

"Canada is a big country way up north," he explains. "When I came to California, I made enough money in the woods to buy

a saw mill. The Whitethorn Lumber Company was for sale for a decent price, so I bought it."

I sit back in my seat. He does talk kind of funny, like saying "bean" instead of "been."

"Why did you leave Canada?" I ask.

"When I graduated Grade 8, my father wanted me to work in our store instead of going to high school, so I ran away from home."

My eyes widen. "Did you join a circus? I've heard stories about kids running away and working in a circus."

He chuckles. "I went to the United States and started working in a coal mine."

"A coal mine!"

"Yep. I worked there a couple years. One day, I decided I would spend my whole life in a dark and dirty hole in the ground if I didn't do something to get out."

"I've never known anyone who worked in a coal mine. So how did you get away?"

He chuckles again. "You might say I played my way out. I started playing poker with the miners, and before long, I made a big enough stake to leave and look for some other kind of work."

"You must be a super poker player," I reply, impressed.

"He's the best poker player I've ever seen. No one can beat him," Ruby adds.

I sit quiet for a while, mulling it all over. Finally I ask. "Do you still own the mill?"

"Yep. And by the way, you both might as well start calling our place Thorn, like other folks who live there."

"When we get to Thorn, we'll take you to visit the mill," Ruby says.

Suddenly, the road becomes real steep and turns into a big S shape. Ruby starts to shift down to a lower gear. "Is this where I double clutch it, Al?" she asks.

"Yes. Just push the clutch in a couple of times while you're shifting."

As Ruby tries to do the double clutch, an awful grinding noise fills the cab. I'm scared to death the pickup is falling apart.

Al clamps his teeth down on his pipe and mutters, "You're not doing it right!"

"I just can't get the hang of it!" Ruby wails.

Finally we grind to the top of the hill. The road to Thorn sure is rough, and I worry about what's waiting for me at the end of it.

From the top of the hill, we freewheel it down the road. When my mother rolls down her window, a wonderful scent hits my nose along with the dust. It reminds me of sweet flowers, spicy bay leaves, and wild berries. Maybe Thorn is going to be okay. I can hardly wait to get there and see what it's really like.

"When are we going to get there, Ruby?"

She smiles. "It won't be long now."

A little while later the country starts to change again. I see a couple of small ranches with pastures that hold cows and sheep. Red dusty roads branch out in all directions into the mountains. Al says they're old logging roads and even today a few people live in some of the old shacks built on them. I wonder if we're soon going to turn in on one of these old roads. I would hate to live up on these mountains with heaps of dust piled high on both sides of our house.

"See those bushes out there beside the road?" Ruby says. "They're whitethorn brush. The closer we get to Whitethorn, the more whitethorn brush you'll see."

I look around but see only some stringy green bushes, nothing white. "Why do they call it Whitethorn?"

"In the spring, they bloom masses of beautiful white flowers with branches of long thorns on them," Ruby explains.

It isn't long before our broken-down road brings us to a little town. This must be Whitethorn. Like in Briceland, everything is covered with dust, only not so deep. We pass a tiny general store on the left and a post office on the right. I don't see a bar yet, but I'm sure it's here. Other dirt roads split off from the main road. A

river cuts off the houses on the right, and to get to them, it looks like people have to cross a scary-looking narrow wooden bridge.

The main road follows alongside the narrow river, and we soon pass a meadow full of whitethorn and poison oak. What fun. Now I'll be able to catch poison oak again just like in Bull Creek.

Soon a big gray building comes into sight. Sure enough, we pass a sign on it that says Whitethorn Bar.

"There's our bar," Ruby pipes up cheerfully.

"Our bar?"

"Yes," she replies," Al and Mike and Norma own it."

My jaw drops. Thoughts of drinking, smoking, and sitting in cars on Two Street run through my head.

Ruby notices that I've gone kind of stiff. "Kids here are welcome in the bar," she adds.

I look up at her. "They are?"

"There's no law against it here."

Before Ruby can go on, she's interrupted by a familiar chuckle to my right.

"Yeah, that's because there's no law or police here period."

Ruby goes on as if she hasn't heard him. "And the bar also includes an eating place where everybody, including folks and their kids, come in for some grub."

I'm still taking all this in when she adds, "And another thing you'll like, Sharooney, is that the bar has a jukebox, and you can come in and play it any time you want."

I know my mother is trying to put a good face on it. We both know I wasn't crazy about all those nights parked in cars while she was inside drinking. Well, at least now I can join them, listen to the music, and see what's going on instead of sitting bored in the car.

We continue on to a tiny bridge that hangs over a little creek with big redwoods and fir trees on both sides.

"Get ready. As soon as we cross this bridge, we'll be home," Ruby says.

The wooden bridge is so small it looks like leprechauns made it. Will it be able to hold up our pickup? I'm afraid Ruby might make a mistake and drive us right off into the creek below. I shut my eyes as we drive over it, hearing the rumbling of the boards as we roll across.

"Open your eyes, Sharooney. We're home."

I open my eyes and see a house with a tall, gray picket fence around the yard. *Pretty fancy,* I think. I've never seen a fenced yard in the country before.

Ruby drives down the gravel driveway and stops the pickup just in front of the garage. One side of it has piles of wood, a chopping block, and an axe. The rest of it is empty, just big enough to park the GMC.

After Al gets out, I jump from the pickup and head for the house. Wow! I'm going to live in a house with a big covered porch with a redwood rail around it. I skip up the stairs and yank open the front door. My mouth drops. The whole kitchen has knotty pine walls. I run past a big cook stove and an icebox and turn into a living room. I can't believe it. All the walls are a golden color with dark, knotty swirls. I run my finger over one of the smooth, varnished boards. My fingerprint stays on the wall where I've brushed off a layer of smoke. I bet the walls would be even prettier if they were washed. I sniff thick cigarette smoke in the air, but I don't mind because I'm used to the sour stink.

As I look around, I spot two bedrooms off the living room. Hooray! There's a room for me. I quickly look into each and decide that the smaller one is mine. I run my fingers on the knotty pine walls again as I admire the little dresser and mirror.

In the mirror, I see a short, skinny kid wearing a grimy T-shirt and tangled brown hair. I note her dark brown skin and think of my father, and then I look at her green eyes that I wish were dark like his. I notice too this kid's arms are hanging at her sides and her hands are curled in tight fists. I beam as the kid raises her arms and shows off the little muscles rippling on them.

Skipping back into the kitchen, I fling open the icebox door and am surprised to see the familiar bowl of moldy beans in our

new house. These beans seem to be wherever we go. Oh well. Next I admire the nice little table by the windows with a green Coleman lamp sitting on it.

Ruby comes into the house carrying my bag of clothes.

"How do you like it?" she asks.

I smile from ear to ear." It's fancier than all the other houses we've lived in. I really like the knotty pine." I look again at the small, white icebox. "But how can you have an icebox running without electricity?" I ask, skipping mention of the food for now.

"It's attached to a propane tank out in the yard."

"I can't wait to go out and start exploring."

Ruby begins to look serious. "I'm sure you'll have a great time, but remember how I told you this country has open range. No fences. You can go in all directions and can easily get lost."

"I never get lost. I always know where I'm going."

"Well, just to make sure, I want you to learn the four directions just like you did in Bull Creek."

"That'll be simple." I shrug.

The door opens and Al comes in carrying an armload of wood for the stove. "I'm hungry," he says.

"I'll whip us up some grub if you take a minute and teach Sharon where the sun comes up and sets."

"Yeah, I'm hungry too," I let her know as I plop down on a chair at the kitchen table. I'm relieved to hear there's food around here somewhere.

Al takes off his hat, hangs it on the wall by the table, and lowers his big body into one of the other four chairs. As he slowly lights his pipe, he keeps looking over at me like he's figuring out the number of board feet in a redwood tree.

This lesson isn't going to be easy, I think. Al seems like the kind of guy who makes you work for things.

He takes a puff on the pipe. "I'll give you a tip before asking you about the directions. West is on the other side of the Whitethorn Road." He gives me a sly smile. "Where do you think east would be?"

I have to think for a minute. "East is opposite from west," I tell him. "So east must be in the back of our house."

"Good. Now tell me where south is."

I'm starting to get nervous. This is getting harder. "Let's see," I say slowly. "If I stand looking west, south should be on the left and north on the right."

"And what sides of the trees have moss?"

I throw my hands in the air. "Everybody knows the moss grows on the north side of the trees."

Ruby seems pleased, but she warns, "I want you to stay pretty close to home for a while anyway. I get confused real easy in the woods. If you wander off, I'll get lost looking for you."

My stomach tightens up. In some ways Ruby is not so grown up. Sometimes I have to protect her. I remember when I was about five years old and she, my father, George, and I went down the Mad River in his rowboat. When we got to the mouth of the river, George pulled the boat up to the shore and we walked on the beach for a while. When we came back to the boat, Ruby and I got in and George pushed it back out into the river. He stayed on shore.

Soon Ruby got all upset. "I don't know how to row, Sharon. You've got to pick up the oars and row us back or we'll drift down the river and float out to the ocean."

I was so afraid I about peed in my pants. But I climbed over to the middle bench, clenched the handles of the big heavy oars, and rowed us back to shore.

I pull myself out of that long-ago trial and look at my fearful mother. "Don't worry. I'll stay close to home until I know where I'm going."

Later while I'm outside exploring, I discover a big grove of giant redwood trees behind the house. I can hardly believe it, but they look as big as the old-growth redwood trees in Bull Creek Flats.

At the top of the highest tree is a silvery colored dead branch. There's something sitting on it but I can't quite make it out. I squint real hard. What d'ya know. Two buzzards are sitting up

there looking down on me. I wave at them, excited that such interesting birds live in my back yard. On second thought, they're not very nice birds. I wonder if there are lots of dead things around here for them to eat. I'm glad I waved. At least I let them know I'm alive and not their lunch.

3. Bar People and Church People

I watch as Ruby lifts another kettle of hot water off the stove and pours it into the washtub sitting on the floor. "I want you to get in the tub now," she says. "Wash up real good so you'll be nice and clean for school tomorrow."

I hate taking a bath, but tomorrow is the first day of school. It's always scary starting a new school. Ruby and I have moved around a lot since she left George. Whitethorn will be my seventh school.

Ruby grins at me. "In the morning, I'm going to take you to a neighbor's house so you can walk to school with their little girl, Jackie. She's in the third grade just like you."

I raise my eyebrows. "What kind of kid is she? If she's a little dummy, I don't want to walk with her."

"I'm sure you'll like her. Her family rents their house from us and they're real nice people."

I'm not sure what Ruby means by "nice." She thinks everybody is nice no matter how bad they are. I guess that's why people like her so much. "What makes them so nice?"

"They take good care of their two girls and they don't smoke or drink."

My whole family smokes and drinks. Does that mean we aren't nice? I decide not to say anything to Ruby for now. "Tell me some more about them," I say instead.

Ruby drops her smile and goes quiet for a minute. There must be something about them that bothers her. "They go to the Holy Roller Church," she finally says.

"Jumpin' Jehoshaphat. The Holy Roller Church! What's that?"

"It's a church that's very strict and the people believe almost any kind of fun is a sin." She looks at me carefully. "You have to mind your tongue when we go to their house tomorrow. Don't say anything about the bar or reading the funny books."

I shake my head. This is going to be harder than I thought. I love to read my funny books and I spend a lot of time in the bar because my stepfather, Al, owns it.

This Jackie is probably a little dummy just like I thought. Oh well, the least I can do is go look her over. It would be nice to have someone to start school with.

Morning rolls around and Ruby gets me up. I put on my new jeans and shirt and stuff my feet into new, tight shoes. After breakfast we jump into the pickup and head for the neighbors.

We park in front of a little house with a well and water pump in front. The house is set back in a cluster of trees and looks out on a small meadow. We knock on the door.

When it opens, a woman in an apron with a very square jaw and bright eyes looks down at me. "So this is Sharon," she says, smiling as she looks me over.

I bet she doesn't miss a thing, I think, squirming a little under her piercing gaze. I paste on a smile and mumble, "Hello."

"This is Jackie's mother," I hear Ruby add.

"You can call me Margaret. Come on in," the lady says in a welcoming voice.

I step inside, feeling as if I passed the test for now.

We walk into a clean little kitchen. The table is set and I can smell bacon and eggs frying. My eyes light on a room just off the kitchen. The door is wide open. Holy cow! A scrawny little kid is sitting in her bed. Her eyes are barely open and her blonde hair is hanging all over her face. She's so small I wonder if Ruby made a mistake and she's only a second grader. What a fix. I don't want to

go to the new school with someone who's a second grader. Worse yet, she's not even out of bed.

"You have to get up now, Jackie. Sharon is here," her mother calls out. "You're both going to be late."

The kid finally stumbles out of bed, mutters a cranky, "'lo" at me and heads for the outhouse.

While Ruby and Margaret talk, I look around the kitchen. I've never seen a kitchen like this one. No dirty dishes piled all over the drain board. No pots of old food parked on the cook stove. The walls are not sooty and a pretty little curtain hangs over the window by the sink. Above the kitchen table hangs a large wooden cross with "Jesus Saves" written on it.

I'm looking at the cross when Jackie comes strolling back into the house. She splashes water on her hands, sits, and slowly starts to eat her breakfast. I can't get a good look at her because of the long hair straggling down, covering most of her face. It's a wonder it doesn't fall into her eggs.

I wish Ruby would say that she will take me to school instead of parking me here. But she just turns to me, gives me a big hug and a kiss, and I'm left to wait for this slow little grump. I'm so mad I'm ready to tear my hair out. I don't like to be late on the first day of school. It's all I can do to be polite and not frown. It's going to be lunchtime before we get to school.

Jackie finally finishes her breakfast, drags on her clothes, brushes her teeth, and combs her hair. I look her over again and decide she might be kind of cute. Her eyes are a clear bright blue. Her blonde hair has dark streaks in it. Reminds me of a fancy golden zebra. I also find out she is in the third grade. That's at least something.

We leave the house and start walking to school. We're kind of shy with each other and don't say much as we walk along through a meadow and down the road to the school. I'm still upset that we're so late, but this Jackie doesn't seem to care.

The school is another surprise. It's not like the big, white building with a bell tower at Bull Creek School. It's a tiny house with a redwood shake roof sitting near a little fern-covered creek.

Among the Silent Giants

When we go inside, I see first, second, and third graders sitting in desks in what probably used to be somebody's living room. A pot-bellied wood stove with a pipe reaching up through the roof stands in the middle of the place.

The teacher is fat with a round, jolly face. "Now who do we have here this morning?" she asks.

"I'm Sharon Porter," I answer, looking her square in the eye.

"Welcome to our school, Sharon. My name is Mrs. Wilson." She points to a desk across the room. "You can take the empty seat by the window."

Oh good, I'll be able to look out at the creek when I'm bored. Jackie sits at the desk next to me.

I study my scarred yellow desktop. Some kids from long ago have carved their names on it. There's even a game of tick-tack-toe scratched into it. The desk has a seat attached, the same as the ones at Bull Creek. A bottle of ink sits in a hole at the front. I perk up. I like ink. Pencils are slow and boring, but ink flows across the page like a dark river, making me feel like I'm on an adventure.

The first day goes pretty well. The teacher asks us what we did this summer. Most of the kids talk about swimming and hunting. I tell the class about Bull Creek.

At the end of the first day, Jackie and I amble along on our way home. Although we hardly talked in the morning, we chatter all the way. Jackie is smart and makes me laugh. When she smiles she has a bright twinkle in her eyes. That almost makes up for her being such a shrimp.

We stop by a redwood stump that has a branch of huckleberries growing on it. The berries are starting to become blue and they're almost ripe enough to pick. We decide to keep an eye on them and pick them when they're ready.

"Do you like to read?" Jackie suddenly asks as we move along.

"I love to read."

"So do I, but books are as scarce as hen's teeth in Whitethorn. Do you have any books I could borrow?"

"I can look around the house." Remembering Ruby's warning, I don't mention the funny books.

As if reading my mind, Jackie asks, "Did you go to church in Bull Creek?"

I shake my head. "There wasn't any church there."

"We have the Pentecostal Church here. Everybody in my family goes there on Sunday mornings and Wednesday nights. Maybe you can go to church with me sometime."

"Maybe." I shrug. *A church where people think fun is a sin is no place for a kid*, I'm thinking. On the other hand, it might be a kick in the head to watch them rolling around on the floor.

I leave Jackie off at her house, telling her I will come by again in the morning, if she promises to be ready and waiting. She agrees, but I'm not betting on it.

Before I reach my house, I have to pass my stepfather's bar. I spy his old green pickup parked in front. I figure he and Ruby are inside the bar, so I pop in to see what the regulars are up to. As I enter, I can't help thinking Jackie's mom would call going into the bar a sin. *I'll even things*, I think, *by going to church with her and Jackie next Sunday*. From the doorway I wave to Ruby and Al, feeling better already.

On the way home from school Friday, Jackie invites me to stay all night with her on Saturday and go to church with her the next morning.

"I'll have to ask Ruby," I tell her. I don't really have to ask Ruby. She lets me do just about anything I want. But I'm stalling because I'm afraid I might have to roll on the floor.

"Who's Ruby?" Jackie asks.

"Ruby is my mother."

Jackie stops dead still. "You call her Ruby? Nobody calls her mother by her first name."

"I do," I assert proudly, feeling very grown up but not very interested in the subject. "What do you do when you go to church?" I ask instead, getting back to my own worry.

"We sing a lot and the preacher gives a sermon."

"I won't have to do anything but sing and sit quietly in my seat?"

"Nope." She gives a little skip.

Looks like I have to come straight out with it. "Will I have to roll on the floor?"

Jackie jumps straight in the air! "Everyone always makes fun of us because some church members roll on the floor! People are just plain stupid. Rolling on the floor means Jesus has baptized you with the Holy Spirit and you are saved."

"So I won't have to do it, right?"

"No!" she shouts. "You don't have to do it." She stomps along ahead of me and hollers back, "I don't know if I want you to come now, if you're going to be so dumb."

I reach out and touch her shoulder. "Oh, come on, Jackie."

Wham!

In a flash Jackie twists around and sinks her teeth into my right arm. She keeps trying to bite me again and again. I hold her off by pushing her forehead back. But her mouth stays wide open and her teeth are just an inch from getting my arm again. I finally knock her to the ground and sit on her. It's a good thing she's small or I wouldn't be able to handle her.

"I'm not going to let you up until you promise me you won't try to bite me again!"

She squirms in the dirt for a while and then gives up. "Okay, but you have to quit making fun of my church."

"I wasn't making fun of your church. I was just trying to find out what the heck would happen if I went with you."

I hold her for a minute longer and then let her up. I watch as she turns and marches off to her house. My arm has a row of teeth bites beginning to swell and turn blue. A trickle of blood is dripping down to the ground. What a little brat. I was only trying to make up with her and this is what I get for my trouble. I'm going to have to be careful with her from now on. It's a good thing I'm bigger and stronger or I would really be in a jam.

Walking slowly, I hold my arm and try to stop the bleeding. When I get home, I go through the kitchen and find Ruby reading

a book and smoking a cigarette. "How was school?" she says, like all adults ask when their kid comes home.

I give her the usual, "Fine." That's all she needs to hear and I easily walk past her into my bedroom. I get a clean rag, take it to the kitchen sink, wash off the drying blood, and wrap the dry piece of the rag around my arm. I parade by her in the kitchen, but Ruby just keeps her nose in her book and naturally doesn't notice my bandage. I don't bring up anything about staying with Jackie. I figure the whole thing is off. Anyway, I'm fed up with the little twerp.

Saturday morning there's a knock on the door. I open it and there stands the little twerp, wearing a face full of shining smiles.

"Would you like to take a hike up to Goat Rock?" she asks nicely.

I think on it for a minute. She acts like she didn't bite me yesterday. What the heck, I might as well forget it and go on being friends. There's no one else I like as much, anyway. I'll just have to watch out for those teeth.

"Sure," I answer. "I'll get dressed."

The following Saturday night I stay with Jackie. We've quit fighting, and I'm not asking her questions about her church. We're bedded down for the night and talking about *The Call of the Wild* by Jack London.

"What a brave dog he was," I tell her. "I'm glad he got to be free in the end."

"It was so awful he had to leave his nice home and was treated so mean. It made me cry."

"I didn't cry, but it got me to thinking about how we treat dogs around here. My dog, Rocky, never gets to come in the house and he sleeps out on the porch no matter how cold it gets in the winter. He doesn't even have a bed to sleep on. And the food he gets is not always good. When Ruby runs out of dog food, he has to eat our skimpy leftovers. Sometimes he gets fresh pancakes and stuff, but other times the only thing he gets is a moldy bowl of beans that's been sitting in the icebox forever."

"I know what you mean. Even the minister at the church treated his dog so bad he starved him to death."

"It's hard to believe the minister would be so mean to his dog. It's wrong to be cruel, isn't it, 'specially for a minister?"

"Yeah," Jackie replies and falls quiet, lowering her head as if she's feeling ashamed for what the minister did.

"And we both know if a dog doesn't behave himself or his owners get tired of him, they just take him out and shoot him," I quickly add, sorry for making Jackie feel bad. "Like last summer when I was staying with my Aunt Maude and Uncle Gene, he shot my dog, Mutt."

"Why did he do it?"

"Because he got in a fight with another dog. Mutt was my first dog and I got him when I was three years old."

"How awful!"

"The worst thing about it was Mutt went hunting with my uncle a lot and he knew that a gun could kill. I used to tease him sometimes by pointing my finger at him, and he would whimper and try to hide."

"I bet he knew he was going to be shot when your uncle pointed his gun at him. The poor thing."

"I've got an idea. It's too late to do anything about Mutt, but I could make Rocky a little bed to sleep on at night. And the next time there's nothing in the icebox, and I grab my rifle and fishing pole to catch me some game to eat, I'll try to remember that Rocky is hungry too."

The next morning, as usual, Jackie won't get out of bed.

"Hustle along now, Jackie, we're going to be late," her mother, Margaret, warns. But no matter how many times Margaret tells her to "get a move on," Jackie lies there like a log stuck in a log jam.

Her family is all dressed up and ready before she even starts to put on her clothes. Margaret is wearing a blue cotton dress with white polka dots all over it. Her dark hair is combed back from her face, showing off her fine square chin.

Jackie's father, Ed, is wearing his Sunday-best cotton pants and a dark-green dress shirt. Army-colored suspenders hold up his trousers. He's a tall, lanky, blond-haired logger with a skinny neck and a large Adam's apple that rolls up and down when he talks.

Jackie's older sister, Margie, is wearing freshly washed jeans and a blue and white T-shirt. She's tall and skinny and has a large nose like her father.

Finally tired of waiting, Margaret gives up. "We're going on to church, Jackie. You and Sharon can come when you're ready."

A while later, Jackie and I, dressed in our old jeans and clean T-shirts, finally leave the house. It's only a ten-minute walk on the open dusty road to the church. Feeling a little grumpy from the morning hassle, I decide being friends with this slowpoke is going to cause me to be late for everything. I hate being late. If she wasn't so smart and so much fun, most of the time, I would quit being friends with her.

The church is painted white and has some nice green bushes planted beside its steps. A big wooden cross hangs high up on the outside wall. The words "Jesus Saves" is carved on it just like the one above Jackie's kitchen table. Two or three cords of firewood are stacked neatly along the outside wall.

Jackie and I tiptoe into the church and take seats in the back of the room. The inside walls are plain wood, as is the high ceiling. About fifty people sit on long, polished wood benches. The sermon has already begun. The minister is a baldheaded man in a rumpled suit. *Is he the guy who starved his dog?* I wonder.

"You must come to the Lord and be saved," he shouts. "If they don't accept Jesus, sinners who go to bars and drink will burn in hell forever."

Burn in hell forever? I picture my family lining up at the bar drinking beer, when a red-faced man in the middle of the room pops up and shouts, "Praise the Lord."

"Amens" follow the "Praise-the-Lord" guy and loud "halleluiahs" and "Jesus Saves" push their way through a roar of "amens."

I wish I could just get up and get out of here. Jackie told me all I had to do was sit quietly in my seat. Now everybody is calling up to God. What am I supposed to do? I look over at Jackie and feel better. She's just sitting there, her mouth shut.

Suddenly, a big man sitting on the aisle starts talking in a strange tongue. His eyes are closed and the words don't make any sense. He's quiet for a minute, and then his body starts jerking and he falls to the floor, rolling and hollering in the funny language. The church explodes with shouts of "Praise Jesus."

As he's rolling on the floor, I think of the old drunks I've seen in the bar who have fallen off their stools and squirm on the floor before they pass out. The same way, the man's fit in the church ends with him lying quiet and still like a dead man.

"Thank Jesus for baptizing our brother with the Holy Spirit," the preacher calls out. "Speaking in tongues is a powerful gift from our Lord testifying to salvation." He smiles and lifts his arms high in the air. "Let us sing to the glory of our Lord Jesus."

Everyone stands and starts to clap their hands and sing. Smiles lifted up to the ceiling fill the whole darned place. I check on Jackie; she's standing and singing too. I stand up and clap. The singing and clapping get louder and louder and many people start crying.

After the song, the minister calls to his flock, "Come to the altar and give yourself to Jesus. Don't listen to the voice of the devil, who tries to hold you back from the Lord."

A few people start to walk slowly to the altar, where they kneel before the minister. Some have tears rolling down their faces. He lays hands on each one, one at a time, as he recites, "Thank you, Jesus. Bless you. Jesus is your salvation." As he continues, the criers moan like people with bad bellyaches. I'm sure glad Jackie and her family are not going up so I can stay safely in my seat.

Finally, the whole service is over and I'm released from my misery. Jackie and I walk out into the sunshine. I feel like I've been twisted inside out.

"I never knew so many people needed saving," I manage to croak, my head spinning.

"That's right," she says, turning to me. "You have to accept Jesus and be saved or when you die, you're going straight to hell."

I shiver and imagine flames roaring around me and licking my flesh. Holy smoke!

As soon as we get back to Jackie's house, I get my things and hurry for home. I think of my family and worry for all of us. They would never think of going to church. I've even heard my stepfather say he doesn't believe in God.

Later at dinner, I ask Ruby and Al, "What do you think about the church?"

"I'm sick and tired of them," Al says, slamming his big hand on the table. "They're always talking about closing our bar. The bar is the only other place where people can get together and visit. Mike and Norma do a nice job of running it. Norma cooks good meals in the restaurant and families bring their children to eat or have a soda."

Mike and Norma are from Oklahoma. She's big and fat and talks like an Okie. They went in with Al and built the big bar and restaurant a few years ago. They live in the back part of it so they're there all the time. Mike is a big, tall logger type with thick dark hair. He's lots of fun, but people have to look out for Norma. She can give a whopping tongue-lashing if you make her mad.

"But don't you think it's good that the people in the church don't smoke and drink?" I ask.

Al lights his pipe. "Living a good life is fine, but rolling on the floor and babbling in tongues is another thing. The church is like a drug. It works on weak minds. They're soft in the head."

"They think we're all sinners and are going to hell because we like to dance and drink a little," Ruby adds.

"Are we going to hell?"

"Of course not," Ruby replies. "It's all a bunch of foolishness. They would like to close the bar because it's a temptation for church members to backslide and go in and drink. Many of them used to drink and smoke until they were converted. There's nobody as self-righteous as a person who has been reformed."

"Is it okay if I go to church with Jackie?"

She smiles. "It's okay as long as you don't get converted."

"And don't ask us to stop smoking and drinking." Al laughs, sucking extra heavy on his pipe and blowing a big cloud of smoke at me.

Lying in bed that night, I think again of the times I've been parked in cars while Ruby was hanging out in a bar, drinking and smoking. Maybe the church people have something. The drinking makes Ruby forget that for a kid it's boring and scary to sit for hours in a dark car. As I drift off to sleep, I decide I'm never going to drink and smoke when I grow up.

Jackie and I keep on being best friends. She hasn't tried to bite me again. It's a miracle, but her mother decides to let her stay overnight at my house even though my family drinks. Together we search for books to read. The ones we find are mostly for grown-ups. Jackie discovers *Treasure Island* and *David Copperfield*. A while later, I find a moldy book called *King Solomon's Mines* in a broken-down trunk in my garage. We take turns reading the books.

We find lots to do besides reading books. We play in the woods behind my house. My stepfather has saved two acres of old-growth redwoods there. A creek runs through it and goes right on down to the Mattole River across the road from our house. We love to look into the creek and find water dogs. Water dogs look like swimming lizards, black on top and bright orange on their bellies. Sometimes we lean over too far and fall right into the creek, clothes and all, making us laugh. Falling in is an especially big joke when we're wearing a new pair of jeans. We've started thinking that new jeans have a hex on 'em and getting near a creek in a new pair can cause us to fall in.

One of our favorite things is collecting moss and making a fairy garden on top of a big old stump. There are lots of different kinds of moss growing in these redwood trees. Some are tiny green pincushions. Others are a lacy, darker green. We add tiny white mushrooms and pretty stones from the creek and stick a tiny branch into the moss to make it look like a tree. When we're

done, we like to look at it, come back and check on it, and go on admiring it for several days.

Also on our property is a big tree house inside a burned-out trunk of a huge redwood tree. People say these woods have been here for more than two thouand years. The big old trees are so quiet and still, we think they have spirits in them or perhaps ancient gods that are keeping an eye on the two of us.

Jackie read a book once about Lamas in a place called Tibet. I don't know what a Lama is, but we think they might be the spirits that are in our huge trees. Jackie says the Lamas are magical women who are very powerful. They wear bright-colored clothes, and the most powerful ones dress in brilliant red robes.

One day, inspecting our biggest, tallest redwood, we discover that this particular tree is so mysterious and sacred, it's likely that one of those magical Lamas is living in it. We start watching for signs that would tell us if Lamas lived in the other trees. After much debate, and some outstanding detective work, we notice the mushrooms that sometimes grow between the scraggly red barks. The mushrooms come in all sorts of fantastic shapes and sizes. Some are flat and stacked like pancakes and others are built like lofty fairy castles. They come in all kinds of colors, just like the Lamas who live in Tibet. The mushrooms are our best clues that a Lama lives in the heart of a tree. We now know when we discover colored mushrooms growing on a redwood tree, a red Lama or an orange Lama probably lives in there.

By now we're spending two nights at Jackie's and two at my house. Twice a week I go to church with her. On Wednesday nights we go barefoot if it's warm enough and we don't even have to change our clothes. On Sundays we wear shoes only if it's too cold to go barefoot.

I go to church mostly because I want to be with Jackie. I also like it that church people don't get into fights just for the sport like the folks at the bar do. The church is clean, nice, and peaceful when there's no rolling around, and even kind of fun. I like the singing and clapping and I've learned a bunch of songs so I can

sing along with them. I also learn lots of other things I never knew before.

Right now, I especially like the woman who is teaching us from the book *Pilgrim's Progress*. The book is about this man called Christian who is worried about going to hell and goes looking in many places for ways to be saved. I can't say I understand a lot, but the teacher makes the story especially fun by using a black felt board, putting colorful people on it, and then moving them around. I've never seen anything like it.

Al and Ruby might think that church people are soft in the head, but I'm sure glad to learn that there are different ways of living and having fun besides drinking, smoking, and fighting.

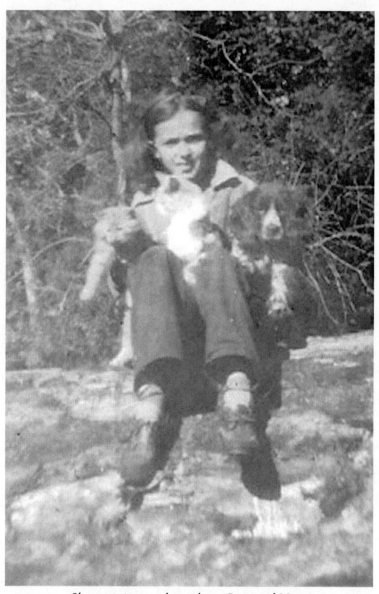

Sharon sitting on a log with cats Rusty and Mama Cat and dog Rocky in Whitethorn

4. The Importance of the Outhouse

I can't help hanging around the bar. That's where I need to be if I want to see my mother a lot, which I do. But lately I try not to read funny books because the church says it's a sin and I don't want to take any chances on landing in hell.

Jackie makes it hard on me when she comes over and heads straight for my *Superman* and *Batman* funnies. She grabs them and takes them out to the front porch and starts reading. Even though she's a little religious nut and knows it's a sin, once she gets her nose in them, she won't quit until she reads them all.

She's at it again today. "Aren't you worried that God is watching you reading the funny books?" I ask her.

She doesn't even look up.

"And it's a sin and you'll go to hell?"

She just sits there like a dumb stump. She's also ruining our plans to go exploring in the woods today. "If you don't stop reading, I want you to go home," I yell at her. She doesn't budge. I call Ruby to come out to the porch.

"Jackie won't quit reading. Make her go home!"

Ruby comes out of the kitchen, her hands covered with flour from kneading bread. I'm hoping she tells Jackie off and sends her home. But she barely whispers, "Jackie, it's time to go home now."

I don't know why I thought she would be tough with Jackie. She's only tough after a couple of drinks. Then she acts like a big boss.

Jackie ignores us, as usual, and keeps on reading until she has finished all my funny books. Ruby and I can't do anything about it unless we knock her off the porch. But I know how to fix her. I march into the kitchen and order Ruby not to buy any more funny books when she goes to Eureka.

The next morning, Al and I sit at the kitchen table finishing breakfast. He's puffing on his pipe and reading the newspaper that came in yesterday's mail. These days he hogs most of the light by pulling the Coleman lantern over beside him. He's getting blinder by the day and now has to have the lantern even in broad daylight. Ruby is outside feeding the cats and dog moldy beans and table scraps.

After Al finishes a couple pages of the newspaper, he hands them over to me. I don't care about the news, but I used to like reading the funnies before I met Jackie and started going to church. And before I started worrying that I might be a little girl living in a funny strip.

One of the funnies I especially wonder about is one with a little girl who always gets in trouble in school. I think she's a little bit like me. I don't always listen to my teacher and it's hard for me to stay in my seat. I wonder if she has any idea that people are watching her entire life. She's supposed to have been drawn by some newspaper guy. But wouldn't it be something if she were really alive and didn't know the whole world was watching her?

Of course I'd rather be Superman or Batman. But I've already proven I'm not either of them. I remember the day I put on a cape made out of an old raggedy towel and tried to fly over a tall gate. All I got for my trouble was a big black eye.

Suddenly there's a knock on the door and in walks Jackie, all dressed up in her jeans and denim jacket. Her hunting knife is hanging from her belt.

"Are you ready to take a run in the hills?"

"I have to get dressed first." I'm not exactly happy to see her right now, but I give in, thinking a run might give me some more ideas about who the real me is.

Jackie and I always try to dress exactly alike, and our jackets and hunting knives tell people we're a team.

"Don't you think you should leave your jacket? I'm not taking mine. We're going to get hot once we start running."

"Yeah, I guess we'll get hot. I'll leave it," I say. "I have to go to the outhouse first. Wait here; I'll be right back."

Our outhouse is a two-holer like everybody else's in Thorn. I don't understand the need for two-holers because two people usually don't go at the same time. Besides, when you sit on one hole, hordes of flies come buzzing out of the other hole and fly around your head. The best thing in the outhouse is the Sears Roebuck catalog. It sits on one side of the bench, waiting for a person to tear off a page. If you have to while away some time out here, it can also be interesting reading.

As soon as I get back to the house I strap on my knife and I'm ready to go. We always run barefoot. Out in the yard, I see my big orange tomcat, Rusty, sleeping in the sun. We walk over to poke him when suddenly Ruby's big Plymouth Rock rooster comes charging across the yard, heading straight for us. His neck is stretched so far it looks like a big feathered snake with a beak. We both yelp and race for the gate. If the black and white monster catches us, he'll attack us with his three-inch spurs and bang big bruises all over our legs.

We make it out the gate and slam it shut. He smashes into it and is momentarily stunned, sprawled in the dirt. Serves him right for being so mean. We always have to keep a lookout for that ornery bird, but sometimes he appears from nowhere and we get beat up. Today we leave him in the dust and go on our way into the hills.

The Mattole River is only a few hundred yards from my house. We cross the Whitethorn Road and walk through a forest of fir trees. Tall ferns slap our legs, leaving yellow pollen prints on our pants. As we reach the river, we wade through the top of a

bubbling falls that runs into a deep hole of water. As we splash against the current, I'm reminded of the hundreds of salmon that climb the swollen falls in the winter. In the late fall and winter, salmon by the hundreds, with skins of various shades of red make their last trip up the river. The early travelers are generally all red, whereas the latecomers may show no signs of extra color. Some of them are beat up from climbing the many rock falls and squeezing through piles of log jams. Parts of their skins are shredded, and ribbons of dead peelings drag alongside them. The fish are on their way upriver to the spawning grounds where they were born. After they spawn they will die.

When we get to the other side of the river we make our way through thick manzanita brush. I'm in the lead as usual, but I'm careful I don't let go of a limb and let it fly back into Jackie's face. If I hurt her she may go on a biting spree. Soon we come to a deserted logging road that has been made many years ago by a bulldozer or Cat.

From here we start our run. Running in the hills is a lot of fun. We just run and run, laughing and giggling most of the time. I'm not sure why we laugh because it takes extra wind that could be used for going up the hills, but it seems so funny to be running for no reason.

After a mile or so, we turn off the road into a second-growth forest of redwoods. Second-growth trees are usually smaller than the old growth because they haven't had the hundreds of years to grow big and tall. We use the well-worn deer trails through the trees because they're easier on our bare feet. On the trails we pass lots of tall ferns, mushrooms, and berries. We even hear a gray squirrel chattering his complaints as we trample around in his territory. We eventually make it clear to the top of the mountain, laughing all the way.

"Let's stop here," I tell Jackie. "We can sit in the shade and eat the huckleberries growing on the logs."

"Those huckleberries look real fat and sweet, but first I have to go."

As I watch her heading for a big tree, I yell, "Don't set your bare butt down in a patch of poison oak." Dropping a bare butt down on poison oak seems to happen to everyone in Thorn at one time or another, especially to a visiting city slicker.

After Jackie gets back, we pick the huckleberries one by one and plop them in our bagged-out T-shirts, which we've pulled out from the bottom to form a sort of cup. Ruby isn't going to like it when I come home with berry stains all over my shirt, but I don't have anything else to collect them in.

As we sit down to eat some berries, I think about the funnies again. Are they real people who are read by the whole world? I think of the church and God. *But who is God?* I wonder. Maybe he's the guy who writes the funny strips, telling people what to do and think. I take a deep breath. These thoughts are getting too big for my head, and I feel like it's going to bust if I keep on. I would like to talk to Jackie about it, but I don't want her to think I'm touched in the head. My best bet would be to try her out by talking about make-believe playmates.

"Did you ever have a make-believe playmate when you were little?" I ask.

"No, but I've heard that some kids have them," she says, berry juice dripping down her chin. "In my opinion, it's pretty strange." She looks at me with her piercing blue eyes. "Did you have one?"

"Yes ..." I answer, worrying that she might get the best of me. If she thinks having a make-believe friend is strange, she might think I'm loony tunes talking about people in the funnies.

"How long did you have this friend?" Jackie presses on.

I plunge. "I had my friend for two or three years. He was real nice and lots of fun to play with. His name was Dobby. Ruby used to set a plate for him at the table. If she didn't, I would have a tantrum. Sometimes people who couldn't see him would start to sit on him and I would have to tell them they couldn't sit there because they would squash Dobby."

"Is he still around?" Jackie asks, squinting at me.

"No. One day he went into the army and I never saw him again."

"How old were you when he went away?"

"I was about five," I tell her. "I've heard only smart kids have make-believe playmates. I'm not surprised you didn't have one." I laugh, quick to duck the berry she throws.

We finish our berries and start for home, walking leisurely now. Jackie is jabbering away but I don't hear her because I can't get my mind off the funnies. People all over the world may be reading me at this very minute. And if they are, who is the guy drawing me? Somehow I feel it's connected to the church and God, but I can't figure it all out. I feel scared, but I don't want to show it if people or God are watching me. I can just see the next funnies headline: "Sharon is Scared," for the whole world to see, including Jackie.

We finally get to my house and Jackie picks up her jacket and goes home, leaving me to whittle figure-four sticks for my chipmunk traps while I mull further on the possibility that I'm in the funny papers.

When I go to bed that night I stay awake for hours. Could I prove I was not in the funny papers? My thoughts turn to doing detective work like Jackie and I did, in the old-growth forest, when we decided colorful Lamas lived in the huge redwood trees, depending on the color of the mushrooms growing on them.

The next morning the mail delivers another newspaper. I grab the funnies. I first look for the funny strip about a little girl like me. I don't find it. I'm not surprised because the whole country would be watching me looking for my funny strip. I imagine them laughing at Sharon looking for herself.

Next I search the funnies for clues: Do the people do things that I do or is there something they do that I don't? I go out to the back porch to sit in the sun and mull on it some more. A few minute later I gotta go, so I head for the outhouse. Crouched over one of the holes, my thoughts keep tossing back and forth. Then it hits me.

"They never do it in the funnies!" I shout. I'm not a character in a funny strip! No one is reading me. I go to the pot every day,

so I'm a real girl who lives in Whitethorn." I'm so excited I almost fall off my perch in the outhouse.

Thinking on it in bed that night, I know I've proved that I'm a real little girl. I also think going to church with Jackie has given me many more questions to think about and find answers to. But I'm only eight years old and I know I can't expect to find all the answers right away. I think of how long it took for that guy Christian in *Pilgrim's Progress* to find the answers. I turn on my side and tuck the blankets under my chin. I smile, thinking about all the many adventures and detective work waiting for me in the years to come.

5. Stardust: A Tale of Three Horses

The winter rains have mostly passed and spring is finally here. Small shoots of grass have pushed themselves up through the deep muck. Jackie's sister's horse, Scout, is at last able to wrap his rubbery lips around the tiny green morsels and cut them off with his teeth. He has grown pretty skinny over the winter because he's had to survive mostly on twigs and last year's clumps of soggy summer grass. He's the only horse around here.

In May, on a beautiful dreamlike morning, a big gray horse appears in Whitethorn. Nobody seems to own him. He may have drifted up the Whitethorn Road from somewhere near Briceland, a small town about ten miles away, or he may have simply stepped out of the mist of a fairy tale. My friend Bobbie Jo found him wandering in a nearby field and put him in a makeshift corral at her house.

Today, I run down the Whitethorn Road to Bobbie Jo's house, where I'm stopped dead by the sight of the towering beauty in the corral. I rush closer and take in his huge body and lofty gray head. He's taller than any horse I've ever seen. I inch my way into his corral and put my hand on his velvet nose. He welcomes me with a nudge, as if asking, "Where's the grain?"

"We don't have grain here in Thorn, but I can pick you some grass," I tell him, happy that he's friendly and gentle.

While I'm picking grass, Bobbie Jo appears and goes into the corral and tries to get on him. She jumps and jumps but can't make it up to his back. I'm not surprised. She doesn't do much except spend a lot of time putting makeup on her pretty face and looking for clothes good enough to wear to junior high.

When she gives up trying to get on the grand horse, I feed him the grass I've picked. He eats it up like candy. His big lips open wide as he grabs and chomps down on the grass. *It will be a cinch for me to get on him now*, I think. It doesn't matter that I'm only eight and small for my age. My arms are strong and I'm good at climbing trees. I'm sure I can make it up his tall back.

"I'm going to get on him," I announce, "but we need to make a bridle first."

We search the barnyard and find an old rope covered in dried mud. Its frayed ends go deep into the earth like twisted roots and it takes both of us to pull it up. We clean it and make it into a large bridle, complete with long reins. I fit the bridle around his head like on Scout's, putting the rope behind his ears and attaching it to the part of the rope around his nose.

I grab his mane with my left hand and try to swing my legs over his back. He's almost twice as tall as I am. On the first try my feet make it only halfway to the top. He's not skinny like Scout so his big belly gets in the way.

Bobbie Jo watches with a smug smile on her face. "You're too small to make it all the way up to his back."

Her challenge makes me try even harder. Time after time I swing on his mane and try to reach what I'm sure is heaven. Each time I give a great big swing, I get my feet a couple inches higher. Finally I make it up to his back, covered with sweat and breathing hard.

Bobbie Jo stares at me, not looking too happy. I sure showed her!

Perched high on the big gray's fat back, my legs are spread wide instead of down. I love the feel of his big hairy back against my legs. I feel like a king looking over my Whitethorn kingdom. I

sit here knowing my life is changed forever. The back of a horse is where I belong. But he's not just a horse; he must have a name.

I think on it real deep. I got it! "From this moment forward, I pronounce you 'Prince.'" I pull one of the reins to the right and Prince turns around. I give him a little kick and we're on our way. I think I may be a natural-born rider. Everything goes great until Prince starts to trot and I begin to bounce up and down. But I'm not discouraged because I know I will soon be riding like I'm part of him.

A couple of weeks later, I'm riding like a cowboy. I float along on Prince's back when he walks, trots, or gallops and I swing up on his bare back like an acrobat.

Then, on a hazy day at the end of the month, I go out to catch Prince and he's nowhere to be found. He has vanished! Did he return to the town of Briceland, or did he travel back to the enchanted land he came from? It's hard to be without him. I no longer sit high upon his back, galloping through the woods and fields of Thorn. No one has heard any news of him since he disappeared. Wherever he is, I hope he's happy and fat and remembers our time together. He taught me how to ride and foretold of my life with horses. I'll miss him forever.

I'm sitting on my porch with Rocky, my brown and white cocker spaniel. He's my friend and I can talk to him about secret things. I lay my hand on his little head and whisper, "I miss Prince so much. I don't know if I will ever get another horse to ride." Rocky looks up at me with his big sorry eyes and I know he understands.

The rattle of an old car clunking up our driveway suddenly takes my attention away from my sorrowing over Prince. I can make out my eleven-year-old cousin, Sonny, sitting in the back seat. He's three years older than me. My Aunt Maude from Bull Creek, Sonny's stepmother, and Uncle Gene, his father, are in the front seat. Uncle Gene's driving.

As soon as the clunker stops, Sonny jumps out, runs, and hunkers down beside me and Rocky. Sonny is a daredevil type who I often try to imitate because I admire his courage. He does

all sorts of wild things, like coon hunting all night with his pack of hounds and going up steep cliffs that everyone else is afraid to climb. I also like the way he dresses. He always wears jeans and a T-shirt with an unbuttoned long-sleeved shirt on top. He usually wears shoes, but I don't much admire that since I think it's a lot braver to go barefoot, like Jackie and I do. He also smiles and jokes a lot like he thinks he's smarter than everyone else. I don't like his way of teasing. He sometimes makes fun of me for being so skinny. One time he roped me when I was galloping bareback on Prince and pulled me right off on a gravel road. It hurt like the devil but Sonny just laughed. I was scared and mad, but part of me liked his boldness. And there's no doubt he's a good roper if he could snare me off a galloping horse.

Later, while we're sitting on my back porch, I tell Sonny my sad story. "My big Prince disappeared and I don't think he'll ever come back."

"Gee, that's too bad. Now you don't have a horse to ride."

Well bless my soul. Sonny has never ever given me a word of sympathy. He always just pokes away at me with his teasing. Hearing an understanding word from him, I decide to bare the rest of my feelings.

"I don't see how I will ever get another horse. The only horse here in Thorn is Scout, who belongs to Jackie's sister, Margie. She never lets me ride him."

He laughs. "Cheer up. I know where you can get another horse."

My heart almost stops. "Another horse? Where?"

"He belongs to my neighbor in Bull Creek. His name is Dash and he can run like lightning. I'll bet he could even outrun Scout."

Scout is known for his speed and his habit of running away. When he gets out of control, the only way Margie can stop him is to pull one rein sharply to the left, causing him to fall down on his right side. Margie usually doesn't get hurt because she quickly pulls her leg out of the way before he hits the ground.

"This horse is a real looker," Sonny continues. "He's on the short side but has a fancy head and is built like a brick outhouse. The guy who has him is only asking one hundred twenty-five dollars. I think you should buy him."

I jump up. Holy smoke! It would be great to own a good-looking horse with lots of speed. I'm sure Sonny knows a good horse when he sees one. "I'm going to tell my mother about Dash," I say, hop-skipping into the house.

I find Ruby in the kitchen talking with Maude, her younger sister. I can see it's going to take a while before I can get a word in because Maude, as usual, is talking a mile a minute. Maude sometimes calls Ruby "Bear" or "Chris." I know their father gave her the nickname "Bear" because she was grumpy as a kid, but I keep forgetting to ask about "Chris."

I tune in to Maude's long-winded story. "I bought two new dogs, Bear. One's a black and white mutt. The other one is a black cocker spaniel puppy."

"So how many dogs do you have now?" Ruby is trying to keep a straight face.

"Well, these two make it four. And five cats."

I roll my eyes. My aunt is crazy about animals. She started out with a big yard of chickens and now she's gone to collecting cats and dogs. I decide I can't listen to all this. I'll talk to Ruby later.

Just as I'm heading out, my Uncle Gene comes into the kitchen with Al. Gene is a good-looking guy with dark hair who thinks he's smarter than anyone in the world. I guess that's where Sonny gets his know-it all-attitude. Mumbling hello, I hurry back to the porch with Sonny.

He greets me with the same cocky smile as his dad's. "I've a surprise for you. Open your mouth, shut your eyes, and I'll give it to you."

I know Sonny can't be trusted, but I take the chance that he has something good this time. As soon as I open my mouth, I know I've made a terrible mistake as a big bunch of foxtails fly into it. I panic, thinking I might swallow one. They can work themselves in. Any movement in my mouth, and they'll crawl

down my throat. It takes me ten minutes to draw them all out. I could kill Sonny for doing this to me. Maybe he doesn't know the danger he puts me in. But then again, maybe he does. I think back on him roping me off a galloping horse. The devil! I stomp away to the kitchen for a drink of water. Turns out Ruby is finally alone.

I tell her all about Dash. "Would you please, please buy him for me?"

"Well, we would have to see him first and make sure he's gentle," she says. "The price is all right, but I don't want you to get a horse that's dangerous."

"Sonny says he thinks the owner would be willing to truck him up to Thorn and let me try him for a week."

She smiles at me. "You really have to have a horse, don't you?"

"I want a horse more than anything in the whole world," I tell her, jumping up and down.

As I try to go to sleep that night, I imagine what it would be like to ride Dash through the grassy fields and up mountain logging roads. I think about having a race against Scout and leaving him in the dust. I can hardly wait for Dash to come to Thorn.

A few days later, as I'm walking home from Jackie's house, I see a pickup rolling up beside the Whitethorn Bar. I watch as it backs up to a small bank by the road so the pickup bed is level with the bank, making it is easier to unload. I look in the back and see a bundle of muscle wearing a saddle and bridle. His eyes look wild like the rough waves of the Pacific Ocean. He sure didn't step out of a fairy tale. He looks like he's loaded with the tough blood of a mountain horse.

Sonny hops out of the pickup and gives me a big smile. "Well, here he is. The fastest SOB in Bull Creek."

The driver of the pickup steps out and Sonny introduces him to me. "This is Len. He owns Dash."

Len looks to be about sixty years old. He's a real cowboy with deep-sunken eyes under a big hat and a gimpy left leg he probably got from rodeo days. I take my eyes off Dash long enough to say hi. I turn back to the pickup bed and watch Sonny unload the

beautiful horse. When he walks onto the bank, I see he's not very tall, but he holds his beautiful head high and looks ready to go.

Sonny tightens his saddle and jumps up on his back. Dash instantly starts to move. Sonny pulls him up and circles back to me. He swings off and hands me the reins. "I'll hold him while you get on."

I put my foot in the stirrup and swing my leg over the saddle. This is the first time I've been in a saddle and it feels funny. It would be easy to slip my foot through the stirrup and get it caught. Dash starts to pull away from Sonny.

"Let him loose," I cry. "I can handle him."

As Sonny lets go of the reins Dash bolts, and it takes all my strength to pull him in. I call back, "I'm going to ride him down to my house so Ruby can see him."

As Dash comes charging up to the house, I pull him up short. Ruby rushes out, looking scared. "He sure is spirited," she shouts.

"I like him this way."

"You listen to me, I don't want you to get a horse you can get hurt on!"

I don't ever remember Ruby giving me an order. It must be serious. "I won't get hurt. I can handle him fine." I trot Dash back and forth in front of the house so she can see I'm in control.

Ruby watches me, but she doesn't look any happier. Just then, Dash jerks his head down, pulling the reins and my knuckles over the saddle horn. My knuckles get scraped and start to bleed. I can't hide it.

"Are you okay?" she asks, running over to me.

"I'm just fine. It's only a little scrape."

Dash makes things worse by dancing around and jerking his head down again. My knuckles are dragged over the saddle horn once again and more blood splatters on it. I feel all hope of keeping Dash dripping away with it.

"I don't know why Sonny brought you a spirited horse like this. He should have had better sense. What did he think he was doing, bringing you a horse that could hurt you?"

"But look how pretty he is," I protest.

"I don't care how pretty he is. I'm not going to let you keep him."

I can't squeeze the tears back. I look down at my bloody knuckles and hope they're scarred for life. Then I'll always have something to remind me of Dash. Every time I look at the scars, I'll remember Dash.

For the rest of the month, I pass a lot of time poring over the scars forming on my knuckles. At times I also go fishing with my friend Timmy. I love fishing. It helps take my mind off the lost horses.

Today is July 13, my ninth birthday, and except for a "Happy birthday, Sharooney," and hotcakes as a special treat for breakfast, Ruby acts like this is just another day. I know she hasn't baked a cake. No hint of a present, either.

I'm feeling pretty blue today. A celebration could have taken my mind off pining for Dash and Prince. It's been almost a month since Dash was sent back to Bull Creek. I never got a chance to race him against Scout. I would have loved sailing past him and Margie, leaving them both in the dust. I miss Prince too. How big and beautiful he was. I felt like a king sitting high up on his back. Now it looks like I'll never have a horse. All I have is a ropey, raised scar on my knuckles to remind me of the one I lost.

Before long I hear the blasting of a car horn tooting like World War II has just ended. It jolts me from my dreary thoughts. Ruby gives me a sly grin and we both jump up and run to the door.

I hear my Aunt Doris's sing-song, "Sharooney! Come see what we've got for you."

We open the door and see my aunt's full two-hundred pounds weaving up the walk. She's drunk as usual. She waves her arm toward the pickup, but I don't follow because I'm so distracted by her face. She's painted up like a great big clown. Her face is a white mask of powder. Standing out from the mask is a mouth smeared with thick red lipstick. While I'm staring, she grabs me by the arm and drags me to the pickup where my Uncle Max is just getting out of the driver's seat.

As soon as we get to the pickup, a different white face pops up over the top of the cab.

"Oh!" I cry out, startled by this other white face with bright red lipstick around its mouth and a huge red ring smeared around its right eye. But this face is not my Aunt Doris. It's a horse!

I quickly move to the side of the pickup and peek through the wooden slats. I can make out a coat of red and white hairs and a jagged white stripe running up the right leg and over the hip. The horse looks like strawberry roan paint. I notice its ears are a little long, and its bottom lip droops slightly, but they uncover a good set of teeth.

I frown as I glance at its full face again. What kind of a horse have they brought me? This sure isn't my dream horse Prince, or even Dash.

As I'm trying to figure it out, Uncle Max comes over and stands beside me. A wide-brimmed hat covers his bald head and he looks mad. "Doris shouldn't have smeared lipstick all over her like that," he complains in his high-pitched voice. "I couldn't stop her, damn it. This is a nice little horse. I'm sure you'll like her once this stuff wears off."

I feel a small thrill starting to grow in my body. Uncle Max calls the horse "her," so she must be a mare. I like the idea that she's a mare. Dash and Prince were both geldings and they could never have a foal. I think of the beautiful Arabian stallion that lives in Briceland only ten miles down the Whitethorn Road. Maybe I can get her bred to the stallion and have a half-Arabian foal.

Ruby joins us. "This is my birthday surprise for you."

I turn around, wide-eyed, "You bought her for me?"

"I certainly did. I knew you had to have a horse. Doris knows a lot about horses and I was sure she could find the right one for you."

I look over at Doris as she takes a nip of her bottle of muscatel wine. "Her name's Stardust!" she slurs.

"Stardust!" I repeat—but is the horse as nice as her name? I wonder. I watch Max unload her. She makes a clatter with her

hooves backing out of the pickup, scrambling to the ground. I look her over as Max leads her to me. She's on the small side and has a narrow chest but I think she's cute. I walk up to her and pet her on the nose. It's nice and soft. I pick up the bridle hanging on the saddle horn and put it on her. She stands quietly while I tighten the cinch on her saddle. When I get on, she doesn't seem to want to go, but I give her a kick in the ribs and turn her away from our house.

I'm getting more and more excited as I ride her down the road. Her painted face is long-forgotten as I put her to a trot and then a gallop. Her gait is smooth and easy. I rein her in to a walk. Her saddle is just the right size for me and looks almost new. She's my horse now, and no one's ever going to take her from me.

I turn Stardust around and ride her back to the house. From a distance I see Ruby waving at me. As I ride up, she smiles at me, pleased as punch.

"How do you like her?" she asks.

"I love her," I say, jumping off and giving her a big hug. "I didn't even know you were looking for a horse for me."

"I wanted to surprise you. I knew that the best birthday present I could get you would be a horse. It wasn't easy to buy her. I spent every dollar I had."

"How much did she cost?" I ask.

"One hundred and fifty dollars, including her saddle and bridle."

Doris interrupts, "We've brought you the best little mare in the country. We got her from some Indians."

Holy smoke! Now I've a real Indian horse to ride. "Thanks, Aunt Doris, for picking her out. I really like her."

Doris spreads another big grin as she finishes rolling her Bull Durham cigarette. I watch with admiration as she takes a match and lights it with a quick zip up the leg of her jeans. Doris is my favorite aunt when she's sober, and I usually don't even pay too much attention to her benders. She's sober when she's home on the dairy ranch and is as strong as a bull elephant from many years of lifting bales of hay and heavy cans of milk. Doris always

gets nervous when she leaves her house, so she drinks to help her nerves. As a little girl she was afraid to start first grade, so Ruby had to begin first grade with her when she was only five.

My Aunt Doris might have some peculiar ways of going about things, but when she sets her mind to a thing, it usually turns out right. She picked out just the right horse for me.

Thinking about it in bed that night, I can see it's best that I didn't get Prince or Dash after all. They were dream horses, and they could never have a baby. I love Ruby for spending her last dollar to buy my first real horse. Stardust and I will be a team forever, and I'll always remember my ninth birthday.

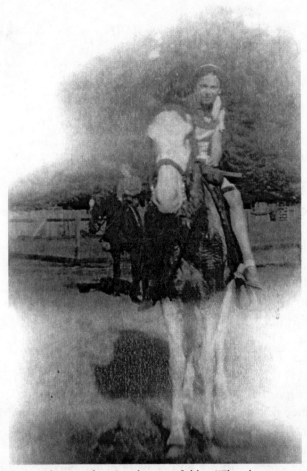

Sharon riding Stardust in a field in Whitethorn

6. Family Circus and Visit to Arcata

The summer is almost over and I've to go back to school soon. It won't be long until the heavy rains start and everything turns to mud. I'm sitting at the kitchen table watching Ruby make my favorite bread. As the dough rises, she cuts off slices and fries them in deep bacon grease. She calls them "dough floppers."

While I'm polishing off the floppers, Ruby hands me an unopened letter. "This came yesterday. It's from your father."

A letter from George, my dad! I tear it open. He's going to come up to Whitethorn ten days from now and take me home with him for a couple of weeks. He lives in Arcata and spends every bit of his spare time fishing on the Mad River. I love to fish with him. I can hardly wait for him to come get me.

After I finish reading the letter, I once again wonder why Ruby and George are not together. I just can't understand it. George is a real nice man. We would have had an easier life living in town if she had stayed with him.

I look over at her. "Why did you leave George?"

Ruby keeps working on her plate of floppers. "He sure was the best-looking guy in Humboldt County. He just wasn't smart enough for me." Ruby talks a lot about how she was the smartest kid in school and how she finished high school at sixteen. Everyone also knows that in her second year she was often asked to read her poems to the senior English class.

I can't say I understand it. I don't know anyone else who's left her husband because he wasn't smart enough. But in my family, the most important thing in the world is brains.

"Was he dumb?" I mumble between floppers.

"He wasn't dumb. I was just so much smarter than him." She shakes her head. "He couldn't even spell right."

I can't spell right either. I love reading but spelling is hard for me. I wonder if she thinks I'm not smart. I remember the time she got a big laugh when I was writing a paper for school about the golden horses of California. I guess I didn't spell horses right and called them "hores" instead. From then on, she told everybody she knew about the "golden hores of California." I don't know what a hore is, but I guess it was a real funny mistake since everybody laughed.

In some ways it's hard to live with Ruby and my stepfather. Al thinks he knows everything, and she thinks she's so smart she should have been a lawyer. They're always giving me problems to solve, like the fox, the duck, and the bag of grain. The trick is to get them all across the river in a small boat that can hold only one of them and the boat guy. If the fox is left with the duck, the fox will eat the duck. If the duck is left with the grain, the duck will eat the grain. I've never been able to figure this out even though I'm going into the fourth grade this fall. They laugh at me because I can't come up with the right answer. Al teases me so much about it I sometimes throw things, yell, or stomp out of the room.

Ruby has never said I was smart but she sure is proud of my strength. When we're at the bar she often takes my hand and shows people the thick rows of calluses I have on my palms. Then she tells them how strong I am.

As soon as I finish eating, I hear a soft knock on the door. I open it and my scrawny friend Timmy, Bobbie Jo's little brother, is standing there, tattered clothes and all. His family is dirt poor, but all of them are real lookers. There's also some rough stuff when his father gets real drunk. I figure Timmy is hungry, as usual, so I let him have the last flopper. He gobbles it down and then we walk outside to sit in the sun.

"I'm s-o-o-o bored today," I groan. "I don't have a single thing to do."

"I'm bored too," Timmy says, elbows propped on his knees. "I don't feel like fishing, exploring mountain roads, or anything."

We're quiet for a while, taking in the morning sun. Suddenly an idea pops into my head. "Why don't we have a circus?"

"A circus?" he says, wide-eyed. "How could we do that?"

"My two white rats, Whisky and Frisky, could do some tricks. Rocky knows how to sit up and beg and he even barks for food." I jump up. "We could do some acrobatic things like me holding you up in the air with my feet." I let that sink in for a minute. "What d'ya think?"

Timmy's eyes brighten up. "My little sister knows how to stand on her hands and my sister Bobbie Jo can do a back flip."

"And I can get pieces of cloth from Ruby's sewing kit and we can make costumes for Whisky and Frisky. We can even paint our faces and dress up like clowns. But we need to have the circus before my father comes. How about next Saturday?"

"Yeah, and we'll put up some signs so people know we're having it."

"Let's make them right now!"

Timmy frowns. "With what?"

"Don't worry. I'm sure we'll find something."

"Are we going to charge people?" Timmy asks. He's always looking for money so he can buy something to eat.

"I think it should be a free circus. We're not going to have monkeys or elephants like they have in a big circus."

His shoulders sag.

"Come on"—I grab his arm—"let's go look in the sheds and see what we can find."

I pull him to the three old sheds standing in the middle of our yard. I keep my rats in one of them. Ruby throws junk in the others.

We climb up the battered gray stairs and go in to visit Whisky and Frisky in their wire cage. They both stand on their hind legs and stick their pink, wiggly noses through the wire. I give each

one a small nut. Their water and food bowls are full so we go to the next shed.

This one is a jungle of junk. Way in the back I see a couple of big cardboard boxes. I look at Timmy. "Crawl over there and bring back those two boxes." As he's tunneling his way to the boxes, I spy a can of paint. "And grab that can of paint off to the left."

Timmy drags the boxes out and then goes back for the paint. I pick up a small paint brush by the door and we haul everything to the garage. As soon as we plop the stuff down, I take my hunting knife out of my belt and cut two nice pieces of cardboard.

I paint the signs because I don't trust Timmy to do it right. When the paint dries, we take one of them down to the end of the driveway and prop it up with a stick, facing the Whitethorn Road. We amble back to the garage, feeling we're well on the way to our circus.

"You take the other sign and put it down by the Whitethorn bar," I tell Timmy.

Just then Ruby returns from a trip to the store. When she gets close to our driveway, she stops the pickup, jumps out, grabs our sign, and throws it into the back.

When she drives up to us, she doesn't look very happy. "You can't put signs like that out on the road," she yells.

Timmy and I look at each other wondering what could be wrong about putting up our sign on the road. Does she think it's a bad idea to have a circus?

It doesn't take long before Ruby lets us in on the problem. "You can't have a sign that says 'fart' on it."

"Fart!" I holler. "I wrote 'free.'"

"Well, it doesn't say 'free.' It says 'fart.'"

I'm stumped. How could I have written fart instead of free?

Ruby starts laughing. She goes into the house bent over with giggles. I bet she can hardly wait to tell Al about the "fart" circus.

Timmy and I stand around for a while feeling like a couple of dopes.

"Are we going find out how to spell 'free' and make some new signs?" he finally asks.

"No! And we're not going to have a circus either," I shout, throwing myself down on the grass, my hands cradling my head. Tears well up, but I wipe them away before Timmy can see them.

He turns and trudges home and I drag myself into the garage and sit on the woodpile. My father can't spell and Ruby thinks he's dumb. When he comes to get me, I'm going to find out if he's smart or not. I know just the test. I'll ask him to solve the riddle of the fox, the goose, and the grain.

The day George is coming to get me finally rolls around. I haven't seen him since last summer. I'm all packed and ready to go. I pace around the yard with butterflies bouncing around in my stomach. He should be here any minute.

Soon a shiny blue car comes driving up to the house. It's him! I race to the car and jump up and down waiting for him to get out.

He grins as he climbs out and gives me a big bear hug. "Are you ready to go?"

"I sure am." I stand back and look him over. He's still good-looking. I love his beautiful dark-brown eyes. He's gained a few pounds since last summer but he's still in good shape with lots of muscle and great big hands. I check his left hand, where the little finger's been cut off. I've always liked looking at the little stub. He works in the barrel mills and cut the finger off getting it too close to an electric saw. Nobody I know has a father who has had one of his fingers cut off.

"You sure have grown since last year. And getting prettier all the time."

I hang my head to hide my red face, but I'm really pleased that George thinks I'm pretty. Ruby has never told me I was pretty. I sometimes wonder if she thinks I'm ugly.

"Come on in and have a cup of coffee," Ruby yells from the house.

"I could use a stiff cup of logger's brew before heading back."

The two of us troop into the house and settle at the kitchen table. Ruby pours them both a cup of coffee.

"Can I have a cup?" I ask eagerly.

"You're too young to drink coffee."

"Oh please," I beg. She usually gives in if I play my cards right. "It would be such fun to have coffee with both of you." I wheedle her until she gives in and pours me half a cup. The three of us now sip our hot brew together, grinning at each other over our steaming cups.

I'm sure glad they get along now. There was a lot of fighting when I was little. I remember one scary morning when Ruby got a hammer and pounded the coffee pot to smithereens. She did it in a fit because George wouldn't get up out of bed to eat the breakfast she cooked for him. But they act like good friends this morning and look so nice together—George with his black hair and easy-going grin; Ruby and her turned up nose and curly red hair. She's not as good natured as he is. I've never seen him mad and he often whistles cheerfully as he walks along. Ruby, on the other hand, can charm the socks off almost anybody, but she likes to get into squabbles—such as the difference between "push" and "pull." She'll fight you to the death that they're both the same. And when she talks to men, she loves to show off her smarts by using big words. I'm glad today she's not bringing up her latest favorite "push-pull" ideas and we can just visit real friendly for a while.

"Keep a close eye on Sharon when she's in the boat," Ruby warns. "And don't take her out on the ocean in your rowboat."

George sometimes steers his boat down to the mouth of the Mad River and goes right into the ocean where he can catch lots of fish. I'm not scared to go out with him because I know he can handle the boat real well. It would be fun to go past the rolling shore waves and fish out in the deep ocean.

"Don't worry about it," he tells her. "We're going to stay on the Mad River."

Finally, George and I take off for Arcata. He remarried a couple of years ago. Signe is a very nice lady. She has a son about six years old. She loves to clean house and wait on my father, and she serves dinner at the same time every day. She even buys things she knows I love, like tomato juice, which I almost never get at home.

The ride to Arcata takes most of the afternoon. Our drive east to the town of Redway is mostly on gravel mountain roads. Redway runs into Highway 101 North. From there we weave through miles of giant redwoods before rolling into the town of Scotia. After Scotia, it's a straight shot north to Eureka. Arcata is about a fifteen-minute drive north of Eureka along Humboldt Bay. Catching up on all the news since we saw each other last year make the hours roll easily by.

George tells me about his job at the barrel mill. He and his father have always worked there. Since he got part of his little finger cut off, he now oils all the machinery and no longer works with saws.

I talk about fishing and the big trout I caught this summer. "He was almost a foot long," I brag.

"How did you catch him?"

"He was hiding deep in a logjam, and I dropped my hook into a hole in the middle of the logs instead of hanging it in front of the jam. It was tricky getting him up through the small crack. But I had hooked him pretty good and I was real careful pulling him out."

"Sounds like you're getting to be mighty good at catching fish," he replies, putting his big hand on my shoulder. "You'll have plenty more chances to show your stuff when we go out on the Mad River," he adds, pulling me closer.

When we finally get to his house, Signe is waiting for us. She's not nearly as good-looking as Ruby, but she makes up for it by keeping the house organized and the food on time. She and George almost never argue. The kitchen is filled with the smell of something cooking in the oven. I think it's roast beef.

The two-story house has always been in the family because my Grandpa Porter built it long ago. It's on the edge of town and

the barrel mill is just across the pasture. The streets around the house are gravel but turn to pavement as they get closer to the main part of town.

Many folks in Arcata work in the sawmills and the barrel mill. But it's not a loggers' camp far away in the woods like Whitethorn. It's a cute little town off a bay with two-story houses for folks to live in. The center of town is a nice little square park with flowers, trees, and benches. Around the square are lots of stores like a five-and-dime, and even a movie house. In the center of the square is a large statue of President McKinley on a tall stone pedestal. Grandpa Porter remembers the big celebration in 1906 when the statue arrived from San Francisco. He said the statue had survived the 1906 earthquake and was a gift to the town of Arcata from a rich Arcata fella who liked McKinley.

Grandpa Porter still lives in the family house. His family moved here from Nebraska when he was about my age. He's even darker than my father and has the same coal-black hair, now turning gray. He says his father was a French Canadian carpenter, but I think he was an Indian. I know he really misses Grandma, who died of cancer last year (1948). I miss her too. She was my favorite grandmother because she was always so cheery and warm and not as glum as my other grandma, who folks call "poor ole Ma." My cheery Grandma had her ear to the radio all the time and loved Amos 'N Andy. Whenever the national anthem came on, she would order me to stand and hold my hand over my heart just like she did.

I remember what fun I had with her when I was little. One time she took me out to see the baby chicks that Henny Penny had just hatched. She picked up one of the fuzzy little chicks and let me hold it. I loved the little chick so much, I had the most awful urge to squeeze it and squeeze it some more, until Grandma loosened my grip and gave it back to the mama chicken.

George's house is really different from home in Whitethorn. It's heated by a wood stove but has electricity, an indoor toilet that flushes, and even a piano in the living room. I love poking around the keys when I'm there. I had a piano teacher in Whitethorn but

no piano to practice on, so I made a paper copy of the keys and practiced on my make-believe piano.

Shortly after we arrive, Signe's son, Gary, comes running into the kitchen. He looks about the same as last year—short, scrawny, with a head of curly hair. I don't like him because he's a real pest. He's about three years younger than me. Though he can talk as well as anyone, he likes to jabber sounds that are not words for hours at a time. He drives me crazy.

Signe serves dinner around 5:30. The food is lip-smacking good. I have roast beef and tomato juice. Signe didn't forget how much I liked it. After dinner, I ask George if I can clean his spinners. We're going fishing first thing in the morning and I love to get into his fishing box and shine his collection of spinners.

"Good idea," he says. "They're getting pretty dull because I've used them a lot this year. I'll go get 'em for you."

"Keep your hands out of my spinner box!" Grandpa yells as George heads out the door to the garage.

Grandpa is not warm and cheery like Grandma was. He doesn't talk much and is grumpy most of the time. He has a great big garden in the backyard and doesn't like anyone to walk in it. One time I chopped off the tall hollow stems of his giant onions, thinking they would make great sheaths for my wooden swords. When he saw his "sheaths" he just stared, quiet as a stone, and then stomped away. Later George took me aside and said Grandpa never wanted to see me in his garden ever again.

"How's school?" Signe asks while we're sitting at the table, waiting for George to come back with his fishing box.

Grownups don't seem to know what to say to a kid, except to ask about school. I hate to answer school questions because I don't like school and don't want to tell about my school troubles. But I answer anyway. "About the same ... boring. I spend most of my time in the corner."

Signe gives me a serious look. "Why is that?"

I put my hands on my head. Why in the world did I have to blabber about sitting in the corner? Now I'll have to say more. "I talk a lot and sometimes use my pencil to poke kids I don't like."

Just then George comes in with his old black tackle box and rescues me from more school talk. He puts the tackle box down on the living room floor. "Go get some newspapers so we can keep the floor clean."

I cover the floor with paper and then plop down on the floor. I lift the lid. It's a pirate's treasure of dozens and dozens of George's special spinners. I reach in and gently pick up one of the spoon-shaped spinners and rub some polish on it. It is thinner than a regular spoon and doesn't have a handle. With a dry rag I rub it to a sparkling shine. I check its attachment to the hook. When we slowly drag the hook behind the boat tomorrow, the spinner will twirl around the hook, flashing a golden gleam that attracts the fish.

After I finish the first spinner, I happily polish thirty more.

*

George wakes me before daylight. "Hop out of bed," he calls. "The fish are hungry first thing in the morning."

After breakfast, wearing his usual old, baggy clothes, George puts on his worn-out floppy round hat and starts to load up his fishing gear, humming as he goes. He loves to sing but loses the tune all the time. It doesn't seem to bother him and I like his cheeriness.

We drive about fifteen miles north and west to his small fishing cabin at the mouth of the Mad River. No other cabins are close by, and the back of it looks out on a field of weeds and sand. The cabin has been in the family for at least fifty years. It's weathered and gray and has never been painted. Inside there's a hand pump for water and a two-holer toilet between the kitchen and the garage. The walls are decorated with a big stuffed fish, nets, and photos of family members holding big fish they caught. The place also has two bedrooms with double beds and a nice covered porch with a couch for sleeping in the summer.

I pick up George's fishing poles from inside the house. He carries the outboard motor from the garage and hauls it across the road down to the little floating dock on the river. I also bring the wooden oars in case the motor stops working. We will be close to

the mouth of the river and don't want the boat to drift out into the ocean. I'm not worried. My father is so strong he can row the boat wherever we want to go.

As I walk down the wooden plank to the dock, I remember a time when I was about five years old. I was so excited about going fishing; I ran down the plank and couldn't stop at the end of the dock, flying right off into the deep river. George had to jump in the water, clothes and all, and fish me out. We both laughed as we stood dripping on the dock. I was very proud of him for saving me.

The rowboat is tied up at the dock. I can see it was painted green sometime in its life. The paint is chipped all over and bare wood shows in lots of places, especially in the front where it has run into the dock or pulled up on the shore.

When we get all our stuff loaded, George uses an oar to push the boat out into the middle of the river. Then he starts the engine.

"Here we go." He grins. "Let's troll until we get close to the mouth of the river."

He slows the boat so the fish have a chance to bite. He lets his line out on the left side of the boat, and I hang my pole on the right.

"Remember, if one of us hooks a fish on the line, the other needs to reel in quick. We don't want to get our lines tangled."

"Okay," I agree, crossing my fingers for a big fish.

We troll our spinners deep in the water but don't get a single nibble. Before long we come in sight of the mouth of the river. As I look up at a great, tall cliff on our right, my eyes almost pop out at the amazing sight. A shimmering white curtain is floating from the top of the cliff. Not only does it cover the cliff down to the greenish moss on the river bank, it's as wide as a huge circus tent.

My father turns off the motor and anchors the boat. We sit quietly as the morning sun climbs higher in the sky, casting a silvery shine on this magical show. A few strips of the shimmering curtain are floating away from the cliff, and are hovering like long

silver ribbons over the water. Their tips glow a light green, colored by the moss that once held them at the river's edge.

I finally find my voice and whisper, "What is it?"

"It's a gigantic spider web made by millions and millions of tiny spiders," he says, grinning. "I'm glad you got to see it."

"Is it there all the time?"

"I've only seen it a couple of times and it's always in the fall. I don't think it happens very often and few people have ever seen it."

I'll remember George and me looking at this magical spider web for the rest of my life.

We fish the rest of the morning but don't catch a thing. Today we don't care. We've seen the giant spider web and had a pretty ride down the Mad River. At noon we dock the boat and drive back home.

The rest of the vacation just flies by. We go fishing three more times and catch four or five fish. Signe feeds us lots of good dinners. Gary and I get to go to a couple of picture shows and I put up with his pestering. Too soon it's over and time to go home. I say my good-byes to everyone and hop inside the car with George.

As we bump along, I think about how great it was to be with George again. I like to fish just as much as he does. He never gets mad, is always cheerful, but I still don't know if he's smart. It's time to give him the riddle about the goose, the grain, and the fox. I'm almost afraid. What if he can't figure it out? I take a big breath and put him to the test.

"Let me think about it," he says.

My mind is on the butterflies in my stomach during the short quiet before he speaks.

"Let's see. The man can take only one at a time and he can't leave the goose with the grain or the fox with the goose. First thing he needs to do is take the goose over to the other side of the river. Then he goes back for the grain and crosses the river to where the goose is waiting. He drops off the grain and takes the goose back with him to the other side where the fox is waiting. He unloads the goose, gets the fox, and crosses the river. He leaves the fox with

the grain and goes back and picks up the goose. The goose, the fox, and the grain all make it to the other side of the river without the fox eating the goose or the goose eating the grain."

"Hoorah," I holler and throw up my hands. I've never heard the answer before, but I think he has it. Ruby and Al almost made me believe they were the only ones smart enough to figure it out. George figured it out real quick, even if he can't spell. I must be smart too, even if I spell "fart" when I mean "free."

When I get home, Timmy and I are going to put on the greatest "fart" circus Whitethorn has ever seen.

7. A Mysterious Sickness

Grandma has just moved from Bull Creek to Whitethorn and lives in a little cabin just down the road. I feel much better when she's around. She's my champion. When she's at our house, she picks the best parts of the food for me. I always get the legs of the chicken and the biggest piece of dessert. My stepfather, Al, is too blind to see that I get the best and Ruby doesn't notice.

Ruby hates arguing with my grandma because Grandma always insists on having things her way. Almost anyone can tell Ruby what to do, and Grandma sure does. The exception, of course, is when Ruby is drinking. Then she's as stubborn as a mule.

I love the stories Grandma tells me about her life as a teenager. One of my favorite stories is about the time she poured honey on the dress of a girl who had been mean to her. The girl couldn't go to the dance that night because her dress was dripping with honey. Grandma also tells another funny story about a man coming into town in a fancy buggy pulled by a fine-looking team of horses. Grandma didn't like people who showed off how rich they were. So when he tied up his team and went into a store, Grandma and her friend jumped into the buggy, whipped up the horses, and raced through town screaming, "The horses are running away!" We always have a good laugh at the end of her stories.

"Sharon, you gotta get up!" Ruby hollers for the third time.

It's Monday, summer's passed, and I'm now in the fourth grade. Today my head hurts like I've been hit by a tree. *Ruby is not going to like this*, I think, but I plow ahead with my usual, "I can't go to school today. I'm sick." I pull the covers up over my head and wait for the storm to hit.

"You're going to get out of that bed and go to school," she shouts. "Every Monday you whine you're too sick to go to school, and when I let you stay home, you're not too sick to go out and ride Stardust. You're going to school today, sick or not."

She sounds pretty set on my going to school. She's not usually like this. She generally goes along with almost anything I want. That's why some people say I'm spoiled. But this time I'm really sick. And now I'm stuck in the same fix as the little boy who cried wolf too many times.

"I don't know what I'm going to do with you," she goes on. She can be cranky in the morning and I have to be careful. She doesn't beat me up, but she sometimes throws glass ashtrays at me. She always misses. Either she doesn't aim well or I'm a good dodger. It's probably a bit of both.

I hide under the covers, not moving an inch while Ruby carries on. She finally gives up and lets me stay home. Grateful, I crawl out of bed, dragging a pillow and blanket behind me, and make my way to the big old couch in the living room. I dump my pillow on the sagging couch and cover up with my old blanket. Ruby usually lights a fire in the living room stove in the morning, but today she's so mad she might not do it.

I ask in my best feeble voice, "Please light the stove. I'm so cold." I'm shivering but she doesn't seem to notice.

"It's not that cold in here, and you don't need a fire," she growls, but flings a couple of logs into the stove anyway, sloshes it with coal oil, and lights it with a match. The fire burns brightly but soon fizzles out. I beg her to come start it again. When she comes in from the kitchen, I can see that she's madder than ever.

"If you had gone to school, you wouldn't have been cold. It's warm in the classroom!" She charges the stove like a redheaded rhino, yanking the small iron door open with a loud clang. She

reaches down and picks up the coffee can, half full of coal oil. She knows better, but she heaves all the coal oil onto the smoking wood.

I gasp, fearing there might be a live coal left in the stove. Sure enough, the stove explodes into a flaming fireball. She snatches her hand back, and as she retreats the flame follows the dripping can clear across the room, creating a wall of fire from the stove to the other side of the room.

I'm trapped! The only way out is to jump over the fire. The flames are taller than me, except for a small part farthest from the stove. I suck in my breath and leap over the blaze. I quickly check myself, surprised and happy. I didn't catch fire!

Ruby is standing like a stump in the middle of the room. The house will burn down if we don't get the fire out. I race to the kitchen and grab Al's big leather jacket and throw it on top of the blaze. It smothers some flames but is not big enough to put out the whole fire. Ruby now runs to grab a couple more jackets, gives me one, and together we beat and smother the flames.

When it's over we stand in a daze huffing and puffing, the smell of singed cloth and coal oil nearly choking us. Looking around, I see the floor is scorched and the big stuffed chair, sitting across from the stove, has a few more holes and black spots on it. Otherwise, there's not much damage.

Ruby is the first to move. She slams the stove door, where a bright fire is now putting a nice warm glow into the room, but otherwise says nothing. Feeling faint, I stagger back to my bedroom, fall on the bed, and huddle into the blankets. I decide not to ask Ruby for anything else. Before long, I am sound asleep.

Later that day I wake up and begin really wondering what's wrong with me. I started feeling funny on Saturday when my best friend, Jackie, and I went horseback riding. My head was pounding like a lumberjack was beating a wedge into it. I could barely stay on my horse. To keep Jackie from finding out how miserable I felt, I told her every few minutes that the horses were tired and we needed to stop to rest them. Every time I got off Stardust, I fell on the ground like a beaten dog.

"Look, Sharon, the horses don't need any rest. If you don't want to ride, let's just go home."

"I don't want to go home," I lied. "But if you want to go home, let's turn the horses around and go back to your house."

Jackie agreed, which was unusual because we generally fight about everything. That night I stayed at her house and barely slept because of the pain pounding my back. Sunday morning I went home and collapsed on my bed for the rest of the day.

A week has passed since the fire. I'm still in bed. My mind feels like it's covered by a thick, sticky fog. On top of that, I don't care about anything. If Ruby set the house on fire again, I would probably just lie here and burn up. My face is so hot, it's like it's on fire anyway.

Later in the day as the fog parts, Ruby's and Grandma's voices come drifting into my room. As their voices get louder, I can make out every word.

"You've got to take her to a doctor," Grandma shouts.

"You know darn well we don't have a doctor here in Whitethorn, and it's a three-hour drive to Eureka. Sharon doesn't need a doctor anyway. She'll get over it. When I was a kid, you didn't take me to a doctor every time I got sick."

"But you were never this sick. She just lies in her bed, doesn't eat or talk. She's going to die if you don't take her to a doctor."

I don't care who wins the argument. On the other hand, I don't feel like taking a long ride to Eureka. It might be better to lie here and wait to die. It turns out I don't have a choice anyway, because Grandma wins out as usual, and we're on our way to Eureka.

The trip to Eureka is a killer. I can't lie down because I'm sitting in the middle of the pickup seat with the long gear shift battling with my legs.

Grandma holds me tight against her big strong shoulder. Every time we go around a turn, we sway back and forth like drunken bowls of Jell-O. If only I could be dropped off beside the road and left to die.

Things get a little better when we hit the pavement near Garberville. The road doesn't have as many turns and bumps, and though I hurt all over, at least I can fall asleep.

Grandma wakes me up as we drive into a big town. I look out the window and see old moss-covered buildings and the foggy sky. This has to be Eureka, where the sun never shines. I was born here so I know about its gloom.

Ruby heads for a gas station and parks by a payphone. "I'm going to look in the phone book for a doctor."

Grandma looks down at me. "Do you need to go?"

"Yeah," I mumble as I lift my pounding head.

She helps me out of the truck and takes me to the bathroom. I pee, and for good measure throw up white foam.

We go back to the truck, and Grandma pulls out her handkerchief and starts wiping my sweaty face. She suddenly stops mopping and her eyes pop wide open. "My God, you're turning yellow!"

Ruby climbs back into the driver's seat. "Will you look at this kid?" Grandma tells her. "She's turning yellow all over! Her eyes look like egg yolks."

For the first time, Ruby looks worried. "I phoned a doctor and he says to come right in. The office is only a few blocks away."

She starts the truck, grinding the gears and almost jerking us out of our seats. My grandma hangs on to me but my head flops over. The next jolt slams me back into her lap.

The doctor is a nice man who flashes a friendly smile as he listens to my heart and pushes a flat stick down my throat. When he pulls up my shirt, his smile disappears. "There's a rash on her belly."

He turns away, gets a needle, and jabs it into my arm, causing me to reconsider his niceness. I watch as the big needle sucks off what looks like a quart of my blood. After more poking and prodding, he turns to Ruby and Grandma. "I'm not sure," he says slowly, "but I think she has typhoid fever."

For a minute nobody makes a sound. Ruby turns white and starts to cry. I've never heard of typhoid fever, but it must be awful. I'm getting scared. Maybe Grandma's right. I am going to die.

"We have to wait until tomorrow for the results of the blood test," the doctor says. "Keep her away from other people until we know for sure."

The three of us stagger out and get into the pickup. "Where can we go where there are no people?" I ask, looking up at Grandma.

"We'll go to Doris and Max's ranch. It's only a few miles outside of town. They'll let us stay the night."

Sure they'll let us stay. Almost anyone can stay with our family, even drunks who cause all sorts of trouble.

When we get to the ranch, Ruby tells us to sit in the car while she talks to my aunt and uncle. Before long, my Aunt Doris comes out to our car.

"You just come right on in, Sharooney. We're not worried about catching anything. We wade around in manure all the time and don't get sick. I'll fix you a little bed and cook you up a good soup."

Doris is sober today. She's real nice when she's not drinking. She's also a great cook. The soup she soon serves me smells good, but I can't eat it. Later in bed I can hardly sleep, my head and back hurt so much.

The next day we pile back into the pickup and ride to the doctor's office. When we walk in, he meets us with a grim smile. He fiddles with his papers then looks up. "It is typhoid fever."

"What can we do?" Ruby wails.

"She needs to be isolated from people until she gets well."

Isolated from other people? Who'll take care of me if I can't be with people? I squeeze back the tears before anyone can see them.

"We're going to do whatever the doctor says!" I hear Grandma reply.

"She must go to the Humboldt County Contagious Disease Hospital immediately," he declares.

I haven't been in a hospital since I had my tonsils out. And this one is not just any old hospital. It's a place where people go who have something so terrible they have to stay away from everybody. I'm really in a jam this time.

When we drive up to the hospital, it looks gloomier than the rest of Eureka. The building is a huge hunk of gray cement, moss sprouting from every crack. Grandma and Ruby haul me up a flight of gray cement stairs. At the top, the big doors open on a gray cement hallway.

A stern-looking nurse comes marching down the hall and orders me to follow her.

"Can I go with her?" Ruby asks.

"No! She has to be in an isolation room and no one but nursing staff can go in."

As I walk away from Ruby and Grandma, I look back, wondering if I'll ever see them again. I give them a weak smile, hoping I look brave.

I follow the nurse down the hall and we go into a large green room. I notice right away the screens and bars on the windows. They weren't fooling when they said I had to be away from people. Looks like I'm going to be caged up in this place. For some reason I think of Whisky and Frisky, my pet rats. I wonder, for the first time, how they feel about being locked in a cage.

The nurse sits me in a chair beside a small bed. "Take off your clothes," she orders. She seems more like a jailer than a nurse. I don't like taking my clothes off and letting her see my scrawny body. I've lost lots of weight since getting sick. I put on the white cotton nightgown she hands me.

She turns down the bedcovers and tells me to get in. After I'm in bed, I look at the bars and metal screens on the windows. They don't need the bars. I'm so worn out; I couldn't escape if I wanted to.

Looking me over once more, the nurse turns and leaves the room. I hear the rattle of keys as she locks the door. Here I am, cut off from everyone, like a logger's leg that is so filled with infection it has to be put out of sight and buried as soon as possible.

A few minutes later I'm surprised by Ruby knocking on my window. She smiles and waves at me and points to a handle on the window beside my bed. She makes a winding signal. I grip the handle and turn it until it opens the window a few inches. The thick screen and the bars divide us.

"How're you doing?" she asks.

I'm so sick I don't want to talk, but I don't want to hurt her feelings. "I'm pretty sleepy, but I guess I'm all right."

Grandma stands beside her. She looks relieved. "I'm so glad we got you to a place where you can be taken care of. It was a long trip, but you couldn't just waste away back in Whitethorn." She gives Ruby a look, clearly giving the message that I would have died if I had stayed in my bed in Whitethorn.

"Why do I have to be locked up?" I ask Grandma. "I've never heard of anyone getting locked up because they're sick."

She hesitates a minute and then explains. "Typhoid fever is like a cold. It can be catching."

"But they don't lock people up when they get a cold. It must be a lot worse."

"It is more than a simple cold," she admits. "That's why you're here. They know how to help you, and no one else will get it from you."

Ruby changes the subject. "Grandma and I are going to stay at Doris and Max's dairy ranch. We'll come back tomorrow and bring you a toothbrush and something to read."

"That's fine," I say, feeling sicker and sicker. "See you tomorrow."

As soon as I fall asleep, the nurse comes in and takes my temperature. I just get back to sleep when a big man, dressed in white, comes in and takes more of my blood. Before he leaves, he tells me that lunch will be brought in a few minutes. I wonder why all these people are coming in when I'm supposed to be away from people. I decide I'm too tired to think about it.

Before long a different nurse comes in carrying a tray of food. She's dark-haired, and unlike the other nurse-jailer, she has a nice

smile. "Here's your lunch," she says, setting a tray on my bedside stand.

I look at the food and almost throw up. There are three awful little bowls of what looks like baby food. One bowl has yellow stuff in it, the second is filled with a sick, green mixture, and the last is full of something gooey and white. I turn over and go back to sleep, hoping the awful bowls will be gone by the time I wake up.

And so the days drift by with clouds of brightly colored bowls of baby goop briefly landing on my bedside stand and floating back to wherever the heck they came from. Not only do I have to endure the bowls, most everyone wants my blood. A parade of blood takers drains my veins all the time. One man even came all the way from San Francisco to get it fresh. I suppose they know what they're doing, but I worry they might bleed me dry.

As the typhoid fever slowly burns itself out, I start to notice how neat and orderly everything is in my room. I can count on the nurse coming in every day to make my bed. I like to watch her turn the top sheet neatly over the covers.

I've never seen a bed made that way. At home, I just crawl into the pile of covers with my clothes on. Changing the sheets doesn't happen very often either because it's a big job. Ruby has to heat water on the stove and wash the sheets on a metal scrub board. When I get home, I'm going to make my bed every day and fold the top sheet a couple of inches over the covers. I would like things at home to be as clean and neat as they are here in the hospital.

The better I get, the more bored I'm feeling. Things liven up when my father visits. I'm able to see him more often here than in Whitethorn. Today he knocks on my window and waves a book. "I brought you a science fiction book I think you'll like. I'll give it to the nurse, and she'll bring it to you."

"What's a science fiction book?"

"Science fiction is about people exploring other planets or inventing strange machines that take over the world. They're fun to read, and I think you'll like this one."

I've never read a book about people going to other planets. I can hardly wait to start reading it. I've been mostly doing puzzles and I'm getting tired of them.

"Caught any fish lately?"

"I sure did." He smiles. "I went trolling in our rowboat and caught five steelhead. You would've had a great time reeling in the fish. You just get better fast, and we'll be out in that rowboat together before long."

Later, Ruby and Grandma come to visit. It has started to rain, but they still have to stand outside my window. Grandma always tries to cheer me up. She smiles and claps her hands together. "Heavens to Betsy and seven hands around, you're looking better."

It's funny when she says, "Seven hands around." Everyone knows it takes eight hands to make a circle.

"How're you feeling today?" Ruby asks, looking tired and worried.

"I'm feeling better than yesterday. When do you think they'll let me go home?"

"Not for a while yet," Grandma warns. "You haven't even started to eat."

"I might be able to eat if they would bring me some real food. They say regular food would make me sick, but I don't believe it. I'm too old to eat baby food."

"I talked to the doctor yesterday," Ruby says. "He told me that the public health people have looked all over the county trying to find out where you caught typhoid fever. You're supposed to be the only case in Humboldt County in twenty years. They think you probably caught it from contaminated water. They've tested the wells of everybody we know, but they all came up clean. They even went upstream from our creek where we get our water, but they didn't find any outhouses draining into the creek. It's just a mystery. Your fourth-grade teacher also sent a message to you. She said not to worry about your schoolwork because you're smart enough to make it up when you get back."

I think to myself, *Oh yeah, I'm worried about my school work.* In a pig's eye. It wouldn't hurt my feelings if I never went back to school.

After Ruby and Grandma leave, I start thinking about this mysterious typhoid fever. Where could I have caught it? Since I didn't get it from the creek or someone's well, I must have gotten it somewhere else. I start thinking about the time my white rat Whisky got out of his cage and a bunch of my friends and I found him down in the bottom of our outhouse. I rescued him by putting food on a hoe and lowering it down to where he was. When he got on the hoe, I pulled it up and grabbed him. My friends made faces because they thought he was dirty. They all said I shouldn't touch him.

I wanted to show off a little, so I ran and got a coffee can and filled it with Hexol and water. I put him in the can, put on the lid, and shook it real hard.

Everyone groaned, "He's still dirty."

"He's not dirty," I told them, but they still didn't believe the bath had done the trick. "I'll show you how clean he is," I said. I opened my mouth wide and put Whisky's head and little pink front feet into my mouth.

My friends looked like they were going to throw up. Later, I put Whisky back in his cage and gave him water and more food. That was not long ago. But I don't see how I could have caught it from him. It's supposed to be in drinking water. Oh well, we'll probably never know where I caught typhoid. Still, I decide not to tell the grownups about the stuff with Whisky.

At dinnertime, a nurse comes in and sets a tray down on my bedside stand. I take a look. There's real food on it! I know right away this is going to be the best dinner of my life. I decide to take it nice and slow and enjoy every single morsel.

I walk across the room, get a wooden chair, and pull it up to my bedside table. I sit down and carefully pick up my napkin and place it under my chin. I draw a deep breath. My nose almost dances as the smell of real food waltzes up to it.

I start on the soup first. It's so tasty it must have come from soup heaven. Next, I tenderly eat the macaroni, one small noodle at a time. The bread and butter happily follow the soup and macaroni. I turn to the grapes and pop each plump morsel into my mouth, hold it on my tongue for a minute, and then crunch down, squeezing the sweet juice into my mouth.

The next morning a smiling nurse comes in and whoops, "Surprise, surprise. You're going home tomorrow."

I can hardly believe it. After two weeks, they're finally going to let me go. I'm as happy as a clam. And tomorrow is Christmas.

The next morning I'm so excited I wake up early. After breakfast, I get into my old clothes and wait for Ruby and Grandma. This is one of the happiest days of my life.

Around noon, the nurse comes and leads me out to the office.

Ruby is waiting with a big smile on her face. "Are you ready?"

"I sure am! But where's Grandma?"

"She went to Bull Creek to visit her sister, Midge. We'll pick her up on the way home tomorrow. We're going to spend the night at Doris and Max's and go home in the morning."

I'm sorry we won't be going straight home. I don't want to go to the ranch, especially on Christmas. There's always lots of drinking on holidays. I cross my fingers, hoping everyone will be sober.

The ranch is about a half-hour drive southwest and on the mouth of the Eel River. When we drive up to my aunt and uncle's dairy, I see a bunch of cars, including my uncle's old pickup, covered with mud and cow manure, parked in the yard. There are two or three other cars I don't recognize, and they're just as dirty and battered as the others. My stomach feels like it has dived off a cliff. It looks like I'm going to spend Christmas with my drunken relatives and their friends.

The two-story ranch house is about a hundred years old. White paint is chipping all over it and moss has sneaked into its cracks. The house sits on eight-foot poles because the Eel River

often floods their ranch. In bad floods, Max and Doris have to stay on the top floor. A small boat is tied up to the house so they can row back and forth from the house to the barn.

When we walk into the house, I'm almost knocked over by the stench of cow manure, beer, and cigarette smoke. Doris rushes over and pushes a wet mouth against my cheek. "I'm so-o-o glad you're getting well," she slurs. I love my Aunt Doris, but she drinks so much. Today, it looks like she and the others have hit the bottle even more than usual.

Max's father is also here with another one of his twenty-year-old alcoholic girlfriends. Most people welcome us, but others are so drunk they don't even notice us. I wish Grandma had stayed here instead of going to her sister's house. She would have made sure I was all right.

I can see Doris has started to make a turkey dinner. A big bowl sits on the drain board with raw bits of dressing sticking to its sides. Empty beer cans are littered everywhere and dead cigarettes float in half-empty coffee cups. I feel myself wishing I was back in my clean-smelling, tidy little hospital room.

"I'd like to go to bed," I tell Ruby. She takes me to an upstairs bedroom, tucks me in, and leaves me to rest. I feel worn to the bone and doze off. When I wake up, I can see it's getting dark out. I've been here by myself for hours. Either nobody knows how sick I am, or nobody knows how to take care of a sick kid. Or they're probably too drunk to know or care.

I finally get up, weak and shaky, and stumble downstairs to get a drink. Nothing's clean, so I rinse out a dirty glass and fill it with water. Everyone's gone, except Max's father's girlfriend who is going through all the bottles in the bathroom. She tells me everyone went off to town and left her and didn't leave her anything to drink. She's hoping to find some shaving lotion with alcohol in it. She tastes the bottles one by one but doesn't seem to find any she likes.

"They'll be back by five o'clock," I tell her, "when Max and Doris have to milk the cows."

I don't know whether to laugh or cry, but I try not to get caught up with her problem and instead look around for something to eat. The turkey and everything else look like they won't be ready for hours, if ever. I settle for some limp celery and dry cheese and take them upstairs. Again I'm feeling lonesome for the hospital, the neat bed, and the regular meals.

Much later in the evening, Ruby wakes me for some turkey dinner. I can eat only a small bit of it, but I'm glad she thought to bring it to me. Falling asleep again, I think about our leaving tomorrow morning, picking up Grandma in Bull Creek, and finally being on our way home to Whitethorn.

Grandma Blanche Doers

8. Winter Dreams: Fishing, Hunting, and Gathering

It's January and I'm barely home a week from the hospital. They say I'm cured of the typhoid fever, but I'm all bones and angles and don't have the strength to do much. I'm too weak to go back to school. Endless rainy days holed up in the house are weighing me down even more than weakness from typhoid.

As I sit drawing pictures of horses, the whopping winter rains of Thorn are pounding on our roof like a runaway herd. Looking out the kitchen window from time to time, I catch big pepperwood trees by the creek whirling about. Their long bunches of leaves blow up and down and swirl around like a pot of boiling water.

It rains buckets here in the winter, often a hundred or more inches between September and May. Still, it doesn't flood because the Mattole River and all the creeks running into it carry the water down to the Pacific Ocean.

Our biggest problem is the creeks and rivers getting all churned up with mud. During these times we have to get our drinking water by carrying buckets of thick, brown water from the creek and letting them sit until all the muck sinks to the bottom. Then we can use the clear water that's left at the top.

The winter rains and mud also bring logging to a dead halt in Whitethorn. The dirt roads leading to the timberland turn into

deep muck and the loggers, lumberjacks, log pond, the mill, and the cookhouse all sit idle until the rains stop and the mud dries. At this time the men set their muscles to the rowdiest spells of poker, drinking, and fighting.

My stepfather, Al, hired my Uncle Allan and his wife Pearl last Fall to run the Whitethorn Cookhouse, a long, narrow redwood shack close to the sawmill. They bought the supplies and cooked three meals a day, except during the winter rains, for about fifteen loggers and lumberjacks. Pearl, who's very pretty with dark hair, likes me a lot and at times when there's no food to be had at home or elsewhere, I might count on some delicious fried chicken, mashed potatoes, and gravy cooked up by her and Uncle Allan. They also have a cute little baby boy named Lyle.

For most folks, winter is also the leanest time of the year. They have to make do with a lot less money, and those of us who have a little to spend have fewer chances to drive into big towns like Garberville to buy meat, fruit, and vegetables. Most people live on their sacks of flour, beans, and potatoes; the ones better off also have their salt pork and canned food, or the money to buy them at our local general store. A few others raise chickens or ducks. Folks often share their larder, if they happen to kill a deer or catch salmon, with their poorer neighbors.

You'd expect Al, who owns half the bar, timber, land, and houses to live a big step above the rest of the poor folks around here. To my surprise, I've learned better. Looks to me like we're almost as cash poor as the regular folks, especially in winter, when everything stands idle and the rent payments stop. At other times, old machines at the mill break down, need fixing, and may need parts from the bigger towns from as far as Eureka.

Ruby has a ready answer to my regular bellyaches about the endless rain: "Cabin fever!"

Yes, I can see how being cooped up too long can be like a fever, making my body listless and my mind as mushy as the logging roads in winter. The rest of the year my life is outdoors, at least the parts I love the most, like riding, running the woods and mountains, and fishing and hunting.

Sometimes I miss the hospital. I was cooped up there too, but whenever I was awake something was happening to take up my interest. It was all planned out every minute with the ins and outs of the nurses, the doctors, and the meal bringers. I could just enjoy being sick and weak and being taken care of. I also miss my spic 'n span little room, the crisp white sheets on my bed, and feeling the comfort of order everywhere.

I've tried to bring home some of the good order from the hospital by turning down the top sheet over my blanket, folding my clothes neatly over a chair, and making my bed in the morning. But what with this cabin fever and the usual disorder around the rest of the house, I'm now back to dropping my clothes on the floor and getting back into the same messy bed at night that I crawled out of in the morning.

My family has made it their special business to give me extra attention and care since I've been home. But somehow, probably because of this cabin fever, I can't enjoy it as much as I did in the hospital.

Since I'm so skinny the special attention has been all about food and putting some meat on my sorry bones. My grandma walks over to my house every day, even in the pouring rain. She especially likes to put up boiled dinners for me. She boils salt pork and then pours off the salty water a couple of times, refills the pot with fresh water, and tosses in potatoes and cabbage. If she has a carrot, she throws it in with the rest.

Ruby also regularly puts up bacon rinds, beans, and onions in a pot of water and lets it all boil for a long time. She makes some of my very favorites: fried chicken, tapioca pudding, and apple pie.

Grandma Dalton, who lives down the road and is famous for conking Indians on the head with beer bottles, has also taken an interest in fattening me up with gallons of rich milk from her best Jersey cow. Jerseys are known for having lots of cream in their milk and it has helped me get a little fatter.

There's still one problem. My appetite is not nearly up to all the good food Grandma and Ruby are boiling up for me. I just

want to eat sweets, anything sweet. They think it's spoiling my appetite.

At breakfast this morning, I'm about to execute my usual plan for a very sweet start to another gloomy day. I start by dipping into the cup of sugar, stirring the allotted two teaspoons into my coffee, and exchanging a bright smile with Ruby, who's about to read the paper. While she holds it in front of her, I quietly scoop up two more heaping spoonfuls and slip them into my coffee. With a sly smile, I wait a couple of minutes, letting the hot coffee cool.

Drooling, I pick up my cup and take a big slug of the expected sweet brew. "Yeow!" I spit something horrible all over the table, sputtering, "I'm poisoned! I'm poisoned!"

Ruby lowers her paper and snickers. "Serves you right! I knew you were sneaking extra spoonfuls of sugar into your coffee."

"What was in it?" I holler, continuing to spit out the bitter taste, running to the sink and grabbing a glass of water, and then rinsing out my mouth and spitting some more. I can't believe Ruby is just sitting there laughing at me.

"How could you leave something that looks like sugar on the table?"

"Taught you a lesson, didn't I?" She snickers some more. "Don't worry, it won't kill you. It was only a cup of Epsom salts I use in my bathwater."

I stare at her, half mad and half in admiration. She got me good this time.

The long days are also broken up with Al and me playing checkers. He's a mean customer in any game. He won't play unless we make a bet. He wins every single time, and I already owe him 358 cans of Sir Walter Raleigh tobacco. As an added insult, he finishes me off with a "haw, haw" under his breath and a "Come back when you've learned how to play."

Sometimes I get so darn mad I heave the checkers clear across the room, rush to my bedroom, and slam the door on his haw, haws, which have become very loud for added aggravation. Sometimes I get even with a trick or two of my own, like the other day when I put walnuts in his boots. Another time I cut up rubber

bands and mixed in the pieces with his can of tobacco. Because of his bad eyes, I knew he wouldn't see the tiny bits of rubber when he filled his pipe. As soon as he lit up, the rubber melted and ruined his pipe.

Al keeps his vexation to himself but often finds quiet ways to get even. In the case of the ruined pipe, he doubled the cans of Sir Walter Raleigh tobacco I owe him, and for some days following, he beat me at checkers with added glee.

I miss my friends, especially Jackie, and even school. I see them very little because of the endless pouring rain. So the days are slowly crawling by, taken up mostly with daydreams of good times outdoors and trying to get down my throat the "good" food Ruby and Grandma boil up.

I've taken to even missing the days when not a scrap of food is found in the house, except the beans and pork rinds molding in the refrigerator. In our backwoods, it's often feast or famine, even during the good weather. We feast for a while if someone shoots a big deer or goes to Garberville for fresh fruits and vegetables. Otherwise there's no food stocked or meals served at regular times in our house. There's food in the house provided Ruby has kept up with her canning, or if our general store has kept up its stock, and Ruby kept up with shopping.

When food is short or gone, I've got to fend for myself if I want to eat. Holed up in the house, I daydream a lot about those lean days when I fish and hunt for my food, just like the old timers and Indians before me.

In good weather, I get my scrawny little friend Timmy, who's always hungry, and we go to the Mattole River to fill our bellies. But first we dig up some worms, usually found under cow flops in the field that have dried on top but are still wet on the bottom. If the cow flop is too old and dry, the worms are gone. If it's too fresh, the worms haven't had a chance to crawl under it. One by one we put the wiggly worms into our pockets. Before long, we each have a nice ball of fat, squirming bait. Fish lines and hooks are stuffed in other pockets. After getting the bait, I cut down a

couple of willow poles with my hunting knife. We tie the fishing lines to the end of the poles and we're all set.

We usually start fishing at the Mattole River falls, just across the road from my house. Then we head upstream and stop and fish at every logjam we come to. The river is filled with big ol' logs and limbs washed down from the hills after the land was logged by old timers long ago. The logs back up the water a bit and form fishing holes. Once in a while we catch a big fish hiding deep inside its cover. But most of the time we snag small trout three or four inches long.

Fishing is hard work because we have to struggle over big rocks and thick brush in bare feet. By the time we have gone a mile or so, our arms and legs are aching and our pant legs are soaked from splashing through the ice-cold river. The hope of getting a big trout keeps us scrambling over the slippery moss-covered rocks and thorny brush. Nothing else matters.

Worn out after a couple of miles, we keep driving ourselves further.

"Let's go around the next bend before we quit," I usually say, pressing us on.

"Yeah. There might be a big fish just 'head of us."

Dog-tired and with a few measly trout in our pockets, we finally give up, climbing and crawling over the same rocks and brush we happily battled going upstream.

Some of the trout are too tiny to cook, and I forget them in my pockets until Ruby puts the dirty jeans in a big tub to soak, and the dried trout and maybe a worm or two float to the top.

"I can't stand these dead things in my washing!" she hollers.

We have other ways of catching fish without so much work. In the summer, we can catch some just by stepping into a small pool in the river and stirring up the gravel with our bare feet until the water is real cloudy. Then we make a net of Timmy's shirt, and holding each end we wade toward shore. Since the fish are blind in the dirty water, we can scoop up the baby fish, and, flopping around in his shirt, we haul them to shore.

Even in winter, in rainy weather, we can catch a healthy salmon or two out of the hundreds surging up the river to spawn. Healthy salmon are a silver color; if red, they're already sick and beginning to die. To cook the fish we gather twigs and dried grass and light them inside a circle of rocks. When the rocks are good and hot, we roast the fish, head and all, on the rocks. To show off, Timmy occasionally swallows one alive. Those times I let him have the glory. I've no taste for wiggling fish flopping down my throat.

As the rainy days crawl on, I continue to fill them with daydreams of livelier days outdoors, roaming the woods with my rifle, hunting the game of the season: robins in the fall; quail, ducks, gray squirrels, and rabbits year-'round except in winter, when small birds like juncos and titmice become my targets. Juncos are small gray birds with black heads. Titmice are even smaller, about the size of a big spider. We always eat everything we kill.

In Thorn, we learn to use rifles in a safe manner early on. A few simple rules are second nature to us by the time we're ten: never point unless you plan to kill; consider all guns loaded; never lean a gun against a fence or against anything else (it might fall and go off); and always keep the gun pointed toward the ground. With so many different kinds of rifles around and almost everybody older than ten using them, I never ever heard of any accidents with guns in Thorn.

I use my BB gun or a pellet gun to hunt birds. For squirrels and rabbits I use a .22 rifle or a pellet gun. For quail and ducks I borrow Grandma's or Aunt Doris's 4-10 shotguns, which can knock off several birds with one shot.

To most of us kids it's second nature to feather, skin, and cut up the game for cooking. Bigger game, like squirrels, rabbits, ducks, and quail I usually take into the house and fry up in a pan. The birds I cut up and feather right then and there are roasted on my campfire.

Besides fish and game for food, the hills of Thorn are spread wide with carpets of all sorts of wild berries in the summer. I often graze on luscious blackberries, strawberries, and red caps.

And in the fall, miles of hazelnuts and huckleberries appear for the picking.

Spent eating and dreaming, time creeps on into February and I'm finally strong enough to go back to school. For a week or two I'm well behaved, happy to be out of my prison. But as I get stronger, it becomes harder to keep myself pinned down at my desk, and I spend more time standing in the corner as punishment for talking, hopping out of my chair, or losing my pencil. By the end of the school year, I'm the same old kid I was before I got sick, except I'm enjoying everything a heck of a lot more than I can ever remember.

By spring I'm back to running the hills and riding horses with my best friend, Jackie. Today, everything in our world seems to be in the right place, all dressed up in dazzling colors. As we look out over the meadow of poppies and lupine, we see shades of yellow and blue dancing together in the light breeze. We wade into the middle of all this glory and lie down, enjoying the rich colors and the warm sun. Big fuzzy bumblebees fly slowly from flower to flower, their legs weighed down with bags of pollen.

"Let's forget the horses. I don't want to move."

"Want to sing?" Jackie asks.

"Sure."

Jackie and I love to sing. We start, enjoying our voices harmonizing and blending together, ringing out over the golden meadow, and rising up to the big blue sky.

9. Night Ride

At the end of a day riding the hills, we dismount a sweaty Stardust at the back of Jackie's new house. The small A-frame house sits on a flat field across the Mattole River from our place.

I tie Stardust to the porch, open except where it connects to the back wall of the house. To the right of the porch is a ladder nailed to the outside wall. Jackie and her sister Margie use it to get to their bedroom in the attic. Rain or shine, they scramble up and down it like a couple of squirrels.

As we walk across the porch, we're greeted by the only gas-powered washing machine in Whitethorn. I wish Ruby had one like it. She has to scrub all our clothes by hand on a washboard.

Inside the house, Jackie's mother, Margaret, is busy cooking dinner on her large cook stove in the kitchen. To the right of the stove are a wooden drain board and a small sink that has running water. Their water is pumped from the Mattole River by a gas-powered pump. The kitchen also has a propane icebox and a small table with a coal-oil lamp on it. Windows on two sides of the table give light and a view of the Whitethorn Road.

I sit down in the cozy chair in the corner and watch Margaret put a stick of wood into the stove.

"Can Jackie stay all night with me?"

Margaret looks up at me with a twinkle in her eye. "I don't know why you even ask. You two spend at least four or five nights a week at our house or yours."

"Then she can stay?"

"God willin' and the creek don't rise."

Jackie's mother is a cheerful person. She jokes a lot and is always bustling about her house and garden. The hitch is the Pentecostal Church. The church is awful strict and declares reading funny books and street walking are sins. I still don't know why it's a sin to walk on the street, or on the Whitethorn Road, which serves as our street. The road can easily be seen from the kitchen window. When Margaret spies a couple of girls walking on the road, she always says, "They're going to go to hell."

When I look out her window, all I see are some teenage girls walking along looking like they're having fun. I'm afraid Margaret might get mad at me if I ask her why it's wrong to walk up and down the road. I work hard not to walk on the road but to ride my horse instead. I don't want her to think I'm a street walker and heading to hell. She might also not want Jackie to be friends with me.

I try my best to quit reading the funny books, but when I come across one, I always give in and read it anyway. Jackie is even worse. When she comes to my house, she heads straight for my funny books and it's hard to get her to do anything else.

This evening I'm eating dinner with the family, stuffing down fried chicken, mashed potatoes, and gravy. As the house darkens, Jackie's father, Ed, lights the Coleman lantern and hangs it over the table. Jackie's sister, Margie, asks her dad if she can buy a new bridle for her horse, Scout.

He frowns, his big Adam's apple flying up and down as he talks. "You know damn well we can't afford to spend money on horses. It's all I can do to earn enough money in the mill to keep us in food and clothes."

Later, while we wash and dry the dishes, I'm feeling cheery joining in singing religious songs like the "Old Rugged Cross"

with everybody. Jackie is very good at harmonizing, and her father sometimes solos in church, where singing is always a big relief from the preaching.

Just before we leave Jackie can't help starting in on her sister. There's always a fracas between them. Margie is tall with a large nose like her father; Jackie is a pretty little blonde girl with sparkling blue eyes. She's three years younger than Margie, but she comes out ahead in their fights. Tonight, Jackie sneaks up behind her sister and goads her: "How're you doin', Pinocchio?"

As Margie is turning red, Jackie taunts on. "Oh, I'm so-o-o sorry. I forget. You're Rudolph, not Pinocchio."

Jackie almost never calls her sister by her right name, and Margie always falls for her jabs, sometimes winding up getting punished by her father because she starts throwing things at Jackie.

After the row cools down, Jackie and I walk to the back door. As we leave, Jackie can't resist one more dig at her sister. "Bye, Rudy. See you tomorrow." I hold my breath, but Margie lets this final insult pass.

It's a cold night, but I have Stardust's saddle on her, and Jackie and I are both wearing heavy jackets. As we prepare to get on the horse, Jackie pops up, "I want to ride in front for a change."

"You know I never let anyone ride in front."

"I think that's really unfair. Here I am your best friend, and you don't trust me to take the reins."

She's right; I never let her ride in front. I don't like to be at the mercy of whatever dumb thing she might do.

"Just this once," she begs. "I'll be real careful. Stardust knows the way to your house. All we have to do is just sit on her and let her take us home."

I'm too tired to resist and my good sense starts to crumble. "Okay, you can ride in front, but it's really dark, so you need to be careful."

We swing up on the horse, and before long Stardust brings us to the Mattole River and is stepping carefully down a small slope. In the river, she's splashing through the water, her hooves clanging on the wet rocks. We hold our legs up so our bare feet don't get wet. When she reaches the other side, she clambers quickly out and up a sandy bank to the top of a small hill. From there, she steps up her pace because she knows we'll turn her loose when we get home.

As we're nearing the Whitethorn Bar, where all the loggers stop for drinks, Jackie pipes up, "I think it would be fun to gallop."

I'm not sure about this since we can't see where we're going. But against my good sense, I say instead, "Let her rip!" I have both hands in Jackie's warm jacket pockets, and I ride well enough that I don't need to hang on.

"We're going to the back of the bar so the drunks don't see us," Jackie decides, and without another word, she swerves Stardust around to the back, where it's as dark as the inside of a bear.

Just as we get galloping a good clip, something cuts into my neck. My hands are caught in Jackie's pockets, so I can't jump off the horse. Jackie can feel me pulling but hangs on to the saddle horn like death to a dead dog. I can't tell her to let go because I'm being strangled as the pulling goes on, cutting into my throat and making it hard to breath. Finally, we're almost flat on our backs with my head half way down Stardust's tail, when whatever was holding my neck slips up and over my face, giving my nose a good scrape.

Relieved, we both sit up on Stardust, who's still moving. When bang! My neck is struck again; in a flash I remember the clotheslines made of thick wire strung behind the bar. I figure this must be it. My head is going to be cut off. We repeat the same ordeal, with Jackie hanging on to the saddle horn, my hands stuck in her coat pockets, and the clothesline slicing into my neck. Again we're both pulled over backward, but this time Jackie is pulled loose from the horn, and we fall off the horse.

"Why didn't you let go of me?" Jackie screams as we hit the ground.

"I couldn't let go of you, dumb head. My hands were tangled in your pockets and my neck was caught on the clothesline. Why didn't you let go of the saddle horn or grab the reins and stop Stardust?"

"If I'd let go, I would've landed on my butt!"

"And you figured it would've been better to leave my head hanging on the clothesline?" I yell back. "The only reason it wasn't your neck is because you're shorter than me. The line must've passed right over you and slammed straight under my chin. If I'd been holding the reins, I would've stopped the horse as soon as the clothesline hit me."

About this time, although we can't see a thing, we realize we're wrapped around Stardust's hind legs. We unwrap ourselves and I grope at my throat, worrying that the cuts were so deep I might be bleeding to death. I feel some rough places around the front, but I don't think I'm bleeding. I also check my ears because the line had wrapped around them too. It's a miracle, but they're both there.

I'm so mad at Jackie I could pound her. "I'm going to take you home and I don't want you to stay with me tonight!"

"I'm not going home," the little buzzard answers. "You asked me to stay and I'm going to stay even if I have to walk the rest of the way."

"So walk! But when you get to the house, I won't let you in!" I mount Stardust and head for home. I can hear Jackie's footsteps in the dark, trailing behind me.

"Come on, Sharon, let me back on Stardust. You know I'll sit on your porch until you let me in."

She's got me there. If she tells her mother I left her out on the porch all night, she'll never let her stay at my house again. I pull on the reins and let her catch up.

"All right, but you won't take the reins ever again, and I'll hide all my funny books so you'll never ever be able to read them."

Jackie climbs back on behind me and we head for my house. If she was only a little taller, I would gallop back to the clotheslines, duck, and let her neck get stretched for a while.

By the time we get to my house and turn Stardust loose, we've made up. We fight all the time, but as long as I keep the upper hand, we continue to be best friends.

The reason her sister, Margie, can't get along with her is because she doesn't know how to protect herself, so Jackie always outsmarts her.

10. Wild Berries

Today my friend Bobbie Jo and I plan to go for a hike in the hills. Bobbie Jo is three years older so she can teach me lots of things. I also like to look at her pretty face with bright, rosy cheeks, clear blue eyes and shiny brown hair hanging below her shoulders. Bobbie Jo's brother, Timmy, little sister, and parents are also exceptional lookers. Their mother looks like a movie star except for the hardness around her eyes. Their father, Walt, looks like he might have been handsome before he started hitting the bottle. More than most folks around here, the family is dirt poor with never enough food to fill their bellies.

In the fall, when they still have a little money from her father's work in the woods, they usually take a trip east to Garberville on Highway 101. There they stock up for the winter, buying a hundred-pound sack of flour and a hundred-pound gunnysack each of beans and potatoes. One thing the parents never lack, any time, is wine and beer, which they drink year-round.

When he's sober, in the summer their father goes surf fishing out by Shelter Cove, an inlet surrounded by big cliffs an hour's drive west of Whitethorn. He usually brings back pounds and pounds of surf fish and lays them out on their roof. Before the fish dry, they attract millions of flies and yellow jackets, which sting like the devil.

I walk up to Bobbie Jo's house remembering that Jackie and her family used to rent this same house before they moved across the river. Bobbie Jo comes out of the house before I even knock.

"Ready to go?"

"I sure am." She sighs. "Mom and Dad are at it again. I'm glad to get out of the house."

We walk down to the river and wade across. On the other side we climb up an old logging road where we look for wild berries. Late summer the hills are covered with wild huckleberries, redcaps, and blackberries. They often grow beside old abandoned roads where they're easy to pick. The ones growing on hillsides are harder to reach and are protected by trees and ferns. We especially love the tiny, sweet wild strawberries that grow in places that have just the right mix of sun and shade.

I spy a big patch of strawberries and we run across the road, drop to the ground, and start filling our hungry bellies. The tiny ones are sweeter than any big ones grown in folks' gardens. Just as we finish our feast, Bobbie Jo suddenly blurts out," Do you think your mom would let you come over and stay the night?"

I don't know what to say. I've never stayed at her house because I'm afraid of her father.

I can't forget that awful time last summer.

Bobbie Jo and I were sitting on a sunny slope about a hundred yards across the field from her house when we saw her mother come tearing out the door. A few seconds later her seven-year-old daughter followed as fast as her little legs could go. They had just gotten to the woodpile, about thirty feet from their house, when Walt came charging after them. They scrambled past the wood pile. When Walt got there, he stopped to grab a big stick of freshly chopped wood.

Bobbie Jo and I were too far away to hear their voices. We were watching a silent movie, lots of action but no sound. Walt caught his little daughter first and struck her on the head with the big chunk of wood. She fell to the ground and lay there without moving. Her father didn't stop to see if she was all right, he just kept on chasing his fleeing wife. When he caught up with her, he

again raised the big club and clobbered her on the head. She too fell to the ground and lay there still.

Meanwhile, Bobbie Jo was already on the run to help them. I ran the other way home, heart pounding and tears streaming down my face. As I was tearing toward home, I could hear myself making bawling noises.

At home, I hid in the garage until I pulled myself together. If Ruby knew what had happened, she might not let me play with Bobbie Jo anymore. I never found out how seriously Bobbie Jo's mother and sister had been hurt, but they appeared to be alive and well a week later. People beating each other up was nothing new in Thorn.

Bobbie Jo's voice breaks into my silent movie. "Sharon, did you hear? We'll have the whole house to ourselves. Mom and Dad are taking my brother and sister to Briceland for the night. They won't be back until sometime tomorrow."

The idea of staying the night suddenly seems like it might be fun, and I fall in with her plan. "Okay, let's go tell my mother."

When we get to my house, no one is home. I head straight for the icebox to see if there's something we can eat. All I find is the same old bottle of sour milk and bowl of beans with the mildewed bacon rind on top.

"Yuck. Let's go out to the storeroom and see if we can find a can of something." We have to eat here or go hungry. There won't be any food at Bobbie Jo's house.

The storeroom has a few cans of vegetables and a bag of potatoes. I grab a couple of potatoes and a can of tomatoes. "I'll fry the potatoes and we can eat the tomatoes cold."

"Let's hurry. I'm so-o-o hungry."

While I'm starting a fire in the kitchen stove, Bobbie Jo is peeling and slicing the potatoes. I take a spoonful of old lard from the coffee can on top of the stove, and using my finger I push a couple of globs of fat off the spoon into the frying pan. As soon as the fire gets going, I throw the potatoes into the pan. Our feast is soon sizzling.

I turn to the can of tomatoes, open it, and pour half into a bowl for Bobbie Jo. I gobble down my share straight out of the can.

Not long after we finish eating, my mother walks in. "You did a fine mess here."

I ignore her and tell her I'm staying the night with Bobbie Jo.

"After you clean up. And you have to be home by noon tomorrow."

Soon I'm running to my bedroom to get my denim jacket. No need to pack anything. Like most kids in Thorn, I sleep in my clothes.

When we get to Bobbie Jo's small, dark house we light a little coal oil lamp. The dim glow reveals beer bottles and dirty dishes everywhere. An old pot of beans sits abandoned on the cook stove, probably dinner for a pack of hounds. Beans are the main meal for dogs in Whitethorn. As we stumble around the mess to Bobbie Jo's bedroom, nothing reminds me of the pretty little house Jackie's mother used to keep when they were living here.

A strong smell of stale pee hits my nose as we enter the bedroom. Bobbie Jo's younger sister wets the bed. Instead of changing the sheets, the bedcovers are usually thrown back to dry the pee. I pull the covers back down so I can settle on the bed and smother the smell. The kitchen light shines into the bedroom, giving it a warm and cozy glow.

For a while we talk about school. Bobbie Jo started the seventh grade last year and has been riding the school bus from Thorn to Miranda High School. She tells me it's a long ride through winding redwood roads and then north on Highway 101, an hour or more each way.

"I've to get up before daylight to catch the bus during the winter." She loves to teach me about the school and what I will have to do when I graduate from my school here.

"Junior high is real different," she tells me. "For one thing, you have to wear clean underpants every day."

"A fresh pair every day?"

"That's right!"

I've never heard of such a thing! It would mean I would have to have at least three or four pairs and they would have to be washed a couple of times a week.

"Why would anyone need to change their underpants every day?"

"In gym class you have to take off all your clothes and take a shower after class. You can't wear dirty underwear."

"How about socks? Do you have to wear clean socks every day?"

"Yep."

"I guess that will be okay. I've got to have new shoes anyway. Did I tell you what happened to my new school shoes last year?"

"I don't think so."

"The day before school started, I put on my brand new shoes and rode Stardust across the river. It was real hot. As soon as she got into the water, she lay down and started rolling. I had to jump into the water, getting my new school shoes all wet. Boy, was my mother mad."

We both giggle.

Bobbie Jo suddenly sits up and whispers, "Hush."

I hear someone coming into the house, cursing and stumbling around. Oh, God. It's her father. And he's drunk! I start to shake. The only way out is through the kitchen.

We hear him go to his bedroom, followed by the sound of creaking bedsprings and muttering. I give a sigh of relief, figuring he's gotten into bed.

But Bobbie Jo sits up and shouts, "Quiet, you sodden old drunk."

"Don't say anything more," I hiss, starting to shake again. "You're going to make him mad."

"I don't care if I make the old bastard mad. I'm not afraid of him!" she yells instead.

We hear Walt rolling around. "Who're you calling an old drunk?" he yells back and grumbles, "Damn worthless daughter …"

If this keeps up, Bobbie Jo's going to get an awful beating. He might even kill her. I'd like to get out of here, but I might meet him in the kitchen. I plead with Bobbie Jo again. "Please be quiet. Let him go to sleep."

Bobbie Jo ignores me and yells again. "The only person who's worthless around here is you. You slobbering old wino who can't hold down a job!"

The bedsprings come alive again. He's getting up! "I'll show you what kind of a job I can do with a bitch of a daughter."

Bobbie Jo flies out of bed like she's shot out of a gun, runs through the kitchen, and out the back door. I huddle frozen on the bed. It's too late to run. Walt's dark shape blocks the bedroom door. He staggers over to me and grabs my shirt, roughly yanking me to my knees. He pulls back his big fist. "I'm going to smash your filthy mouth until you learn to give your father some respect!"

Walt thinks I'm Bobbie Jo. He's so drunk and the light so dim, he can't tell the difference. Writhing in his steel grip, I scream at the top of my lungs, "I'm Sharon! I'm not Bobbie Jo! I'm Sharon!"

Walt blinks and glares at me, loosens his grip, and stumbles back. "Where is she?" he hisses.

"She ran outside. She ran out the kitchen door!" I know he won't be able to catch her so I don't feel bad telling him where she went.

Walt turns and stumbles back to bed. As soon as I think it's safe, I make a run for it, and quicker than you can shake a dog's tail, I'm on my way home. I know my way even in the pitch dark of night.

Later at home in bed I'm still shaking. That big fist in my face is keeping me awake. To make it go away, I squeeze my eyes shut and begin to think real hard on our bright sunny afternoon, our roaming the hills, and the taste of sweet strawberries. So I drift off to sleep ...

11. The Shoelace Salesman

Today is one of those slow, sleepy days that drain the sap out of everyone. On this hot, sluggish Saturday afternoon in August, I'm hanging out at the Whitethorn Bar, as listless as a hen sitting on her eggs.

It's against the law for a kid to hang out at a bar, but we have no police way out here in the mountains; and besides, my stepfather, Al, owns the joint. He's sitting at his usual place at the end of the long redwood bar. A few loggers are scattered around like big, dried-up weeds, having their long-awaited drinks.

The whole place looks like time has stopped. The only signs of life are the tiny rays of sun trying to push their way through the cigarette smoke. The stale smell of last night's drinks and smokes almost stops my breath. From the juke box, the steady drone of "drifting along with the tumbling tumbleweeds" is the final lullaby casting a listless, lazy spell on the place.

Breaking through the thick torpor, Mike the bartender suddenly barks, "Rolls for free drinks, come and get it!"

A few of the loggers haul themselves up along the bar and start rattling dice. They toss the dice in a leather cup, shake it half to death, turn it over, and smash it on the bar, whooping it up with every throw. *What a dumb game,* I think, smiling half asleep every time they slam the silly cup down.

They're a funny looking bunch with short pants that make them look like big kids. The pants have blue-frayed fringes because the bottom seams are cut off. If a tree comes down the wrong way, a logger has to run like a jackrabbit to get out of the way. If his pant leg gets snagged on a limb, the few extra seconds it takes to tear loose a seam can mean the difference between life and death.

Al, sitting alone at the end of the bar, is having a beer and smoking his pipe. I wonder if he's as bored as I am. Not likely. He loves that pipe and can sit for hours sucking and puffing on it.

I'm just about to leave and see what's going on down at the river when a guy pushes his way through the bar's big swinging doors. With the sun at his back, he's only a shadow at first but as the doors begin to close, I see a fresh white shirt, a tie, and shiny black shoes. His hair is slicked back, making his head look too small for his skinny body.

As he nervously creeps by me, I sniff sickly sweet shaving lotion. Men around here don't wear the stuff, and their dirty old clothes usually smell like sawdust and old sweat.

A city slicker! Things are picking up. A sight like this hasn't been seen in the Thorn Valley for years.

I sit up in my chair and ogle the stranger as he slowly drags his feet to the bar and hoists his rear end on the stool beside my stepfather. Al probably looks less scary than the others because he wears a Stetson hat and is not dressed in logging gear. He also looks like someone who's in charge. This dummy must think he's safer sitting with Al than with the drunken crew sitting a few stools down the bar.

Al takes a puff on his pipe, wearing his best poker face behind his thick glasses, giving no clue that he has found prey.

I can hardly sit still as I watch the slicker order a beer and introduce himself to Al. "Hi, I'm Eddie Jackson. I came up to Whitethorn to sell high-grade loggers' shoelaces."

I nearly fall out of my chair. He wants to sell shoelaces to loggers? Doesn't he know the loggers already have strong shoelaces? Besides, they wouldn't dream of buying laces from a guy from the city.

Al, keeping a straight face, smiles and shakes Eddie's hand. "Nice meeting you. Al Sharpe, owner of the Whitethorn Lumber Company."

Eddie's eyes light up. "You're just the man I want to talk to. You must have a lot of men working for you who could use some good, strong laces."

A dumb shoelace salesman, I think. I guess he hasn't heard the stories, like the ones loggers love to tell about city guys who come looking for work here: first they put him to work on the sawmill's log pond. After they get the guy out on the pond on a log, they start rolling the log he's standing on. Loggers who work the pond can practically dance on the logs without falling, but a man who has never been on a log can be easily rolled off. Falling off a log can be a killer if the other logs close the gaps and keep the guy from swimming to the top. I wonder what they'll do with the likes of a clueless shoelace salesman?

Al sucks a couple of deep puffs on his pipe and sits for a while. The quiet seems to make Eddie more fidgety. When he picks up his bottle of beer, his hands shake and sweat rolls down his face.

"What makes you think we need shoelaces?" Al finally asks.

"Everyone who wears boots needs shoelaces," the man stutters.

Al continues to suck on his pipe, sending up billows of smoke, reminding me of the caterpillar in *Alice in Wonderland*. "Let's see now," he says. "You have a bunch of heavy-duty shoelaces to sell …" He mulls it over a while longer and washes down another swig of beer. "Do you have any of these here laces with you?"

Eddie hops up. "I have hundreds of them in my car."

He dashes out the door and zips right back, dragging two big boxes. He rips off the top of the biggest and fishes out a shoelace.

I'm beginning to feel real sorry for the dumb guy. Whatever Al has in mind won't be fun for the salesman. I have watched Al in action before and it hasn't been pretty. Loggers in Thorn respect Al because he owns the mill, but also because he regularly outsmarts them in poker and has a pair of arms as strong as a

couple of tree stumps. They all have tried, but none have ever been able to pin his arm down in an arm-wrestling match.

The loggers at the bar have long since quit playing dice. Now they're as still as mountain lions that have spotted a deer.

I decide I need a closer look at the miracle laces, so I go over and check them out. I pick up one of the long, brown laces. It's made of cotton and is about three feet long and almost a quarter of an inch wide. The ends are covered with something hard to make it easier to squeeze into the eyelets of a boot. I think they would make great horse halters or could be used for tying limbs together when Jackie and I build forts.

Al takes one of the laces in his big, burly hands and gives it a couple of small tugs. He looks sideways at Eddie. "What makes you so sure these shoelaces are stronger than the rawhide laces loggers wear?"

"Look how thick they are," the salesman whines. "And they're long enough to fit any size boot. They're stronger than the leather ones loggers wear, and they're easier to tie and untie because they don't swell up when they're wet and become hard knots when they dry out."

Al takes another puff on his pipe and blows a cloud of smoke into the conversation. "How much do you want for a pair?"

Eddie coughs. "Tell you what," he says. "I'll give you a dozen pairs for twenty-five cents."

"That's a lot of money for a bunch of shoelaces."

Eddie stops for a minute before making another offer. "I'll give you a break and let you have them for fifteen cents."

"Ten cents is as high as I can go."

I wonder again how this fellow ever got the idea to come up here in the mountains to sell shoelaces. Worse yet, he's trying to sell them to my stepfather, who's playing him like a cat with a mouse. The loggers must be breaking their guts trying not to laugh out loud.

"I can't let them go for ten cents," the salesman whimpers. "It cuts into my profit too much."

Al smiles and again picks up a shoestring, looks it over, and gives it back to the salesman.

"They look puny to me," he says real casual-like as he takes his pipe out of his mouth and fires it up by loosening the tobacco with the end of a match. "Why don't we have another beer and I'll think on it."

After drinking his beer, Al sucks a couple more puffs on his pipe and then picks up a shoelace and laughs. "I still don't see what makes you think these things are so strong."

Eddie's gangly neck turns red. "These shoelaces have been tested and tested and they're the strongest damn shoelaces on the market!"

Al gives him a goading smile. "Well, if you're so sure about them, how would you like to put your money where your mouth is? Make a little bet."

"What kind of a bet?" the salesman drawls, looking closer into Al's eyes.

"How'd you like to bet all the shoelaces you have I can't break one with my bare hands? If I can't break it, I'll buy all your shoelaces for twenty-five cents a dozen."

The bar turns a notch quieter. Heads are locked into the action like granite statues wearing whiskers covered with rock-hard bubbles of beer. A single question is fixed in their minds. Is Eddie fool enough to take the bet?

My eyes grow round as a bucket of bacon grease. The trap is set. The guy can't help but walk right in.

"You damn sure won't be able to break it." Eddie leans forward, lifting his bottom slightly from his seat. "I'll take your bet."

Al picks up a shoestring, wraps each end on his hands, smiles, and looks the salesman square in the eye. "Now let's be sure we have this straight. If I break this shoelace, I get all your laces, even the ones in your car." Al smirks like he does when he's bluffing in a game of poker. "Or maybe you think your shoelaces are breakable and you'd like to weasel out of the deal?"

"You're on," the salesman croaks. "You can't do it."

Al puts his big fists together, causing the middle of the shoestring to hang down in a loop. Never taking his eyes off the salesman, he smiles and gives a huge jerk. A loud snapping noise fills the air as one end of the shoelace flies east and the other flies west.

The loggers roar. I clap and jump up and down. Al smiles and puffs away on his pipe. The salesman stares popeyed. He has never seen anyone so strong. Then it hits him: he has lost all his shoelaces, and I swear his eyes are tearing up.

A few minutes later, Al and a totally crushed salesman go out to his car and bring back the rest of the boxes of shoelaces. After a defeated Eddie puts down his boxes, he scuttles out of the bar, gets into his car, and screeches away.

Al passes around the shoelaces and orders beer for the whole bar. The loggers continue to whoop and haw, cheering and pounding the top of the bar.

Everyone tries to break a shoelace with their big beefy hands. They brag and make bets with each other, their faces turning red as they drink more beer and strain to break the laces. I'm not surprised that none of them can do it.

Al waves me over and points to the boxes of shoelaces. "They're not fit for boots, so you might as well have 'em."

I'm as happy as two fleas on a dog. I can make bridles for my horse and build good, strong forts. There are so many laces, they should last forever. Besides, I'm looking forward to discovering and inventing many more uses for them.

Much later, when I'm at home lying in bed, the boxes of shoelaces stacked in my room take me back to the day at the bar. I wonder about the shoelace guy. Maybe he has a kid like me who won't have enough to eat today or tomorrow because I got his shoelaces and he didn't get anything back in return. I wish Al didn't always have to win. Like in our card games, he never lets me win. He loves to beat me and smile his crooked smile and puff smoke in my face when I'm down. Still, I remind myself, he's a lot nicer than most of the loggers here.

One day I asked him why the loggers are so mean to the new men who come here to work. He said it's because the logging business is so dangerous, a weakling and a coward threatens the life of everybody else he works with. So they're always testing newcomers, Al had explained, and the ones who aren't strong and brave and can't make the cut are naturally driven away. I guess the shoelace salesman just didn't make the cut. Still, here in the dark in my bed, I wonder why I thought it was so funny to watch Al trick the poor guy out of his shoelaces.

12. Trouble with Chipmunks

It's a bright sunny morning and the fresh air smells of the secret scents of summer. I'm on my way to Jackie's house to spend the day with her. As I pass the schoolyard, I spy Johnny Johnson and his grubby friends standing beside the dusty road. My good mood instantly starts to crumble. Johnny is always trying to lord it over me and he's a real pest. Today his face is as grimy as ever and his oily hair is hanging in his eyes. Holding my head high, I try to walk by Johnny and his creepy friends, but he blocks my way and with a brazen look, points to his shoulder where a chipmunk quietly huddles. The chipmunk's eyes look as scared as a rabbit being chased by a hound. He has a string around his neck with the long end tied to Johnny's belt.

"I've trapped fifteen chipmunks this summer," Johnny brags. He looks over at my empty shoulder and smirks. "How many have you trapped?"

"Plenty," I reply. It's almost true. I caught a lot of chipmunks last year, but this summer I've come up empty-handed.

Johnny tosses his hair back and raises his eyebrows. "So where are they?"

"Wouldn't you like to know?" I toss back, almost sticking out my tongue. "I hope your other chipmunks look better than that scrubby one you've got there."

I'm just steaming as I stomp along the gravel road. Who does he think he is? King of the trappers? I've always tried to keep on top of that guy, but he keeps getting my goat. I swear I'm going to catch a whole bunch of chipmunks and show him up. If I could trap two chipmunks at the same time, one for each shoulder, all the kids would be talking about it and forget Johnny.

Most of the boys in Whitethorn trap chipmunks, but I'm the only girl who can do it. After we catch one, we show them off by carrying them around on our shoulders. We let them go in a day or two because they get kind of dull-looking after that.

Yesterday I set a couple of traps near an old log where I discovered chipmunks playing. I used my new figure-four sticks that I'd whittled. I think I carved them right this time. The sticks have to be cut just right or they won't fly out of the redwood cage doors. If the sticks don't make it out the door, they hold up a space at the bottom and the chipmunk can slip out. This summer I couldn't get the sticks to fly out right and one always got caught in the door.

I get home just as Ruby is climbing into our GMC pickup.

"Be careful with that clutch," Al warns her.

Ignoring Al, Ruby looks at me and smiles. "I'm going to visit Doris for a few days. You and Al are going to have to batch it while I'm gone."

Ruby always says Al is batching when he's holding down the fort at home, or when he's living in some shack where he sometimes works splitting posts and shingles from redwood trees. I like that word, "batching." It sounds like someone making a batch of biscuits.

Ruby turns the key and gets the stubborn old motor going. As usual, she doesn't push the clutch in right, and the pickup jerks and sputters before lurching off in a thick cloud of smoke and dust. Although I'll miss her, it will be fun spending some time alone with Al.

"She's never going to get the hang of that clutch," Al chuckles, walking back to the house.

Time to check my traps. I follow a small creek that runs through the redwoods, long, green ferns brushing against my legs all the way to the old log. None of the sticks are caught in the door and the trap is tightly closed. I squat down and carefully pick up the trap, holding my breath as I open the door a crack and peek in. I've done it! Staring up at me is a fine-looking little chipmunk. He's a little small but nicely marked and his brown-striped coat is pretty and shiny.

I think about the other trap. Did I catch another one? I tiptoe around to the other side of the log. The other trap has been tripped and the door is closed tight as a jug. I pick up the trap and sneak a quick look, again holding my breath. Wow! The most beautiful chipmunk I've ever seen is sitting there. He has two dark-brown stripes down his back and a beautiful bushy tail curled around his little feet. Johnny is doomed.

When I get home it's almost dark and Al is busy cooking dinner. He sure knows his way around a pot of stew. My mouth waters as I'm hit with the smell of deer meat and vegetables cooking. I can hardly wait to eat.

"Guess what?" I say, all puffed up.

"What?" Al replies, keeping his attention on his stew.

"I caught two chipmunks!"

Dipping a big spoon into the bubbling kettle, Al takes a taste. Smacking his lips, he mumbles, "Well, be careful and don't let them get loose in the house."

"Don't worry, I'm going to put them in my cages. When they're out, I'll put a string around their necks and they won't be able to get away." Before I lock them in, I hold each one up and inspect it. They're both males.

I watch as Al now turns from the stew to whipping up a batch of his famous biscuit mix. After throwing in a little of this and a little of that, he gets out a big flat pan and piles big globs of dough on it. "Now this here is what I call real biscuits," he says, declaring his authority on the matter. "You can't beat an old logger's biscuits. Nice an' round and smooth as a baby's butt."

They're twice as big as Ruby's, but they're sure not round and smooth. Al is a pretty good cook, but he's got cataracts and he's nearly blind.

"Those are real whoppers," I say, trying to make him feel good. I guess he can't see that each white pile has clumps of dough standing on top that look like little trees in a snowstorm.

He opens the oven door and shoves the pan into an oven that's blazing hot because he piled on too much wood in the stove. "Put those animals away now and get washed up for dinner," he orders.

About ten minutes later Al opens the oven and pulls out what he calls biscuits. They have grown even bigger. The little trees are a lot taller and are now dressed in bright fall colors and topped with charcoal caps. They smell good and taste delicious.

After dinner, Al picks up the dishes and then disappears into the other room to smoke his pipe. He takes the Coleman lantern with him, leaving me with the dimmer coal-oil lamp. Soon the sweet smell of Prince Albert tobacco drifts into the kitchen.

I decide to start training my little team of chipmunks, ready to show off to Johnny Johnson tomorrow. In the gloomy light I'm able to find my roll of white string and cut off a couple of pieces. Each chipmunk's string needs to be long enough so he's hitched to my belt and can sit easily on my shoulder. Tying the string around a chipmunk's neck is tricky because he can give you a nasty bite with those long front teeth. I know how handle them, so I don't usually get bitten.

I tie the string around the neck of the smaller chipmunk without any trouble and, pushing my long, tangled hair back, set him on my right shoulder. I name him Dusty. He sits there wide-eyed for a minute and then jumps to the floor. I haul him back up, but he jumps down again. Finally he gets the idea that he's not going anywhere and stops trying to escape.

After Dusty settles down, I catch the big guy, the really good-looking one. I decide to name him Rusty. He's even spunkier than Dusty, and I spend a longer time teaching him to sit quietly on my shoulder.

I've never had two chipmunks on my shoulders at the same time. With one, I can push my thick, stiff hair over to the other shoulder and there's plenty of room for it. Balancing two chipmunks, it's kind of like a circus act to brush my snarled mane to the middle of my neck.

It would be easier if I had combed it. The only time my hair gets combed is when some well-meaning person catches me and wrecks my whole day by yanking out the snarls and knots. They justify this torture by telling me I look like Shirley Temple when my hair is untangled. I'll hate Shirley Temple for the rest of my life. What's more, I sure don't want to look like her.

Finally Rusty and Dusty sit quietly on my shoulders. Even now they're probably planning their escape. When I turn my head, I can't see them very well in the dim light. I'd like to go into the other room and inspect them under the Coleman lantern, but Al would get mad because he told me not to play with them.

Suddenly out of nowhere, the chipmunks start screeching like a couple of wild cats on a Saturday night and start tumbling around in my hair. They're fighting! I yank on their strings, trying to get them out of my hair, but the little devils just keep on. They're squealing and I'm screaming because now they're biting my head. When I reach back and try to grab one, a couple of teeth sink right through my finger. Bawling, I jerk my finger back and watch as the blood pools in my hand.

"What the heck is going on in here?" Al shouts from the doorway.

"The chipmunks are fighting in my hair!" I howl.

"What the devil are they doing in your hair?"

I'm in no mood to explain. Tears are streaming down my face and blood is running down my arm. The chipmunks are still snarling and squealing and threading their strings through my hair like they're crocheting a rug.

"Get them out! Help me!" I yell, jumping up and down like I'm dancing the Highland Fling.

"Well just a minute, I'll get my gloves."

He runs to his jacket and fumbles around. I'm being massacred and he's too blind to find his gloves! Finally, leather gloves on hands, he pours over my hair trying to figure out what's happening. He can't figure out what to do, and I can tell he's afraid to get bitten right through the gloves.

"Just pull on the strings!" I beg.

He pulls but only makes the knots tighter. "Hold on. I'll go find the scissors."

"Ouch! Ouch!"

The chipmunks are completely balled up in my hair now, growling and snarling, their teeth slashing into my head. How is Al going to save me when he can barely see? I feel like taking off running and screaming down the road, but I know I won't be able to get away from them.

I think I'm done for, when, scissors in hand, Al comes to the rescue. He grabs one of the angry balls of fur and cuts the string, taking a good chunk of my hair with it.

"Hold still," he orders.

I squeeze my eyes shut, trying to block the awful commotion still going on in what's left of my hair.

Al continues to pull and clip, finally freeing one of the chipmunks. Before I can stop him, he goes to the door and lets my prize go.

"No! I was going to show him off to Johnny Johnson tomorrow."

Ignoring my cries and pleas, Al comes back and grabs the other chipmunk with his big leather glove. I groan as I realize that this chipmunk is going to go the same way as the other one, out the door and back to the woods.

When he's done, I run to the next room and throw myself on the couch. The blood is still running down my throbbing finger; worse yet, my plans for showing up Johnny Johnson are ruined. Now I can't prove that I'm a better trapper than he is. I bawl and howl some more.

When my misery finally dries up, I stagger to my bedroom and grab a ragged shirt from the pile of clothes lying on the floor.

In the kitchen, I wash off my finger and wrap it with a couple of strips of the old shirt. A tight bandage around it should stop the bleeding. But nothing will deaden the grief over the loss of my chipmunks. It took me all summer to get my figure-four sticks whittled just right.

A couple days later Ruby comes back from her visit with her sister Doris. When she walks into the house she takes one look at me and shrieks. "What in God's name happened to your hair?"

I try to explain about the chipmunks and Al cutting them out along with my hair. She just stands there, hands on hips, shaking her head. "I can't believe it. I go away for a few days and come back to find you with your hair all chopped up."

"I couldn't help it, Ruby," I whine. "I know males fight for the females out in the woods, but I didn't think they would fight on my shoulders and in my hair."

"I'm going to have to give you a hair cut today. I can't have you running around the country looking like you dove into a chain saw."

"Okay," I tell her, remembering how it hurts when the tangles are combed out of my hair.

After the haircut, I go to my bedroom to check the mirror. I look over my few inches of hair, still looking uneven. I might have to go into hiding until it grows out, I decide. I couldn't stand it if Johnny Johnson laughed at me.

13. Johnny Johnson

The fall brings the beginning of school and bright colors to the trees that can't hang on to their leaves in the winter. My finger has finally healed and Ruby has trimmed my hair a couple more times. Except for another scar on my finger, there's no sign of the night of the chipmunks.

Today our class piles into three cars for a field trip to Shelter Cove. The hour drive west on narrow snaking roads is especially rough on the stomach. When we finally arrive, I draw in big gulps of the fresh air and stretch out my body in the wide-open space.

In no time, we scramble down to the rocky beach below, surrounded by soaring cliffs, and start exploring. The tide is very low today with lots of shallow pools. In the pools, we can see starfish flashing colors of red, yellow, and pink through the icy clear water. Some are soft and mushy with lots of legs. Others have fewer legs and wear hard-crusted coats dotted with small, pale knobs.

We need to be careful walking barefoot on the rocks or splashing in the pools because of the oodles of purple sea urchins wearing sharp needle spines. The sea anemones, on the other hand, are fun to put your toes in because they're soft and squishy and squirt water when poked. We even found a few small abalones clinging to the rocks. What a great day.

Heading for home, the whole class is wet and tired. We hang on as Miss Courtright wheels the car around the steep curves. Afraid that we would start trouble, Miss Courtright separated Jackie and me. I'm sitting in the front and Jackie is sitting in the back between Johnny Johnson and Charley Kitchens.

Like everywhere else in these mountains, the trees have been cut down. But growing between the wood slashings left by the loggers, I can see beautiful flowers like red Indian paint brush and yellow and brown monkey blossoms. I turn my head to point out the flowers to Jackie, but am struck by an awful sight instead. Out of the corner of my eye, I see Jackie and Johnny, their arms wrapped around each other. They're kissing!

I glance back a couple of times to make sure I'm not making this up, all the while working up an awful steam. How can Jackie be such a rat? She knows I hate Johnny and here she's having the first kisses of her life with him. I grit my teeth, clench my fist, and knot my stomach, trying to hold myself from climbing into the back seat and pounding them. How can she slobber all over Johnny's grimy face and put her hands into his greasy hair? Maybe I should get back there and throw up on them. I had a tuna sandwich for lunch so my vomit should be smelly enough to break their hold on each other.

I gotta keep it to myself. I can't let them see how boiling mad I am! I look down at my hands. They're clenched in such tight fists the knuckles are glowing white and my nails are cutting into my palms. My stomach feels like I've had a dose of salts. As I sit there grinding my teeth, I swear I'll get even. I don't know what I'm going to do. But I'm sure going to get even.

I look out the window again. The wildflowers now look dull and gray and the slashings look more pitiful than ever. My life is ruined. I remember what my mother's cousin used to tell us kids, "If you don't behave, I'm going to tear off your arm and beat you over the head with its bloody stump." I always hated it when she said that, but today I could jump back there and tear off all four of their arms. But I can't. I have to sit here and act like I'm feeling just fine and don't give a darn what they're doing.

As soon as the car grinds to a stop in front of the school, I jump out and head for home. In thinking over the day, I wonder why the teacher didn't tell Jackie and Johnny to quit kissing. She must have spotted them in her rearview mirror. I wonder if she favors Johnny and Jackie because they cause less trouble than I do in class. Jackie is a big troublemaker all right, but she doesn't talk as much as I do and doesn't bother as many kids.

Take the girl who sits right in front of me with pigtails half a foot long. I just can't help pulling them when I'm bored, which is often. It's kind of fun, like milking a cow. Miss Courtright better be on the lookout now, 'cause from now on I'm planning on getting a lot more "bored."

The next day Jackie drags into class an hour late. I ignore her hello and swear to myself never to speak to her again. From now on, I'm going to spend all my time with Timmy. That'll get her goat. She's always been jealous of Timmy and has never liked me going fishing with him. Still, I can't help but wonder what she and Johnny did after school yesterday.

At noon the whole school has its long-awaited baseball game between the fifth and sixth grades. It's a scorching hot day, but we don't mind. The winter rains will be here soon enough, keeping us locked up in the classrooms.

I'm the pitcher on the fifth-grade team and Georgia is the catcher. She's deaf, but she reads my hand signals better than anybody. Johnny is the umpire because he can't play worth a darn. Jackie doesn't like to play, so she hangs out in the shade and watches. Nobody slides into home on our baseball field because the school yard is covered with gravel. Even though we don't have a dirt field, we're proud of our regular backstop that keeps a ball from flying into the main road.

In the seventh inning we're tied five to five. The sixth-grade team has one out. I turn and look over the runners on second and third and decide they're not trying to steal the bases. I wind up my pitch and the batter pops a fly into the center of the diamond. I run backward a few steps, hold my mitt up high, and catch the

ball. As Jim is running from third to home, I throw the ball to Georgia, who catches it a split second before he hits the plate.

"Safe!" yells Johnny, ruining a third out.

I charge over to him, yelling, "What do you mean, 'safe'? That ball got there an hour before Jim."

Johnny gives me one of his dirty little smiles. "I say he's safe and I'm the umpire."

I glare at him, fists clenched, ready to knock his block off. He would rather have our class lose than let me make two outs in a row.

Miss Courtright rushes over. "Sharon, Johnny is the umpire and has the right to make the call." She looks down at my ready fists. "I think you'd better cool down." She points to the stand of fir trees just off right field. "I want you to sit out the rest of the game."

There she goes again, taking Johnny's side. He stands behind her looking like a puffed-up rooster getting ready to crow.

I stomp off the field. I've half a notion to go home, but I want to see our team win. A few minutes later Jackson, a fourth-grade boy, comes over and plops down beside me.

"You called it right," he says.

"I sure did."

"We gotta do something about that guy. He always spoils things."

"I'd like to beat him up," I reply.

"He needs a good slug in the jaw," Jackson agrees.

A few minutes later Jackson's little brother, Tom, comes over, wearing a deep frown on his sweaty little face. "Isn't someone ever going to get that guy?"

Johnny teases him all the time about his buck teeth.

"I don't know," I answer. "It sure can't happen at school. Miss Courtright would have a fit."

Jackson glares in the direction of the ball game. "You know, Sharon," he whispers in my ear, "I could get a couple of kids to join us and we could gang up on Johnny and teach him a good lesson."

"Tell you what, Jackson. Why don't you sniff around and see which other kids would like to get even with him. I could probably beat him up by myself, but it might be fun to have a whole bunch of kids get revenge at the same time."

Jackson slaps his leg. "All right!"

Much to my surprise, the game ends with an eight to six score, with the fifth grade winning the game.

The next day Jackson tells me he has six kids lined up to join our gang. Wow! I didn't know so many kids were mad at Johnny. Jackson says he has at least one kid from every grade, even Len, a big, strong sixth grader. Although I want to get Johnny, I flash on the awful fights between the loggers and the Indians. I don't want to be like them, but Johnny has it coming.

I stay back after school and wait for Johnny to come out of our classroom. I watch him as he swaggers along on his way to his house.

"Hey, Johnny," I call.

He whirls around. "What d'ya want?"

"I have a bunch of kids who want to have a fight with you. Seems you've run out of luck."

"You don't say." Johnny flashes a sloppy grin. "What makes you think I don't have my own gang?"

"Oh yeah! The kids in my gang are tougher than boiled owls. We're not scared of a bunch of bullies like you!" I shout, strutting off before he has a chance to open his big mouth again.

On Saturday my gang gathers under a big redwood tree just off the school grounds. I'm the leader, with Jackson second in command. I look over the dozen or so kids who have joined my gang. Georgia sits on the ground up close to me so she can read my lips. She's a little fat but strong. A couple of grubby little third graders sit beside her, probably paying more attention than they ever did in class. Standing in the back with the rest of the gang is the big sixth grader, Len. The fuzz growing on his upper lip tells the tale of being held back. I can't get over how many kids want to be on my side.

Then again, everybody in town knows I'm tough, and Johnny has scared and tormented most of them. When everybody's settled down, I announce, "We're going to need weapons if we want to win. What do you have to fight with?"

Jackson's younger brother, Tom, speaks up first. "I have a broken bicycle chain."

"I can get my Paw's hammer and one of his screwdrivers," mumbles Georgia.

I nod to her and continue to look around the group.

"I can bring my .22 rifle," Jackson volunteers.

I raise my eyebrows and start to object. "I don't—"

He cuts in fast. "I won't shoot anybody in the head or the chest. I'll aim at their feet and legs. I swear."

"No guns or knives," I order. "We might accidentally kill somebody."

The group groans, disappointed.

"That's my rule and anyone who doesn't go along with it will be kicked out. I also don't want axes and hatchets."

Thinking of guns, knives, and blood starts a tingle of doubt to creep up my backbone. I hate the awful things I've seen some people do in Whitethorn and other places in Humboldt County. But I want to get back at Johnny. And fighting is the way people settle things around here.

In the coming week, a whole bunch more kids sign on to my team. I notice Johnson whispering with the school bullies. They're mostly the ones falling in with him.

After breakfast this morning, I catch Stardust, hop on her back, and head for a logging road I've wanted to explore and to find a place for the big fight. Last winter the rains caused a mudslide, clearing away a big limb that had kept me from riding Stardust up the mountain. In the winter the wet slide is too dangerous to ride over, but in the summer, the sun hardens the red dirt into solid concrete.

No matter how many miles Stardust and I've covered, we've never run out of new places to explore. We follow the tracks of the old-time loggers who sliced their way all over these mountains,

first with mule teams and later with their big yellow Cats that ran on gas and could easily dig out roads. I'm glad for the roads, but I wish the big trees were still here.

Stardust's hoofs make dull clomping sounds as they hit the hard-packed earth. Sitting comfortably on her bare back, I size up the small meadow called Setaks Field. It's lined with whitethorn brush and trees, making a natural arena for the big fight.

I'm excited about the battle coming up, though at night I sometimes have second thoughts. I wonder if imagining the fight is more fun than the real thing. I also worry about losing control of the whole deal. The entire school has taken sides. Now everything seems bigger than me. *Is this how the war started?* I wonder. Can a war start by two people getting mad at each other and other people taking sides? Look at the big feud between the Hatfields and the McCoys we learned about in class. They fought for generations. I wouldn't want that to happen!

As Stardust comes to a little group of trees that open up on the school grounds, I spy four or five boys who belong to Johnny's gang. I'm glad I'm on Stardust because I can gallop away if they start to get tough with me. When Stardust gets to the edge of the school grounds, the guys spread out and move toward me, each one picking up a rock from the gravel-covered playground. I push Stardust into a trot and head for a small, rarely used trail.

Looking back over my shoulder as the boys start throwing rocks at us, I give Stardust an extra kick to get out of range. As I turn my head back to the trail, a big tree branch hangs just in front of my face, knocking me flat to the ground.

When I next open my eyes, I'm looking up at branches and leaves. How did I get here? It takes a few seconds for me to remember the boys throwing rocks and running into the big branch. I pat my aching head and find a knot just above my left eye.

Stardust is standing just a few feet away as usual. She's on the lazy side, but if I get knocked off, she always waits for me. The time when the clothesline caught my neck and pulled Jackie and

me right off her hind end, she'd waited then too. I'm lucky to have such a loyal horse.

A few minutes later, my body and I agree to sit up and I look around for my attackers. The darned cowards have run away. I bet they thought I was dead and got scared. Well, I'm still alive and madder than ever.

I stumble over to Stardust, grab a handful of her mane, and swing myself up on her bare back. If I wasn't so mad at Jackie, I'd ride over to her house and have her mother doctor the swelling knot on my forehead. Instead, with a sigh I turn Stardust for home.

When I hit the house, Ruby is doing a crossword puzzle at the table and puffing on a cigarette. I guess I gotta face her.

"What in the world happened to you? You've got a knot on your head the size of a goose egg."

"Stardust swerved under a tree and I hit my head on a big limb." I don't want her to know about the gang fight.

She jumps up, wraps ice in a dishtowel, and presses the bag against the lump. "The cold will stop it from swelling bigger."

Ruby is smart and knows all sorts of remedies. She can make a hot bag by heating salt in a frying pan and pouring it into a pillow case. If someone has a real bad infection with red streaks going up their arm, she makes a poultice with old breadcrumbs and milk. She leaves it on for a day, and when she takes it off most of the infection's gone. And when I have a sore throat or bad cough, she stirs up a hot cup of tea and honey mixed with vinegar or lemon juice. It helps a lot, especially when she adds a spoonful of whisky.

"You've got to be more careful. I didn't know Stardust did things like veering off the trail."

I'm feeling even guiltier now. Ruby always tells everybody what a good girl I am. She says I never swear and always tell the truth. It's true I never swear and my story was very nearly the truth.

Again Ruby looks me over. "You're pretty pale. I think you'd better turn Stardust loose and spend the day taking it easy."

She leads me into the living room and tells me to lie on the couch. I spend the rest of the day resting, drawing, and reading. In the evening, Ruby makes my favorite meal—fried chicken. Sometimes Ruby can be the best mom in the world.

Monday rolls around again and I'm back in school. My eye is blacker than sin but I hold my head up high. I pass the word, and everybody agrees to meet at Setaks Field next Saturday at noon. Even if they leave their guns and knives at home, it's still likely to be bloody with the weapons the kids are planning to bring.

I'm meeting with my gang every day until the fight. Jackson has decided to bring a slingshot instead of a rifle, and I've settled on a bow and arrow. I've had to pump up some of the smaller kids to feel brave and strong enough to go against Johnny and his outlaws.

"Pretend you're in a baseball game," I told them, "But instead of hitting balls, you'll be whacking heads."

As the big day gets closer, Jackson and I are losing steam. On Thursday, Jackson comes clean. "I don't know, Sharon. Johnny and his guys are bullies. Our side isn't like that."

"That's for sure! I've cooled some about Johnny calling the game wrong, but I'm still fightin' mad about those guys throwing rocks at me. They sure didn't worry about hurting me. Why should I worry about them? But I know what you mean about not wanting to be the kind of kid who goes around beating up on people."

"You and I aren't like many folks in Whitethorn. My dad never whips me or drives over to the bars in Garberville looking for a fight."

"That's right! My stepfather teases me, but he never gives me a lickin' and I've never heard of him taking a swing at anybody."

Jackson shakes his head. "There's not much we can do about it now. Everybody would laugh if we backed down."

"They sure would. And if I don't do something after those guys threw rocks at me, I'll never see the end of it."

When the bell rings, I stroll back into the classroom, my mind filled with everything that has happened since I saw Jackie kissing

Johnny. In a short time I've managed to get myself in a lot more trouble than just being mad at Jackie. I think of how Ruby says I have a hot temper and how Al usually sits so calm and quiet puffing on his pipe no matter what happens. I got to think more on this, how I can keep a hold on myself like Al and not let things run away with me. In the meantime, I can't figure a way to stop the fight, so I have to go ahead with it.

On my way home after school, I see ole Johnny sitting in one of the school swings, swaying back forth, grinning like a wolf.

"Well there she goes, wearing her black eye," he calls out.

I walk over and take the swing next to him. "You're going to have more than a black eye when we meet this Saturday."

Johnny laughs. "I bet you'll get another black eye. Then you'll look just like a coon and somebody's hounds will run you up a tree."

"Very funny, ha ha," I toss back, although I swallow a giggle imagining a pack of yelping hounds, ears flying and noses to the ground, mistaking me for a coon. Johnny is as mean as snot, but he can be pretty funny sometimes.

"So how's Jackie these days?" I ask, making sure my voice sounds like I don't give a darn.

"I don't know." He's quiet for a minute, winding up his swing. "Haven't seen hide nor hair of her 'cept once since that trip to Shelter Cove." He takes his toe off the ground, sending him spinning 'round and 'round. When his swing slows to a stop, he declares, "She bites!"

Heavens to Betsy and seven hands around, as my grandma would say. All this time I'm so worked up about Johnny and Jackie, and nothing's happening. I wind up my swing as tight as I can. When I let it loose, it spins way faster than Johnny's.

Later that day there's a knock on my door. When I open it, I see Whitethorn's champion biter trying to work up a smile. "Hi," she says in a scared voice.

I'm not sure what to do. I'm still mad at her for kissing Johnny, but I've been pretty lonesome without her. I look down at her, noting she's still shorter than me. Her blonde hair is hanging in

her eyes just like it does when she gets up in the morning. She's wearing our uniform: a denim jacket and a hunting knife looped on her belt.

I give up. "Hello," I say. "Wanna come in?"

The next day, I catch Johnny standing alone beside the Whitethorn Road. His buddies must be off somewhere, causing the usual trouble. Now that Jackie and I've made up, I don't want to have the fight and I think I've figured a way to have the whole thing fold. I'm going to use some of the tricks I've learned from Al, who uses his head, not his fists.

My bare feet stir up the dust layered on the road by logging trucks rumbling through it every day. When I get up to Johnny, I give him a nice smile. "How're you?" I ask.

He looks puzzled. "What d'you care?"

"I was thinking it must be hard to handle that group of thugs you call your gang. I'll bet they all want to bring guns and knives. My kids want to bring guns and knives too, and there are a lot more of 'em. We're sure to win! And somebody might get killed!"

Pushing around a dusty rock with his bare toes, Johnny studies the road for a while. I think I've got him!

"You know," I venture on, starting to expertly push my own grimy rock, "you're not such a bad guy, and that gang of yours is filled with the worst kids in school. I'm going to give you a chance to leave those troublemakers and join my side."

Johnny looks at me in dumb surprise. "You're kidding!"

"No, I'm not! I'll make you second in command and drop Jackson to third."

He looks down and takes up pushing his rock for a while again. "Make that equal command, you and me," he finally says, looking up. "I gotta save face with my gang if I'm gonna switch sides."

Now it was my turn to stir my rock in the dust. I can't let him trump me; I gotta think hard. I got it! "Okay, but you gotta meet some conditions if you want to share command."

"Like what?"

"The kids in my gang are good kids, but they're armed and mad. They won't take any more BS from you or your thugs. They want change. That, or fight."

"So?"

"So you gotta face the kids in my gang, tell them you're sorry for your old ways, and that you decided to become a new man and join them from now on against the bullies. Otherwise, it's no go. They'll laugh at you."

Johnny again looks down, rolls the ole rock around a few more times, heaves a big sigh, and gives the rock a big kick down the road. "Okay!"

Friday morning Johnny is as good as his word and the kids accept him as a leader.

By Friday afternoon, the fight is sidelined because his gang is falling apart. Just like I figured, the bullies in his gang dropped away like flies when they lost their leader.

Now I'm waiting for the right time to thank Al for his good example, teaching me it's smarter to win by using my head instead of my fists.

14. A Cat's Tale

An earsplitting screech shatters our evening as Ruby and I stand by the sink doing dishes. Ruby, with soapy hands, picks up her rifle from the shelf by the sink. I grab the flashlight. We both rush out to the back porch.

I shine the light on a huge, black tomcat tearing out of the storeroom and leaping to the top of the porch railing. Just as he dives out into the night, Ruby takes aim and squeezes the trigger. For a moment we both stand frozen as the acid smell of gunfire fills the night.

"What on earth are you trying to do, Ruby?" my stepfather, Al, shouts as he stomps out of the house.

We ignore him and run to the storeroom at the end of the porch. I get there first.

"Are they alive?" Ruby cries.

I count the small kittens. "They're all here and it looks like none of them are hurt. Mama cat must have fought him off," I reply, leaning over their box.

"Is she okay?"

"She's just fine. But why do tomcats kill kittens?"

"I wish I knew," she says. "If we hadn't gotten here in time, the big tom would've killed them all."

"Ruby, I've told you again and again how dangerous it is to be shooting that gun," Al hollers. "And now you're out here blasting away in the dark. Don't you have any sense?"

"I've been shooting guns all my life," Ruby says. "Just because you don't know one end of a gun from the other doesn't mean I don't know what I'm doing."

Usually it's hard for Ruby to defend herself because Al always seems to be one jump ahead of her. He's talked her into believing he's smarter than she is. When she runs out of money at the end of the month, Al tells her, "If you knew how to save a dime, you'd have money at the end of the month."

While they're on the porch arguing about the gun, I take the flashlight and go into the yard to see if she killed the tom. I hope so, because he'll come back and kill our kittens. I move the light slowly across the grass and weeds. My eyes go wide as I spot a black, furry tail on the ground.

I grab it up and yell to Ruby, "You shot his tail off!" I dash back to her and show off our prize. "You didn't kill him, but I bet he won't come back again," I say with a laugh.

"If he does come back he won't be bringing his tail." We both chuckle at the thought of the cat running away without its tail.

Pulling at his thick, dark hair, Al stomps back into the house. "I tell you somebody's going to get hurt if you keep on shooting that gun!"

"Al's scared of guns because he's never used one," Ruby whispers. "He was raised by city folk in Canada and has never shot a gun."

Ruby heads back into the house. I skip after her, waving the cat's tail. It's going to go great with my Halloween costume.

The next day, Ruby and I are out in the yard feeding the chickens. "You sure can shoot," I tell her proudly.

"I should be able to shoot," she chuckles. "My dad used to drill me on target practice. Do you remember the night when I went down to the Mattole River and shot that salmon in the head?"

"I sure do. We had salmon steak for days."

Just then we hear a shot. "Did that come from the house?" Ruby asks, her red, curly hair standing at attention.

"I think so," I answer, dashing across the yard and scrambling up the porch steps, Ruby right behind me.

"Let me go in first," she orders. As she opens the kitchen door, we're hit by black clouds of swirling smoke. Ruby again tells me to stay back, but I plow along right behind her.

Holding our breath, we run through the kitchen and stop at the living room door, scared to go any further because of the thick smoke. Embers are floating in the room but we don't see a fire.

Ash is drifting around us. As it thins, a strange sight meets our smarting eyes. I choke back a laugh. Sitting on the couch is my stepfather, covered with gray soot from top to bottom. He looks like a big dirty snowman. He's holding Ruby's rifle, aimed straight in front of him. I can't believe it.

He never fools with the rifle. Did he think the mountain lion we heard screaming the other night had come in? I follow the point of the rifle. It's aimed at our wood stove, which is directly across the room from him. I grab the top of my head with both hands as I figure it out.

He shot our stove!

"What were you trying to do?" Ruby asks in a very quiet voice.

"I was trying to unload this damn gun of yours."

"Well, you unloaded it, all right. But firing at a burning woodstove is not the way it's usually done."

She begins to giggle, and before we know it, she and I are almost falling on the floor laughing. It's a moment of sheer joy. There's nothing so satisfying as seeing a man who believes he's always right covered with soot and ashes because he has shot his own stove.

In my mind, Ruby wins this round. It makes more sense to shoot the tail off a leaping tomcat than to shoot the living room stove.

Ruby, Mama Cat, and the old GMC pickup in Whitethorn

15. Loggers and Indians: Trick or Treat

Although my grandma is half Welsh, I think she looks like the Indian chiefs you see in those old, faded photographs. She's almost six feet tall, has a long nose, and looks very serious. She also knows how to stalk a deer and is a crack shot. When hunting season comes around, she won't go hunting with the men. She hikes alone into the hills and always comes back with a deer. If the men should return empty-handed, she has a good laugh.

Tonight we're all feasting on Grandma's deer. Ruby has fried deer meat and baked potatoes and opened a can of green beans. She divides up the potatoes and beans between the four of us and places a big platter of lip-smacking deer meat in the middle of the table. Al moves the Coleman lantern to the back of the table to make room for the pile of steaks. I dive right in and fork up a big juicy piece, lather lots of butter on it, cut off a chunk, and wolf it down.

"You're a great hunter," I tell Grandma as I chew down on the deer meat. "I bet you could even outhunt the Indians who used to live here."

She flashes a rare smile. "I don't think I'm as good as an Indian, but I'm a better shot than the lumberjacks who work in the mills and the loggers who cut down the trees."

"I sure wish I was an Indian," I say.

"I've always told you, you might be part Indian," Ruby reminds me. "Your father still can't get a drink in a bar unless the bartender knows him because of his dark skin, straight black hair, and dark-brown eyes."

"What does looking like an Indian have to do with buying a drink?" I ask, my mouth still working on the meat.

"Some people don't like to sell liquor to Indians because they fear it will make them aggressive or crazy."

"You'd better hope you're not part Indian," says Al, who's been busy gulping down chunks of deer meat. "Last Saturday night a bunch of Indians came up here and tried to get drinks at the bar. They probably thought they could get away with it because we're so far out in the mountains. But we don't want Indians up here causing trouble."

"Were you there?" I ask.

"I was home playing pinochle with your mother. I heard the bar was already filled with lumberjacks and loggers having drinks and playing cards when the Indians walked in. Everybody froze, bottles of beer hanging halfway to their mouths. A couple of men stepped in front of the Indians and told them to get out and go back to wherever the hell they came from."

I feel myself getting mad. The loggers had no right to treat the Indians like this. "Did they leave?"

"They sure didn't. As they shoved their way up to the bar, big ol' Mel Turner took a swing at one of 'em and everyone else piled on and started slugging away."

"The men weren't the only ones fighting," Ruby adds. "They say Grandma Dalton hopped up on the bar and broke beer bottles on the heads of every Indian who came close to her."

We all laugh at Grandma Dalton up on the bar swinging beer bottles. She's a tough woman. She has long, gray hair and a mouth that could out scream a cougar. Some people say she has a heart of gold, but other people say they would rather try to pet a wolf than to get close to her. I bet the Indians never counted on the likes of Grandma Dalton.

"What happened next?" I ask.

"They ran all the Indians out of the joint and everybody thinks they'll never come back," my stepfather answers. "We don't like Indians in Humboldt County. Let 'em stay on their reservations." He stops for a minute before adding, "Putting them on reservations was probably better than what they did to the Chinese."

"What did they do to the Chinese?" I ask, sitting up straighter in my chair.

"Have you ever seen any Chinese here or in Eureka?"

"No."

"About fifty years ago, they ran every single Chinaman out of Humboldt County. In Eureka they gave 'em twenty-four hours to get on a couple of big ships parked in the harbor. They even set up a gallows in the middle of town with a sign on it that read, 'If you are not out of town by three o'clock, you will be hung on this gallows.'"

"But why did they want the Chinese to leave?"

"The loggers hated the Chinese because they thought they were funny looking and they were taking their jobs. But you know what?" he adds with a chuckle. "After the Chinese were gone, we were in a real fix. We didn't have enough workers to do the jobs."[6]

I'm still chewing on the fate of the Chinese, when Ruby declares, "I don't think the Chinese had it as bad as the Indians. I remember stories about the loggers sneaking up on an island just off the coast of Eureka. They didn't use guns because they didn't want to make noise, so they brought axes and hatches and knives. They killed every Indian on the island. When the bodies were discovered the next day, even the children and babies had their faces and heads hacked to pieces."[7]

A half-chewed gob of steak sticks in my throat. Chinese swinging on gallows, chopped-up babies. I feel sick thinking of the loggers doing such horrible things. And they were cowards to sneak up on the Indians and not give them a chance to fight back. I drop my head and push my plate away.

"Can't finish eating, Sharooney?" my grandma asks, stroking my hair.

I raise my head and mumble weakly, "No. And I still wish I was an Indian."

"Why in the world would you want to be an Indian?" Al wants to know. "We just told you how people treat them in this country."

"I don't care. They're brave and handsome. My father is one of the best-looking men I've ever seen, and he looks like an Indian. The Indians knew all sorts of things about living up in the mountains. The white people here learned lots of secrets from them like what plants are good to eat or make tea with or to use for soap. I bet the Indians even taught them how to whittle the figure-four sticks I make for catching chipmunks."

"Yeah, and the Indians also knew how to scalp people and burn their houses down," Al replies.

I push back my chair and head out of the room. "I don't care. Besides, they don't do that anymore," I toss back. "Next week is Halloween, and I'm going to be an Indian."

By Halloween, I'm all ready. I wear my turkey feather hat that Ruby made for me. The tail she shot off the cat hangs from the side of it by my ear. The tail has dried nicely and it's black and silky. I like to pet it.

In the afternoon, my skinny little friend Timmy comes over to the house. He's Bobbie Jo's brother, so like the rest of his family, he's dirt poor and as good-looking as a fawn in springtime. He has a beautiful, innocent face, brown eyes, and long eyelashes. Of course, he doesn't have a costume. But I know how to fix him up.

Timmy's clothes are ragged as usual, so that part of the costume is okay. All he needs is a little face paint. I get some soot out of the stove and smear it on both our faces. When Ruby isn't looking, I slip a red lipstick from her purse to add to our war paint. I look us over. I think we look pretty good. Of course I'm the chief and he's my brave.

We don't get much treat in Thorn because many people don't have candy to give us kids. So we mostly go out and do tricks. One

of my favorites is pushing over people's outhouses or throwing balloon water bombs through their open windows.

But tonight is going to be different. I am dead set on getting back at the loggers and lumberjacks for being so mean to the Indians. There has been neither hide nor hair of an Indian since that awful fight at the bar.

This morning I picked a bunch of dark-blue cascara berries. They're real ripe and their bulging skins hold lots of sticky juice. I'm going to use them as fruit bombs. I imagine Timmy and me standing by the Whitethorn Road hurling the berry bombs at the loggers' cars as they whiz by. In my mind, I see the bombs break, splattering messes of dripping berries all over the loggers and their cars. It will be easy to hit them because the Whitethorn Road is so narrow you can spit across it.

Hitting the white men might not be nice, but they deserve it after beating up the Indians last Saturday.

As dusk starts to cover the dusty Whitethorn Road, Timmy and I walk along to a lonely stretch and set ourselves up on the right side at the end of a curve. When a car comes around the turn, we aim to throw the berry bombs at the car. Then we'll duck back into the thick brush that grows beside the road.

The first car that comes rolling around the curve is going so fast we miss the chance to throw the bombs. I tell Timmy, "When the next car comes, we have to have our hands up in the air, ready to throw instead of keeping our hands behind our backs."

"Okay, I'll be ready next time." Timmy promises.

A few minutes later the battered hood of a dark, dirty car comes around the bend. It is not going as fast as the last car. I smile when I see the window of the passenger's side is wide open. When the car gets right up beside me, I hurl the ripe bombs with all my might right smack through the open window. The juicy berries hit a man's face, splashing all over his brown skin and long black hair.

"Good grief!" I realize, rooted to the spot, "He's an Indian!"

The car comes to a screeching stop and four big Indians lunge out and start after us. "Run, Timmy!" I scream.

We both dive into the brush. It is so thick we have to crawl on our hands and knees. As we scramble on, we hear the Indians smashing through the dense brush behind us. My Indian hat is torn off by a tree limb and replaced by a thicket of spider webs.

There's no telling what kind of crawly things are hidden in the leaves we're thrashing through. I'm so scared I almost wet my pants. If they catch us, what will they do? Will they kill and scalp us like Al said?

The thorny brush is ripping out pieces of my skin, replacing Ruby's lipstick with real blood. Timmy is just behind me, crawling as fast as he can. Although the Indians are well into the brush, they stop for a moment and become quiet. I turn my head around to Timmy and motion for him to lie down and be quiet. My heart is pounding so loud it's like a drumbeat directing the Indians to our hiding place. Here we are, a couple of animals hiding from the hunters. But these are the best hunters in the world.

We wait and wait without making a sound except for my thumping heart. Then we hear the Indians moving out of the brush and back to their car. We both heave sighs of relief when we hear their car takes off.

"Let's wait," I whisper to Timmy, "this could be a trick. They might have left an Indian on the road waiting for us to come back out."

We wait until it's completely dark, and then we crawl down to the bottom of the brush and wade into the Mattole River.

"They must have gone away. I wonder where they came from," Timmy whispers.

"I don't know what they're doing up here in Thorn, but they're probably some of the Indians who lost the big fight with the loggers last Saturday night."

"What do you think they would've done if they'd caught us?"

"Who knows? They sure were hoppin' mad. And probably madder still since they got beat up in the bar. They might've come up here looking to get even. Scalping a couple of white kids would

sure have done it, I reckon," I said, scared at the thought of how close we'd come.

We stand quietly for a couple of minutes. How could things have gone so wrong? I moan to myself. Here I was trying to pay back the loggers for beating up the Indians, and I attack the Indians instead. Now they're even madder at white people. How can I ever set this right?

I just can't figure it out right now, I decide. But I know how I feel. I feel shame, shame for myself and for all the white people in Whitethorn.

"Would you still like to be an Indian?" Timmy asks.

"Sure. Didn't you see how big and strong they were?"

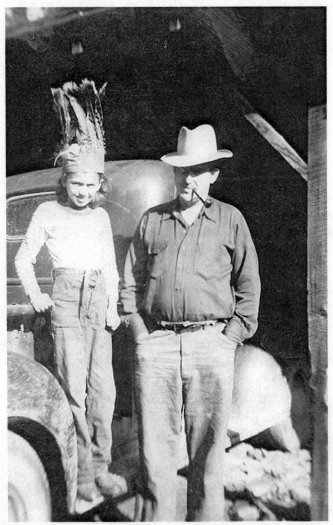
Sharon, dressed for Halloween with live white rat and turkey feathers on her head, and stepfather, Al Sharpe

16. I Can Ride Anything

The horses are running across the field, nostrils flared, sucking up great gulps of air. "Get him closer!" my cousin Sonny yells. I rein Scout a couple of feet nearer to Stardust, and Sonny gets ready to jump from Scout to Stardust's back.

We tried to catch Stardust a few minutes earlier, but every time I offered her a handful of grain, she'd sniff my fingers and twist away. Her buddy, Scout, was more interested in the grain, and I was able to slip a rope around his neck while his big rubbery lips sucked the grain out of my hand.

Scout isn't the one we really wanted to catch because he doesn't belong to me and we can't use him for a long horseback ride. We need to catch my horse, Stardust.

Since I couldn't fool Stardust with the grain, Sonny had come up with a daring idea. "Let's both get on Scout and we can ride up close to Stardust and I can jump on her back."

It turned out to be trickier than we thought. Every time we rode up to Stardust, she whirled and ran away. Finally, at full gallop, we got close enough, and Sonny made the leap onto her back.

Straddling her, he wraps his arms around her neck and pulls her to a stop.

"We did it." I laugh. "We outfoxed that wily old mare."

"I sure did," he says with a crooked grin, sitting on Stardust's back like a champion rodeo rider.

Ignoring his "I" for now, I jump off Scout, turn him loose, and march over to Stardust and slip the bridle over her head. I swing onto Stardust behind Sonny and we gallop off into the hills.

When we get back home, our jeans are soaked stiff with Stardust's sweat. Our wet pants are covered with a bunch of her red and white hair that rubbed off during the ride. That's the trouble with riding bareback. You're sitting right on top of the horse's skin and when she sweats, your pants soak it up. If you ride long enough, the rubbing between the wet pants and her back can cause saddle sores on your butt.

A week later I ask Ruby to drive me around Whitethorn to look for Stardust. She might be up some canyon that doesn't have a road, but she might also be in a meadow where we can see her from the Whitethorn Road, and I won't have to walk all over the country trying to track her down.

"You're gonna have to wait until I finish making this bread and get the yeast rising," Ruby says.

"That's fine," I reply, watching her knead the big ball of sticky dough. "But when it rises, could you cut off a couple of pieces of dough and fry up some dough floppers?"

She tosses the dough into a big bowl and pushes it down. She carefully covers it with a towel. "Okay," she says. "When we get home it will probably be raised enough for us to fry up a couple of dough floppers."

"Yum, I can hardly wait. Where did you learn to make dough floppers?"

She knits her brow. "When I was a little girl in Bull Creek, there was an old Indian man who sold fried bread. He taught my mother how to make it, and we've been making dough floppers ever since."

Setting the bread dough in a warm place, we go out to our pickup. Ruby is wearing a print dress she made herself. She never wears jeans like I do. She always puts on makeup and combs her

hair whenever she goes out, even if she's only going for a ride in the pickup.

We drive up and down the Whitethorn Road looking for Stardust. The grass is dry and yellow in the late summer and the air is filled with the scent of fall. I can smell all kinds of dried leaves from different trees mixed with the rich odor of ripe acorns and berries that are starting to shrivel on their thorny vines.

Before long we spot Stardust and Scout grazing in the same meadow where Sonny and I last caught them.

Ruby stops the pickup and we get out. "Wait here and I'll get her," I tell Ruby, carrying Stardust's bridle and a handful of oats. It's no surprise when Stardust sniffs off my treat and gallops away. Scout as usual comes up and eats the grain while I slip the bridle on him.

"Why are you putting the bridle on Scout?" Ruby asks. "I thought we were here to get Stardust."

"Just watch. You're gonna see something you've never seen before."

Ruby frowns. She's afraid of horses and doesn't really know much about them.

"Okay," she replies. "But be careful. I don't want you to get hurt, you hear?"

"I'm not gonna get hurt. I have a new way of catching Stardust."

On his back, I gather up Scout's reins and head him over to my mare. Her ears are slapped tight against her head, signaling she doesn't like what's happening.

As soon as I ride close to her, she runs toward the gravel road leading to my stepfather's sawmill. I give Scout a good kick, and he quickly catches up to her. Right beside her, I'm feeling a little nervous, but I tell myself if Sonny could do it, so can I.

The horses are traveling fast and we're almost at the gravel road. I want to jump while we're on grass so I won't get banged up on the gravel if I fall. I rise to my knees, take a deep breath, and leap through the air. I land squarely on Stardust's back, but

she makes a sharp turn to the right, and I keep on going straight ahead, straddling nothing but air. Her sharp turn acted like a catapult, doubling my speed.

As I fly above the grass, I can see a lumber pile coming up. I'm sailing straight for it. If I don't come in for a landing pretty soon, I'm going to do a header into the rough lumber. It's not looking good, but I'm beginning to lose air speed. My nose dives into the grass just four inches from the boards. I just lie there with my breath knocked out of me.

"Are you all right?" I hear Ruby's scream as she runs over beside me. Dropping to her knees, she leans over me and puts her hand on my back. "Did you break anything?"

Shocked and not able to move, I don't answer.

"I never should have let you try something so dangerous," she whines, starting to cry.

I know I have to say something to her, or she'll think I'm dead. I manage to croak, "I'm okay."

I'm glad to hear her sigh of relief. "You almost landed on the lumber pile."

"I know." I turn my head to look at her.

Her eyes are shiny with fear. She wipes my face with her hand. "You have grass and dirt all over you."

"I have to do that again," I say in a weak voice.

"Do it again!"

I roll up into a lopsided sitting position and put my hand on my dirty forehead. "I can't let Stardust get away with it. If she thinks she can hold the upper hand, she'll try to get away with more things. Pretty soon I won't be able to handle her at all."

Ruby pats my back and says gently, "I think this is one time you can let her get away with it."

I look up at her. "You don't think I should try it once more?"

I don't really want to try again, but if I don't, my pride will be shot in the head and when Sonny finds out, he'll laugh his fool head off and tease me to no end. I can already hear him. On the other hand, maybe I should do what Ruby wants me to

do this once. I'll let her decide. I know I would jump off Scout again if she wasn't here.

"I don't think you should try it again, ever," I hear Ruby command. "You could have gotten yourself killed."

"But I can ride anything!"

"Maybe you can ride anything, but as far as I know, you don't have a license to fly."

As she's helping me up, and my wounded pride starts to look for relief elsewhere, I start to perk up remembering my upcoming visit next week to my Aunt Doris and Uncle Max's dairy ranch. Sonny is also going to be there, and I'll have plenty more chances to prove myself and show Sonny.

As she's gearing up the truck, Ruby looks at me sideways and shakes her head, smiling. "After that tumble, you sure recovered fast."

The week passes slower than usual. When I finally arrive at the ranch, Sonny is already waiting. The ranch is on the Pacific Coast near the mouth of the Eel River, just a short drive south from Eureka in a place called Lolita Flats.

The next day Max and Doris take us to a rodeo where we see cowboys riding bucking broncos and bulls. I jump up and down I'm so excited. I can tell then and there what I am going to do when I grow up. I keep my plan a secret because Sonny would probably laugh and spoil the many exciting bronco bustin' rides coming up.

Late in the afternoon, as we're driving down my aunt and uncle's long driveway back to their ranch, it bursts out of me: "I'm going to become a bull rider when I grow up!"

Sonny looks at me and sneers. "Girls can't ride bulls."

"Yes they can," I hurl back, huddling down in my seat.

"I've never seen nor heard one doing it."

"Just because you've never seen a girl ride a bull doesn't mean girls can't do it. I'm one of the best bucking horse riders I know, and I don't see why I couldn't ride a bull."

Sonny is thirteen and thinks he knows everything. But he doesn't know me. I'm ten, and I know I could ride a bull.

After we pass over a smelly slue that runs under a narrow wooden bridge, my aunt and uncle's two-story house comes into view. I'm always amazed to see it perched way up on eight-foot poles even though I know the Eel River floods almost every winter. The sun shines only a handful of times a year, and moss, mold, or mildew grow in every crack of the house. It's the last one on Lolita Flats before you hit the ocean.

The west side of their land runs along the ocean and has to be protected by dikes four feet tall. If the salty ocean ever got over the dikes, it could ruin the grassland used for grazing their livestock. Since the saltwater is heavier than the runoff from the Eel River into the ocean, it stays below the fresh water and usually doesn't go over the dike.

Max parks the car in the gravel driveway and we climb the stairs to their house. We pass their tired old rowboat hitched up by the stairs, ready for Max and Doris to use it to row to the barn during the winter floods.

It's always wet outside, even in the summer. Almost every day the fog rolls in and wraps itself around the house, the barn, the rotting fence posts, and every fat cow.

It's not much dryer inside the house, heated only by a small electric heater and the kitchen stove. Max likes to hog the little heater for himself. He especially likes to use the heater to warm his big socks just before milking the cows.

The door to the house opens onto the messy kitchen filled with dusty plants Doris has collected. Ashtrays filled with smelly old butts are strewn about. A lone butt sits silently on a dirty dish; another one floats in a coffee cup. Above the old green gas stove, a shelf overhangs, holding up a Hills Brothers coffee can brimming with bacon drippings. Over in the corner near the door are scattered several pairs of boots covered with mud and cow manure.

Max and Doris sit down for a smoke in the kitchen. Sonny and I settle down in the living room. I haven't forgotten what he said in the car, so I challenge him again.

"I'm going to be a champion bull rider when I grow up. Just you wait and see."

Sonny just puts his hands over his mouth and acts like he's laughing. Between haw-haws he sputters, "I don't think you can even stay on a cow."

On cue, Max chimes in as he walks into the living room, "Don't you think you should start with something easier than a bull, like riding a cow?"

I look up at him eagerly. "Can I ride one of your cows?"

Doris comes in. "Max, you shouldn't let Sharon ride one of the cows. It's too dangerous."

"I think it would be all right for her to ride Midge. She's nice and gentle."

"Well, maybe Sue. Sue would be better than Midge," Doris replies. "Midge sometimes does something sudden, like kicking the milk bucket over."

My aunt and uncle milk their herd of cows at five in the morning and five at night. It's now four o'clock and the cows will be waiting outside the barn pretty soon. I'm itching to climb on one of them.

In the meantime, Sonny and I sprawl on the couch and talk about the rodeo. Then I remember Max has a radio that works. We don't have a radio in Whitethorn so it's always a treat to listen to the radio when I visit. I look at Sonny and whisper. "I think 'The Shadow' or 'The Whistler' is on now. Let's listen."

"Do you know what station it's on?"

"No, but it shouldn't be very hard. There are only a couple of stations."

I find the station right off, and we sit back and listen to the scary sounds of "The Whistler." Before we know it, Max calls us to go down to the barn.

"Can I help lock the cows' heads in their stanchions?" I ask when we get to the barn.

"It's all right if you use a pole to push the locks. I don't want you to get too close or you'll get hooked by a cow horn. But first, you have to help put the grain in their feeders."

Sonny and I get the grain and put little piles of it in each cow's feeder while Max gets the milking machines ready. There are about fifty cows, so it takes a while to get all the feed set out.

Doris finally comes into the barn ready to go to work. She's wearing her tall rain boots and jeans that look like they've seen too many milkings. She's a lot taller than Max and about sixty pounds of muscle heavier. She winks at me. "You still want to ride a cow?"

"I sure do!"

Max walks to the end of the barn and opens the door. The cows moo and jostle each other trying to get to the grain. One of them gets jammed between the herd and the barn door, making an awful ruckus until she squeezes past into the barn.

I help lock the cows' heads into their stanchions with a pole. Sonny does it with his hands because his arm is long enough to keep him from being gored. While we work, the cows' big tongues are busy lapping up the grain.

After the cows fill up one side of the barn, Max closes the door and goes to the other side of the barn to let the rest of them in. Finally, when all the cows are in place, Max and Doris start the milking. Max's stool is strapped on his behind, and since it's one-legged, it looks like he has a tail. Doris, who can get up and down easily, doesn't use a stool. In the meantime, several cats have lined up during the milking. Doris grabs hold of a back tit and squeezes it in a stream in front of the cats. The cats take turns opening their mouths and letting the milk spray down their hungry throats.

After some of the cows are milked, Max hollers at me, "All set for your ride?"

"I sure am," I holler back.

Sonny suddenly starts to mess things up. "I don't think you should ride the cow alone, Sis. You might get hurt."

"I don't need you on the cow with me, and I'm not your sis," I scowl at him.

I know darn well the only time Sonny calls me "Sis" is when he wants something. He's the stepson of my Aunt Maude in Bull Creek. "Not even a real relative," I growl under my breath.

"That's not a bad idea, Sharooney, Sonny riding with you," Doris chimes in. "We want to send you home in one piece."

Max joins the chorus, and kicking the dust and clenching my fist, I agree to let Sonny ride behind me.

We go over to the cow named Sue and stand by her side. She's still locked into her stanchion. Sonny helps me get a leg up and I straddle her big black and white back. She doesn't feel much like a horse. Her skin is moving around under me. A horse's skin is tight, making it easy to stay on. For the first time, I wonder if this is a good idea. Sonny jumps on behind me. I can't back out now.

"Ready to go?" Max says.

"Let her loose," I yell.

As soon as Sue is freed, she turns and starts moseying along toward the door. I start kicking her to move her along while Sonny grabs her tail and starts yanking it. By the time Sue's out of the barn, she's bucking.

Her loose skin is jiggling from side to side, my butt with it. We last a couple of bucks and on the third, I sail head over teakettle, landing in mud and cow manure. Sonny lands right on top of me. The fall doesn't hurt, but Sonny's big stupid self nearly kills me.

"Get off me, you dope," I groan. "I think you've busted my ribs."

As I lie groaning in the mucky stew, Sonny jumps up, fit as a fiddle since I cushioned his fall. He and Doris help me up, and gloved, she tries to brush the mud and manure off me.

"Sonny should never have ridden the cow with me." I cry. "All he did was fall on me!"

"Well at least you can get up." Doris tries to comfort. "Let's go back to the house and rest for a while."

"I can walk by myself," I reply, starting to hobble toward the house, dragging my wounded pride with me.

"I knew you wouldn't be able to ride a cow, let alone a bull," Sonny can't help rubbing in as he follows along.

"Well, you didn't stay on any longer than I did. What kind of a bull rider do you think you'd be?"

Resting back at the house I nurse my crushed dreams of being a bull rider. *It's that darned Sonny's fault*, I tell myself. He wrecked my bull-riding career. And if he hadn't wrangled his way into riding with me, I wouldn't be so banged up right now. I'm sure glad he's leaving tomorrow and won't be around to horn in on the new plan hatching in my brain. Even if I got bucked off a cow, I know I can shoot like Annie Oakley. I'll borrow Doris's shotgun and go duck hunting. I can still become a sharpshooter in a Wild West show someday.

The next morning Sonny is picked up by my Aunt Maude and his father. The pest is gone. Now I'll be able to do things without him getting in my way.

Still thinking about Sonny, I leave the house and walk to the barn where Max and Doris are finishing up the morning milking. I hold my breath as I pass the pen where they keep their old billy goat. Nothing smells as bad as that goat. He reeks of vomit, bad breath, sour oats, and rotten cheese all mixed together.

When I get to the barn, barely past the thick stink of the old goat, I see Doris bringing the heavy milk cans out to the platform where the milk truck picks them up. She's so strong, she can lift a big can full of milk without even catching a breath. After she gets the last can out of the barn, she lights a cigarette and leans against the barn door.

"Can I borrow your 4-10 shotgun and go duck hunting?" I ask her.

She purses her lips and looks me up and down. "I guess it'll be all right. But you be careful with it. Don't put a shell in the barrel until you're ready to shoot."

"I'm always careful," I tell her. "I never lean a gun against a post when I'm going through a fence, and I always look at what's behind the duck before I shoot."

"If Missy sees you walking with a gun, she's sure as the devil going to trot after you. So don't shoot a duck that's way out in the water. If you shoot it, she'll swim after it no matter how far it is. She's not very big, and I don't want her drowning out there."

I thank her and skip happily back to the house. This time I hardly notice the festering stench of the old goat. I get into the house, and as soon as I grab the shotgun and some shells, Missy magically turns up wagging her tail, ready to go. She's a cute little mutt with an adorable face framed by black floppy ears. I doubt if she weighs fifteen pounds.

Missy and I walk down the driveway until we get to the narrow wooden bridge we use to get over the slue and to the ranch house. I've spent many happy days fishing on this bridge. The slue drains into the small bay that eventually opens into the ocean.

I'm very careful with the gun. I push it into the pasture ahead of us before we slip through the wire fence. We walk through the pasture, a mixture of grass and sand. As we get closer to the dike separating the pasture from the salty water, I drop to my knees and slowly crawl up to the edge of the slue, Missy creeping along beside me.

"Good girl," I pet her and whisper.

As I peek over the dike, I see a duck in the water sitting about twenty feet away. I figure that it isn't too far for Missy, so I throw a bullet into the gun and take aim.

Bang and bull's eye! Missy springs into action, ears flying. She leaps over the dike, jumps into the water, and paddles furiously toward the duck. Grabbing it between her teeth, she hauls it back toward me and soaking wet, drags her prize up the bank. The duck is almost as big as she is. Missy drops the duck at my feet, sits back, and looks up at me with big, shining eyes.

"Good girl!"

She wags her soggy tail and I put my arm around her and joyfully pet her wet hide all over. I don't know how she learned to fetch ducks out of the water. It must be in her blood because

I don't think anyone around here taught her to do it. I pick up the duck and Missy and I start back to the ranch house.

I mull over the past couple of days. I got bucked off the cow, ruining my plans to become a bull rider. But I can still shoot like Annie Oakley. I proved it again today, and holding up the duck, I shout, "Wild West rodeo, here I come!" I quicken my steps to show off our prize to Doris and Max, Missy springing right along at my heels.

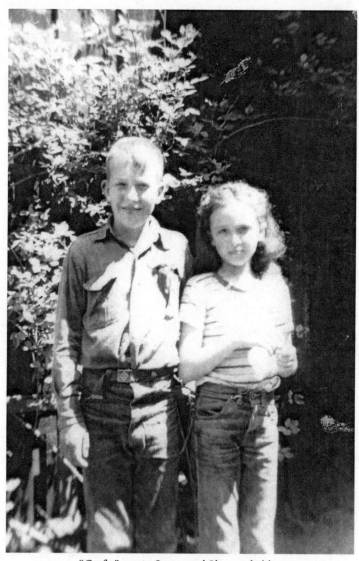

"Crafty" cousin Sonny and Sharon, holding white rat, in her yard in Whitethorn

17. I Never Forgot the Bomb

I've never forgotten the bomb that ended the Big War. I've thought and thought about it, and I've decided I would like to make a bomb of my own. If we ever have another war, we'll have to have a whole bunch of bombs and many people who know how to make them. I don't want to blow anybody up. I just want to invent my own bomb to keep our country safe.

I remember the day the war ended. I was skipping along in front of my house on a quiet, foggy Eureka day when horns started blowing and people started running out of their houses yelling and screaming, "The war is over! The war is over!"

Ruby appeared and grabbed my hand, crying, "The war is over! Japan has surrendered!" and we danced in a circle, singing, "The war is over! The war is over!" Finally she squashed me in a great big hug, her tears splashing down on my face. "Now your father and your uncle Allan can come home!"

Before long, on another foggy day, the whole family stood on the porch waiting for my Uncle Allan. When a black car drove up, we all rushed to welcome him. I remember how he shrank back as everybody tried to hug him at once. Nobody even noticed.

Tears were running down my grandmother's smiling face. Everybody talked at the same time as they jostled and pushed him toward the house. He didn't look at all like the uncle I remembered. He shuffled, stiff and humped over, as if he alone was holding up

the dark, gray skies of Eureka. He looked so scary, I ran back to the living room.

As he came in, I met his eyes, dull and sunken in, staring ahead, not settling on anybody or anything. I've never seen anybody so skinny. He was trembling all over and his pale skin was dripping with sweat. Thankfully, the family steered him to the bedroom to lie down.

"What's wrong with him?" I asked my mother.

"He has malaria and has been shell-shocked," she answered.

"What is 'shell shock' and 'malaria'?"

"He had a terrible time fighting the Japanese on an island called New Guinea. The noise of guns and bombs, no rest, hunger, the heat … all these things upset his mind so that he can't think very well. Lots of rest and quiet will bring your Uncle Allan back as before."

"What about malaria?"

"Malaria is a sickness like the flu. We have sulfa drugs that will help him get rid of it."

Not long after, my father also came home. He didn't have to fight the Japanese because he was one of the soldiers who took over Japan after it lost the war. He looked a lot better than my Uncle Allan, as good-looking as he used to be, except he had a mustache.

I ran and jumped into his arms when I saw him. "I'm so glad you're home. I was afraid you might get killed like Cousin Mike."

"I didn't get killed because we dropped the biggest bomb in the world on Japan. It scared them so much they gave up."

"How big was it?" I asked.

"It was so big it blew up a whole city. Then we dropped another big bomb on a different city and the Japanese knew they were done for."

A bomb that could blow up a whole city! It's hard to imagine a bomb like that. But it brought back my father and uncle. Since that day, I've been trying to figure out how to make a bomb.

One summer I visited my cousin in Arcata who had a chemistry set. I spent hours with that set, trying to discover what mixture of chemicals would blow up. No luck. After that, I searched his parents' bathroom cabinet for anything else that could mix with the chemicals and make a bomb. Nothing worked.

Finally, I collected a bunch of firecrackers, left over from the Fourth of July, and twisted their fuses together and lit them. I got a small explosion, but sure not big enough to blow up a whole city and cause Japanese soldiers to surrender.

My Aunt Doris and Uncle Max's dairy ranch on the coast near Eureka held lots of mysterious things. Every time I visited the ranch, I searched high and low for bomb stuff. Uncle Max had all sorts of medicine for his cows that looked promising, like the huge purple pills he poked down the cow's throats to kill their worms. But even as big and powerful as they looked, I couldn't get them to explode.

Years have gone by without my bomb. I can usually do whatever I set my mind to, but the bomb seems further from my reach than it did five years ago when the war ended.

Tonight I'm just leaving the outhouse, when a huge red glow flares up in the sky.

"Jump in the pickup," Ruby hollers as she comes running from the house. "Looks like one of the mills is on fire."

We drive up the Whitethorn Road for about five minutes. As we turn left on the gravel road leading to our lumber mill, we can see the finishing mill blazing and lots of townsfolk already gathered 'round it. The finishing mill, used to smooth rough boards for building, is just across the way from my stepfather's lumber mill, which is safe.

I've never seen a fire so big. All the boards, stacked and ready for grooming, are also on fire, like kindling in a giant cook stove. The flames are reflecting off the faces of the people, lighting up the sober and the drunk with equal brightness.

Suddenly, a giant explosion hurls a large barrel of coal oil straight up in the air high over our heads. Just as that barrel crashes back into the inferno, another barrel blasts off into the

night sky. One after another the barrels, like fireballs, shoot up to the sky and crash back down into the mill

As I watch the explosions, my body bursts with excitement. I finally realize how to make a bomb.

A week after the fire, I ask Jackie, Timmy, Johnny Johnson, and some other kids to come to a bonfire party in my backyard.

As the kids arrive, I get a nice fire going. I have some marshmallows to roast, and we all get sticky fingers and marshmallow goop on our faces and clothes.

When it's nearly dark, I tell them, "I've got a big surprise for you tonight. I'll be right back."

I disappear into the garage and bring out a couple of two-pound coffee cans with lids on them. Earlier in the afternoon, I filled them half full of coal oil and pronounced them locked and loaded.

I walk to the fire and put the cans down on the brightly burning coals, placing them so they won't tip over.

"What is it?" Timmy asks. "Are you cooking something we can eat?"

Jackie looks suspicious. "I don't think it's something to eat. I know Sharon; she's got something else up her sleeve."

"Just wait, and stand back from the fire." I don't know how big the explosions are going to be, but six feet seems like a safe distance from which to watch the blasts.

Everyone's eyes are glued to the mysterious cans. The smoldering embers wrap the kids in a red glow, and for a second, I see the ghosts of the Indians who once lived in but were driven out of Thorn. The cans start to turn an angry red, and I imagine the fury of the ghosts is entering them.

With a loud boom, the first can blasts off into the sky. Startled, my friends scatter in all directions. I stand, proudly watching my beautiful bomb sailing freely from the earth.

Just as the second can blasts off, I hear our pickup screech to a stop in the driveway.

"What on earth are you doing?" Ruby hops out and yells.

Among the Silent Giants

"Do you want to burn our house down?" Al hollers right behind her, stomps over, and grabs my right arm. "That can could have landed right on our roof, or set the whole forest blazing. You know better!"

I've never told them about my bomb, so I just croak, "Yes," and wrench my arm free.

Ruby puts her arm around my shoulder and takes me aside. "What were you trying to do, Sharooney?"

"Just having a bonfire and some fun with my friends." I look around but don't see any of them.

"Showing off is more like it!" Al cuts in. "Blasting cans of coal oil all over creation. And with everything dried out, you could've burned down the whole country."

Ruby turns me to face her. "You won't do it again, will you? Promise you won't try to make explosions ever again, Sharooney. I don't want you getting hurt. Or hurting other people."

"I promise," I whimper.

"Now put the fire out and come on in!" Al grumbles as he walks toward the house, Ruby behind him.

Alone, I stare into the fire that held so much fun and promise just a few minutes ago. I look up into the sky, but instead of the fiery cans, I imagine our two buzzards perched high above me in the redwood tree. The big blasts probably jolted them awake. I bet they're really scared.

I throw dirt on the flames and extinguish my beautiful bonfire.

Later in bed, I think of how, if there's another war, scientists will probably be making even bigger bombs than the ones dropped on Japan. I also know it won't be me making them. I promised Ruby. When I think on it, I don't even mind very much. It's good that more fathers and uncles will be able to come home. But if you ask me, I never really liked the idea of blowing up whole cities full of other kids and their fathers and mothers. Anyway, I already completed my mission tonight. I finally made my own bomb.

18. Mr. Smith Goes to Whitethorn

Shivering, I throw my wet body down on the warm sands of the Mattole River. The water is bone cold here in the mountains, even in the summer. From my cozy patch of sand, I notice a dark color clouding Jackie's mouth.

"Your lips are turning blue. Get out of the water right now." As usual, I'm the first to get out when Jackie and I are swimming.

She stubbornly swims around for a few more minutes before she climbs up the steep bank and lies beside me. Although she's blonde and blue-eyed, she gets a dark tan in the summer. I like to lie beside her and admire the fine gold fuzz on her arms. I sometimes wish my dark-haired arms were decorated with golden hair like hers.

"Can you believe we start school tomorrow?" Jackie mutters.

"Yeah, and we're going to have baths in a wash tub instead of in the river."

Jackie shakes her head, showering us with her sopping wet hair. "Just when we get the soles of our feet tough enough to walk through a patch of blackberries, we'll have to stuff our feet into a pair of tight new shoes. It's really gonna hurt."

"I can already feel my hair being yanked out by the roots in the morning. Ruby is going to have a job getting the snarls out."

After the sun toasts us dry, we get up, brush off the sand, and put on our jeans and T-shirts. Even though we're both going to

be sixth graders this year, we can still swim in our underpants because our chests are as flat as Johnny Johnson's. Jackie likes the idea of growing tits but I'm planning to cut mine off. I like my flat chest. It makes me look just like Straight Arrow, the Indian whose picture is on the cards hidden inside cereal boxes.

Monday morning I dress in my new jeans and T-shirt and put on the dreaded new shoes. After breakfast, Ruby sends me off with a happy smile. She's probably glad to have me in school instead of running around the country. She's always afraid I'll get lost or eaten by the mountain lion we sometimes hear screaming in the night. We're always amazed how the cry of a mountain lion sounds like a human yelling his brains out.

I've gone to a boatload of schools in my life. After my mother left my father, we moved all the time. I remember starting kindergarten somewhere in Eureka, the town where I was born. My mother had promised she would come and get me right after class was over. I was still scared she wouldn't show up, so I started crying the minute she walked out the door. As soon as the teacher had her back turned, I sneaked out to the dark, cold bathroom and hid in one of the stalls so I could cry without anybody watching.

The teacher came and brought me back to the class, but nothing could dry my tears, not even sitting with the kids who were coloring and having fun. When school was over, my mother was there to get me just like she'd promised. When the teacher told her I'd cried all day, they agreed I shouldn't go to school any more. They thought I wasn't ready.

The next year my mother started me in the first grade anyway. The school was close to Eureka, somewhere near my Aunt Doris and Uncle Max's dairy ranch on the coast. I only remember sitting in a circle with a bunch of kids, taking turns reading from a little book. I was bored because the kids read so slowly, so I turned the pages and read the entire book by myself. The teacher got so mad, she whacked my hand with a ruler.

I went to other schools as we moved around from place to place. I don't remember most of them except going to second grade in Bull Creek where we lived with my Uncle Gene and Aunt

Maude. I was proud that my mother had gone to the same school when she was a kid. The school was a big white building with a tower that held a brass bell. A long rope dangled down from the bell where the teacher could yank it as many times as she wanted. There was no doubt that school was starting for the day when the bell clanged out its big bright morning song.

Since moving to Thorn I've finally settled down in a school. I spent third grade in a little one-room school. In the fourth grade, we moved to the new school built just across the creek from the small one. The fourth grade was fun. I liked my teacher, Miss Morris, who told us about the California Indians. She also taught us how to make reed baskets and build tiny Indian villages with small sticks and moss we collected in the woods.

Last summer, after the end of fourth grade, we found out Miss Morris was put in a mental hospital. I don't really think we drove her crazy. She must have had other problems that made her sick.

Fifth grade with Miss Courtright wasn't much fun because she favored Johnny Johnson over me 'cause I gave her so much trouble in class. I often felt sorry for her for having to put up with us. Even though we're short and skinny, Jackie and I hold the title of being the biggest troublemakers in school. This year, heading into sixth grade, Mr. Smith from Eureka will be our new teacher. I sure hope I can make him like me better than Miss Courtright did.

Our new school since fourth grade looks like a long green box. It has three classrooms with two grades in each class. Sitting beside the school is a big water tank perched on a fifteen-foot tower. A pump pulls the water up from the small stream and into the tank. Every once in a while, one of the teachers climbs up a ladder and puts iodine into the water tank so it is safe for us to drink. I know iodine is poison, and I sometimes worry that the teacher might put in too much of the stuff and poison us kids as well as the germs.

We have electric lights now because they put in a generator for the new school. Sitting in the middle of each class is a big ugly oil heater. The heaters are started each morning by turning a knob to get a puddle of oil to the bottom. When the puddle is big enough,

the teacher throws a lighted match down on top of it. Most of the time the oil catches fire on the first match, but sometimes the teacher has to try again and again.

Watching the teacher trying to start the fire while sitting wet and shivering in the winter, I often think of the story I read by Jack London. The hero is in the Arctic lost and freezing. He will freeze if he doesn't light a fire. The ending is my favorite part. His last match is blown out by the wind. But our teachers always get the heater started up. I wonder if they would call off school for the day if they ran out of matches before they got the heater going.

Few teachers want to drive to Thorn over the eighteen miles of tire-chewing gravel or move clear out here to live in the middle of nowhere. Since being hired, Mr. Smith now lives in Briceland, a short distance from Thorn. Still, he's a city slicker, and not used to our rough ways.

Mr. Smith is tall, skinny, and young. He's got straight blond hair, an extra bit of nose, a pale complexion, and the top of his lip is covered with a large bushy moustache.

The first two weeks of school Jackie and I behave ourselves. Mr. Smith looks happy. He probably thinks he's going to have a good year. But boredom is already starting to crawl up my spine. I've always had a hard time sitting still. The only way I can keep from causing trouble is to stare out the window and daydream. Other times I use my pencil to poke holes in my big eraser, helping me drift off to fun times like fishing, trapping chipmunks, or exploring old logging roads.

Boredom in school has been a problem all my life. Jackie tells me she has the same problem. We're always the best readers in class and we think most of the school work is dumb.

Even so, Mr. Smith tells the class a very interesting story one morning. During WWII he was a medical soldier who took care of the wounded and dying men. "I've seen the lungs of people who smoke and they're black as coal. Never smoke," he tells us. "Keep your lungs pink and healthy."

His story scares me. Everybody in my family smokes. I bet their lungs are as black as an outhouse at midnight. The black

lung trouble gives me a giant reason to stay away from cigarettes. Since I go to church with Jackie almost every week, I also know smoking is a sin. A third reason has come to me by sitting down with paper and pencil figuring out how much money I would spend if I smoked a pack a day for the next eighty years. According to my figures, it would amount to thousands and thousands of dollars. That's a whopping pile of money.

By the third week of school, Jackie and I run out of good behavior. We start by whispering and giggling about Johnny Johnson. He's sitting in the middle of the classroom. From our seats in the back of the class, we see that his neck is as grimy as ever. His oily hair hangs in front of his face as he leans over his paper trying to write the assigned story.

"Do you think the oil in his hair will drip on his paper?" Jackie whispers.

"I'll bet you two bits it'll land on his paper in the next five minutes."

"That's too much money," Jackie says. "He's not worth it."

We both break out laughing, causing Mr. Smith to give us a stern look. "Settle down back there."

We sit up straight in our chairs and drag the smiles off our faces. But I can't stand it for long.

"Do you think Mr. Smith has teeth?" I ask quietly, trying not to move my lips.

"It's hard to tell with his mustache drooping over his mouth," Jackie answers through tight lips. Once again, we start laughing. And this time we can't stop.

Mr. Smith orders both our noses to our usual corners where we spent a lot of time last year. The corners are in the front of the class, just behind Mr. Smith's desk and close together. We try whispering, but Mr. Smith is right on top of us. "No talking," he commands, sticking out his chest and marching back to his desk like he has just won a major battle.

I can't surrender. With my face crammed between two walls, I squeeze out an idea. My plan depends on Georgia, the deaf girl

sitting in the middle of the front row. As soon as Mr. Smith has his back to me, I turn to Georgia and silently mouth a question.

"Would you write notes and throw them to me and Jackie?" She nods eagerly because it's an easy toss from her seat to us. I grin in my corner, knowing that Mr. Smith will never catch us.

When I spy Mr. Smith facing the class, I turn to Georgia. "Write a note to Jackie and tell her we're going to mouth the words to you and you are going to write notes for us."

Georgia pulls out a scrap of paper and writes my message on it. Then she tosses it to Jackie. When Jackie finishes reading it, she mouths her answer to me. Georgia quickly writes it down and throws the note to me. When I get it, I push my body close to the walls so no one can see me open the note: "Great idea," it reads. "Now we'll have something to do instead of staring into our corners."

After lunch, we're in for a big surprise. Mr. Smith has separated us. Jackie now sits at a desk on one side of the room and I'm sitting on the other. I bet he thinks his troubles are over. Jackie and I know they have just begun. We don't like being split up.

Having separated the two of us, Mr. Smith is again a man looking pleased with himself. "Everyone take out your pencils," he orders.

My arm shoots up. "Mr. Smith, I lost my pencil."

He looks at me, stomps to his desk, marches toward me, and slaps a new pencil down on my desk. I scrunch up my shoulders and remember how mad Miss Courtright got last year when I lost my pencils. *I gotta keep better track of my pencils,* I tell myself, feeling not too positive considering my record.

Sure enough, by late afternoon, I'm without a pencil again. Fresh with courage from a long afternoon's lessons, I speak in a clear, loud voice, "Mr. Smith, I lost my pencil!"

I was looking forward to a little action, but I nearly jump out of my seat as Mr. Smith lunges at my desk and attacks it with all his fury. He tosses my papers, rubber bands, and my dried cat tail up in the air until every scrap I own lies on the floor around my desk. He doesn't find a single pencil. Again to my surprise,

when he finishes tearing my desk apart, Mr. Smith straightens his shoulders and walks calmly to fetch a new pencil for me.

"Clean up this mess," he says.

I clean it up, but we both know this is not the end of the pencil problem.

And so it continues. I can't help losing my pencils. And it seems Mr. Smith can't help losing his temper when I call for another one. As the weeks go by, I'm losing a pencil two or three times a day. I'm as confused as Mr. Smith about where my pencils go. Maybe I leave them at someone's desk when I'm wandering around the classroom, or I accidentally drop them out in the school yard. I just don't know. It's a mystery to me too.

At times I wonder why, being a man and all, Mr. Smith doesn't have a better handle on things. Maybe terrible things happened to him in the Big War, like they did to my Uncle Allan. Maybe seeing all those awful wounds and dead bodies with their black lungs and stuff was so terrible he was having a hard time getting over it.

Although I planned on being 'specially nice to Mr. Smith, the next morning I can't find my pencil again. For the second time this morning, I find myself whining, "Mr. Smith, I can't find my pencil."

By now, the whole class has joined me in holding our breath when I make this announcement. We're not disappointed, as today we're treated to an especially awesome spectacle. Standing in place, Mr. Smith starts stomping up and down, his face turning red like an old wino's, his arms raised and pulling at his hair. When he's done, he simply sends me to my corner.

Since Jackie is still laughing at the scene that just played out, Mr. Smith glares at her and points her to her corner. We put Georgia to work again writing notes for us. I feel kind of sorry for Georgia. The only time we're friendly with her is when she's writing notes for us. But being so lonely, she's probably grateful to have us include her in passing notes. Still, I feel guilty. Today, I feel awfully guilty about Mr. Smith too. I feel more sure that something terrible happened to him in the War and I make a new resolution to keep track of my pencils.

The next day, I am out of my corner trying to write the answers to a test. I've never been able to write very well because I have trouble forming the letters.

Mr. Smith walks by and looks down at my paper. "Your writing looks like chicken scratch!" he snaps.

As he's tearing up my test, I'm wishing I had lost my pencil, as usual, and saved myself this indignity. He troops on to his desk and brings back a paper with examples of the ABCs.

"I want you to copy these letters three hundred times each. You have to learn how to write decently if you're going to pass the sixth grade."

I spend the rest of the day writing the letters over and over again. Mr. Smith checks on me often and tears up the papers he doesn't think are good enough. He sure got me this time.

After writing ABCs all day, you'd think I would start to hate him. I don't. No matter what, I like him because he's so different from many of the loggers. He doesn't swear, even when he's real mad, and I never smell beer on his breath. And though I'm a heap of trouble, I feel at the bottom he likes me too.

Once a month we get relief from the regular lessons when a teacher from the county comes to our school. She has dark hair and I think she's real pretty. I put myself on my best behavior when she visits. She brings with her a small phonograph and a handful of records. She plays music for us that she calls "classical." We've never heard anything like it. The only music we listen to in Thorn is church music or cowboy music at the bar.

Most of the kids in class hate her music, but Jackie and I love it. The fine music seems to tell us there's a better world out there somewhere and beautiful people who do interesting things.

After the county teacher leaves, it's even harder to pay attention to Mr. Smith's lessons. The words seem to drag out of his mouth and he says the same thing over and over again. Sometimes after staring out the window and seeming like I'm not listening, I raise my hand to answer questions that no one in the class has been able to answer. I want to be sure he knows I could be a good student if I wanted to. It's a wonder this doesn't make him want to pull

his hair again. I would hate to see him go bald because as I said, I kinda like him, and if I never smoke when I grow up, he deserves part of the credit.

Good intentions aside, Jackie and I spend more time in our corners than at our desks. Meanwhile, like a disease that's spread, the rest of the class is also busy making Mr. Smith's life miserable. Johnny Johnson throws spitballs and paper airplanes across the room. Charley Kitchens, a funny-looking redheaded boy likes to throw erasers. Other kids keep busy talking, laughing, or getting out of their seats.

One morning Mr. Smith comes in looking happy and confident for a change. Chest puffed out, he stands at the front of the class and makes what appears to be an important announcement. "During WWII the Japanese kept their prisoners in line by dividing them into small groups." He pauses, giving us a sly smile. "If one member of the group did something wrong, the whole group was punished."

Oh gosh, I can see it coming. He's going to divide us into groups and if one kid gets in trouble, the whole group will be punished. Mr. Smith goes on to further explain the Japanese system, which involves, as usual, repeating himself until he's sure we understand.

Jackie and I meet at recess and discuss the situation. "I don't know what to make of this," I tell her. "I don't think it's fair. He shouldn't use tricks the Japanese used on captured American soldiers. After all, he's supposed to be on our side, not the Japanese."

When we come back into class, we see that Mr. Smith has written four groups on the blackboard. Under each group, he has written the names of kids. The set-up is pretty clear. He puts the students who hardly ever get in trouble in the first group. The second and third groups have the names of kids who get in trouble once in a while. As the biggest troublemakers in class, it comes as no surprise to find Jackie and me in group four. Johnny Johnson and Charley Kitchens are also in our group.

"If anyone acts up, recess or lunchtime is taken away from the whole group," Mr. Smith tells us.

It doesn't take long before it's clear the new program is not working. Everyone is mad about being treated like prisoners in a Japanese camp and even the good kids start acting up. I leave my seat and wander around the classroom more than ever. I also lose more pencils, causing Mr. Smith to pull more and more hair out of his head.

In a short time, our group loses every single recess and lunch for weeks ahead. But we don't really care. Jackie and I use the time reading books on Greek mythology taken from the dozen or so books that make up our library. Johnny and Charley sit on the floor playing marbles.

One morning we come into the classroom and are greeted by a strange new sight. A tall plywood wall juts out into the room hiding the space where Mr. Smith's desk usually sits. Mr. Smith is nowhere in sight.

Jackie and I look at each other. "What the heck is this?" I ask, feeling uneasy. "It looks like a fort."

"It sure does," Jackie agrees, "and a place to hide."

"Maybe he's expecting an Indian uprising." I laugh but soon go quiet to ponder a wild idea.

"What're you thinking?" Jackie asks.

"I'm thinking about Custer's last stand."

At 9:15 Mr. Smith appears from behind his fort. He again seems hopeful as he tells us that he's going to stay at his desk most of the time and will appoint student monitors to put checkmarks on the blackboard when someone breaks a rule. He will come out from behind the walls only when he's teaching. If anyone has a question about an assignment, they must knock before coming in to see him.

"Do you think he's going to wind up in a mental hospital like our fourth-grade teacher?" Jackie whispers.

"I don't know. I've never heard of a teacher boarding himself up like this. I wonder if he's beginning to think he's back in the War."

We don't know what Mr. Smith has in mind, but to us kids it seems like he's in hiding. He must be kidding, hiding in his fort and asking one of us to keep order in class. He is giving up.

Feeling very brave, I speak up loud and clear so that Mr. Smith can hear me behind his wall. "I don't want a kid to give me checkmarks. Mr. Smith should be out here in the classroom. He's the teacher and he should be the one deciding who gets a mark and who doesn't."

"Yeah, let him come out."

"Show his face," others chime in.

When Mr. Smith finally slinks from behind his fort, Charley hurls an eraser, followed by an explosion of erasers from the whole classroom. It's the Indian uprising I predicted! Mr. Smith runs here and there, ducking and covering his head and face with his arms. Finally he throws up his hands and tears out of the classroom.

We sit in stunned silence at what we had done. As time goes by, we begin to wonder if he's coming back.

Jackie whispers, "I bet he's not coming back."

"Sure he's coming back," I reply. "A teacher can't just walk off. It's against the rules."

A while later, the teacher from the third- and fourth-grade room comes into our classroom. She looks as mad as the devil. "You idiots have just lost one of the nicest and best teachers this school has ever had. I hope you're happy with what you've done! Everyone is to go home for the day."

A school board meeting is called right away. Jackie and I are said to be the ringleaders of all the trouble. My mother isn't mad at me, thank heavens, but she's furious about not being invited to the board meeting. She had to learn about it from Jackie's mother.

We never hear anything more about Mr. Smith. I hope he didn't have to go to a mental hospital like our fourth-grade teacher, Miss Morris. I wonder how he could survive the Japanese but not us kids. I wish I hadn't given him such a hard time.

For the next couple of weeks, the pretty teacher from the county is here teaching us. Now I'm never bored. But one gloomy

Friday, she tells us we're getting a new teacher. "He'll be starting next Monday."

Monday morning we're all knocked off our butts when we find out who the school board hired. A big muscular guy stands at the front of the classroom. As soon as we take our seats, he says in a deep, powerful voice, "My name is Mr. Hammer and I'm your new teacher. I don't usually teach," he adds with a devious grin. "I'm a professional wrestler."

As we stare at his tough-looking body, nobody doubts it. He looks like he could whip his weight in wildcats.

Jackie and I are both on guard. This guy looks dangerous. I quickly make up my mind to keep track of my pencils and plan to pay attention every minute of the day.

As the weeks crawl by, Mr. Hammer proves to be as treacherous as we thought he would be. Although Jackie and I are well behaved, some of the other students in the class are slow to figure out what they're up against. Johnny Johnson throws a spitball across the class. We all watch open mouthed as Mr. Hammer puts a hammer hold on him. He tightens it until Johnny screams.

"Had enough?" Mr. Hammer asks, "or would you like me to put on a little more pressure?"

"Enough!" Johnny groans. Mr. Hammer lets go and Johnny staggers back to his seat.

I've decided this guy might really hurt someone. It isn't long before he does. Poor Charley Kitchens throws an eraser at a boy next to him. Mr. Hammer marches over and slaps both of Charley's ears with his big hands. The loud smack bounces around the classroom. The impact of air hits Charley's eardrums so hard I'm sure he's going to be deaf.

By Christmas the whole class is as quiet as fallen trees. Mr. Hammer freely enjoys himself, torturing any student who steps out of line.

I'm still bothered and awake some nights thinking on it: how I couldn't help letting nice Mr. Smith down, no matter how hard I tried; how I now have no trouble at all behaving with scary Mr. Hammer; how I couldn't help losing my pencils with Mr. Smith,

who was more hurt than hurting us; and how I've never lost a pencil yet with Mr. Hammer.

It's all been backward, I now know, and that's what's been keeping me awake some nights. I can be so darned contrary and make things come out all wrong and upside down some times. It's scary. If I go on like this, I'll keep on hurting and driving off the nice Mr. Smiths and being stuck with Mr. or Mrs. Hammers for the rest of my life. Thank heavens I'm only eleven years old. I still have plenty more chances to change, and put it all right-side up, and make it all turn out better for me and all good folks around me.

19. The Last Match

The rain roars out of the darkness, splashing over our windshield like waves crashing on a beach. Our headlights catch flashes of huge redwood roots lining the dark road, threatening to snare our battered old pickup if we drive too close.

It's ten o'clock at night and Ruby and I are on our way home to Thorn. We've been visiting my Aunt Doris on her ranch near Eureka. We started late because Aunt Doris insisted we eat dinner before we left. She couldn't start cooking until she and Uncle Max finished the evening milking.

"Can you see the road?"

I squint. "I think I can make out a white line in the middle. Looks like we're a few inches to the right of it," I answer calmly, not letting Ruby know how scared I am.

We're driving on a narrow, winding stretch of Highway 101, lined on both sides with giant redwoods, and it's bound to get more dangerous still, when we leave the highway and turn up the twisting, gravel Whitethorn Road.

"We should have started home before dark," I say.

"I know it. But I didn't want to hurt Doris's feelings."

"You worry about other people's feelings too much."

I watch the windshield wipers sloshing back and forth. It's clear they're losing their battle with the downpour.

Ruby, hunched over the steering wheel, is barely managing to keep us from smashing into the oncoming trees. "I think we're getting to the stretch with the motels. Do you think we should stop?"

"If we don't, we're going to get killed!"

Soon I spot some lights up ahead. "Look, there's a motel coming up on the left!"

Ruby slows our pickup and turns into the motel's slushy driveway. Mud splashes out of deep chuck holes and covers the windshield, leaving a filmy view. Only a shiny pink light is visible to guide us to the office.

Ruby stops the pickup and climbs out into the storm. "Stay here! I'll see if we can get a room."

I look out the side window and watch the winds whipping parts of broken redwood branches through the air. Some slam down on the pickup. Heavy rain also blasts across the metal roof, sounding like the roaring falls of the Mattole River in winter. I'm sure glad we stopped driving through this storm.

A few minutes later Ruby hops in and whirls us around a couple of big redwoods to a little cabin behind the office. By the time we climb up the steps and stand at the cabin door, we're drenched.

Stepping inside the little room, I'm struck by how pretty it is. The walls are knotty pine, like our house, but these walls are not dulled with soot and smoke. They're freshly shellacked and shiny. The biggest surprise of all is the oil heater standing in the middle of the room. It's exactly like the one in my school. Although I'm glad to see a heater, it seems too big for the tiny room. The one at school can heat up the whole big classroom until everyone is way too hot.

Ruby walks around the big heater. "We need to get this started so we can dry our clothes." Her face crumples into a big frown. "But I don't have any idea how it's done."

"We have one just like it in our classroom. And I know all about how to light it."

"You do?"

"Sure. Just give me some matches and I'll have it started in a jiffy."

"I gotta have a cigarette first." After she lights her smoke, she drops down on a big cozy chair and hands me a little box of matches.

I open the box. "Only three matches!"

"Don't use them all. I need one for my cigarette in the morning."

I open the heater door, turn the knob, and wait for the bottom to fill with oil before lighting a match. The match sparks for a second and then dies out. Probably some dampness from the rain.

The next match flares but goes out just before it hits the oil. I look at the last match in the box. Ruby is going to be madder than a wet hen when she finds out I used up all the matches.

I think again of the Jack London story about the poor man who froze to death in the north. The wind blew out his last match. Now here I am, holding Ruby's last match. Thank heavens our lives don't depend on lighting a fire. Worst case, we'll be cold and wet all night. Either way, I hate the thought of facing my grumpy mother in the morning without her cigarette.

I strike our last match. It bursts into flame! Slowly, I lower the match far down into the middle of the heater. As it starts to burn my fingers, I let go, close my eyes, and count to ten. When I peek down into the hole, my heart takes a happy leap. A tiny flame is burning and glowing brighter and brighter.

"I did it!" I shout.

Before long, the small room heats up and we hang our wet clothes on chairs and push them up by the heater.

"This is kind of fun. It's like being on a vacation," Ruby chirps.

"Yeah!" I warm my hands over the heater. "My first time in a motel. Have you ever stayed in one before?"

"Sure. One time your father and I went on a fishing trip to Oregon and we spent two or three nights in a motel just like this one."

My thoughts turn to the end of this Christmas vacation. "I don't want to go back to school," I moan. "I hate our new teacher. He's so mean."

"Maybe you should've been nicer to Mr. Smith."

"I know. I shouldn't have caused so much trouble in class. When I saw him pulling his hair out and jumping up and down, I should've stopped right then and there."

"A good lesson for you. Now let's get ready for bed. And turn off the heater."

I go over to the heater and give the knob another turn. Then I jump into bed with Ruby and we cuddle up and go to sleep.

Sometime during the night, I wake up, gasping for air. It's as dark as a black hole. I can't see a thing.

I nudge Ruby. "Wake up! You've got to wake up!" Not even a stir.

I try to sit up, but I can't muster the effort. I'm drenched in sweat, and even my hair is dripping wet.

I remember that the bed is pushed up against the wall. Maybe it's right under a window. I put my hand out in the blackness and feel a windowpane. My fingers find the hook at the bottom of the window; they grasp it and push up. It doesn't budge. I try again, but my sweaty fingers slip off.

I try to wake Ruby again. I push and push on her. "Please wake up. I can't open the window." No matter what I do, she doesn't move.

I know if we don't get fresh air soon, we're going to die. I almost cry, knowing it's all up to me.

Wiping my sweaty hands on the sheet, I push once more, using all my strength and will. The window moves, opening a small crack. Too weak to push it further, I drag myself high enough to put my nose close to the fresh air.

Sucking in the air, I feel like I'm coming back from the dead. Soon I'm strong enough to sit up and raise the window a little higher. I turn to Ruby, who is now stirring.

"It's too damned hot," she moans. "Why is it so hot?"

Now it dawns on me. Instead of turning the heater off, I turned it on full blast.

I crawl to the end of the bed, slide down to the floor, and crawl over to the heater. Groping around in the dark, my fingers touch the knob. I turn it to the left, hoping it goes out. I know it won't right away because the puddle of oil needs to burn up before the flame dies.

Next, I crawl to the door and open it wide, letting more of the rainy night air into the cabin. The room starts to cool down even though the heater is still burning away.

"Sharon," Ruby calls. "Turn on a light."

Able to stand at last, I switch on the dim light. My mother is sitting up. I'm so happy. I was afraid she was dead.

"I told you to turn the stove off when we went to bed. What happened?"

I hang my head. "I guess I turned the knob the wrong way."

"We're lucky to be alive," she says, wiping her wet face with her hand. "This knotty pine room is probably air tight."

"At least our clothes are dry," I say.

We both laugh.

The room gradually cools off and we feel safe enough to go back to sleep by the open window.

In the morning, Ruby gets up and starts ruffling around in her purse. She finds a loose cigarette and sticks it in her mouth.

"Give me the matches."

I find the match box on the floor and hand it to her, holding my breath.

Ruby opens it and stares into the empty box, her mouth open, the cigarette dropping to the floor.

I bend down, pick up the cigarette, and hand it to Ruby, who jams it back into her purse.

"So you used up the last match," she snarls.

"I'm sorry. I used it to get the fire started."

"And nearly killed us!"

"But also saved us ..." I answer quietly.

Ruby shakes her head with a sly grin and then pulls me down next to her.

"You did, huh?" she says, smiling wider, nodding, and hugging me to her.

And that day, with more rain, twisting roads, and flying mud, I also helped Ruby guide us safely back to Whitethorn.

20. The School Bus Driver

We finally graduated from the sixth grade. Most of us, except Charley Kitchens, survived our wrestler teacher, Mr. Hammer. Charley's still stone-deaf in one ear from his blow. We heard a rumor that Mr. Hammer went to Eureka, where he was arrested for manslaughter. I hope he has to stay in jail for the rest of his life. He should have gone to jail for hurting Charley, but there are no police out here, so his family just let it go.

Since we don't have a seventh grade in Thorn, we have to take the school bus to Miranda where there's a junior high and high school. It's a rough hour-and-a half drive on gravel roads and paved roads winding through redwoods. I keep thinking I'll get used to this trip, but it has yet to happen.

This morning I get on our dilapidated yellow bus at seven o'clock. I settle back in a seat and hope to catch a little nap before the bus picks up the other kids. I close my eyes and start to relax when the bus hits a big pothole and nearly throws me to the floor.

A few minutes later the bus chokes and comes to a heaving stop on the side of the road. I peek through the dirt and grime on the window, trying to get a decent view of the familiar little dirt road winding up the hill. At this time of the year the road is mostly red mud. A row of small, rundown shacks cling to the road's slippery sides. Tiny smokestacks jut out of the tops of their

old redwood shake roofs. Blue smoke snakes down around the shacks' flimsy flanks and crawls slowly over the muddy road.

I soon spot my best friend, Jackie, tearing up the road. A grim smile tugs on my face. She's always late. Serves her right if she misses the bus again.

I'm not feeling very keen about her this morning. We had another fight yesterday. Jackie got mad for no good reason and tried to bite me again.

Jackie clambers into the bus, panting like a small wolf that has just run down a big deer. She's wearing her usual outfit—jeans, T-shirt, and an old denim jacket. She always looks two or three years younger than her age. I guess that's because she's not very big. She's strong for her size, though, but I can still whip her any day, and if I'm lucky, she won't grow too fast and get bigger than me.

After scrambling onto the bus, Jackie plops herself down on the seat across from me. "Hi, Sharon," she says, all sweet and innocent.

I look her over and decide she's probably in a better mood today. It's best to be cautious, though, for I can never tell for sure what she might do.

"Morning, Jackie," I reply, not saying any more for now, and also wanting to punish her a bit for yesterday.

Just then the bus gives a warning growl, shudders, and leans toward the driving part of the road. As it begins to move, our ears fill up with the sound of grinding gears and crunching gravel. I don't hang on this time. It wouldn't do for Jackie or anyone else to see me needing to grab on.

Continuing to ignore Jackie, I look toward the front of the bus and study the back of Orville Coon's head. He's our school bus driver. His ruffled brown hair looks like it didn't get combed much this morning. He drinks pretty often, so he likely tied one on again last night.

Orville is a big friendly guy with a leisurely kind of style, never in a hurry. He strolls along like a big old dog on a hot summer

day. His smile is so agreeable it can make you think he was your favorite uncle. Everybody in town likes him.

Driving the bus is only one of Orville's jobs. In the summer he works in the woods felling redwood trees or cutting them up in the mill. He also tends bar. Some mornings he's so hung over he's as pale as the belly of a fish. I've learned he's probably going to be either hung over or drunk when he starts up the bus. I personally prefer him to drive with the hangover.

In the winter, rain puts most men around here out of work. Nothing for them to do except drink, play poker, and fight until the rains are over. Our Orville is more enterprising than the others; he wound up driving our bus, when most men are out of work and hard put to feed their wives and kids.

Although Orville has his drawbacks, most of us riders of the bus are generally glad to have him behind the wheel. We like him. Anyway, up here in Thorn we're used to guys either drunk or hung over. Most of the men are pretty mean the morning after. Not our Orville. Even if he has just finished puking up the remains of last night's spree, he always has a light in his eye and a sleepy, cockeyed grin on his face.

I think we're real lucky to have such a good-natured guy twisting the wheel and pushing in the clutch on our hair-raising little roads. As usual, today Orville is cranking us around one of those snaky curves when a logging truck on wheels a mile high comes rolling straight for us! Before we know it, the truck and its load of giant redwood logs shoves right up beside us, coming less than an inch away from our bus! We all sit there scared stiff, gaping through our tiny windows at the monster that has hogged our road.

Nothing scares ole Orville. He just goes right for the blustering beast and grabs just enough of the gravel road for us to scrape through without us being crushed to death. He then straightens out the wheel, gives her a shot of gas, and everyone slides down in their seats in relief as the bus clatters on down the road.

So five days a week Orville drives us down from the hills of Thorn. He drives us away from our tarpaper shacks, our two-holer

outhouses, our shiny Sears Roebuck catalogues used for toilet paper, our coal-oil lamps, and our sacks of dried beans and flour. He drives us away from our buckets of water carried from the creek and from our fishing poles and hunting knives and guns. On down the road we go, rattling along over eighteen bumpy miles of winding gravel, down to Highway 101. From there on it's smooth sailing down paved roads leading in all directions to the big world outside, including our school in the town of Miranda.

As the bus clatters along today, Jackie and I look out our own private windows. The country looks pretty much the same as it did when I first made the ride from Bull Creek. The mountains are bare except for the scraggly skeletons of old tree limbs and broken logs, most of them lying in the deep crevices of the scarred earth. Small beginnings of tan oak and an occasional fir tree are doing their best to grow in the naked parts of the land. It's encouraging that manzanita and buckeye trees pretty well escaped the loggers. The trees are too small for lumber and their bark is not good for tanning leather like the tan oak trees.

From my window I can also see the thorn brush growing proudly by the road. Whitethorn is the only place I know where this prickly stuff grows. My stepfather says an Englishman brought it here a long time ago. In England they used it for hedges. I am not sure if my stepfather is right about this story. Why would a guy bring this thorny brush here? We have no use for hedges here and it simply grows wild all over the Thorn Valley.

Still, thorn brush is a real treat for Jackie and me because we like to crawl around under their big canopies in the spring. The floors of our whitethorn hideaways are turned into fairy gardens by bleeding-heart flowers that push their way through their feathery green leaves. I like to just lie in the lush bed of flowers, but Jackie doesn't sit still easily. For fun she sometimes pulls off a leaf of thorn brush and chews it for a minute or two. It makes her mouth and lips all pucker up and she makes a face and spits it out. I never tried chewing it because I'm sure it's poison. She hasn't keeled over yet from chewing, but Jackie is such a tough little thing nothing could kill her.

As the bus continues to roll along, stop, and fill up with kids, I stretch out in the comfort of my own seat. With a satisfied smile, I remember the plan Jackie and I hatched during the summer.

We decided that as long as there was no way to get out of riding the bus, we might as well fix it so we could be comfortable. Our plan was to be so obnoxious no one would want to share a seat with either of us. We had years of practice being a pair of pests and had no doubt we could clear out a couple of seats for our very own.

When we got on the old bus this first September morning, Jackie and I each took a seat by a window. We planted our scrawny legs full out on the worn Naugahyde seats and then watched as the bus filled up with the usual crew—mostly big, tough high school boys.

When Johnny Johnson got on, he swaggered down the aisle, dirty brown hair dancing back and forth with each cocky step. Although his face was clean, his neck told the story of a long absence of soap and water. He spotted Jackie and sauntered over to stake his claim on her seat.

He looked down at her with a thin smile. "Move!" he commanded.

Jackie looked up at him, pulled her legs from the seat, and quietly slid over by the window. A few minutes later she began talking in a loud voice and wiggling around in her seat. Every once in a while she "accidentally" kicked him in the legs. For variety, she delivered a few pokes to his ribs. Soon, Johnny gave her one of his sneers and moved to a seat with two other boys. We continued to torment any boy who wanted to sit by us until he caved and scurried off to find another seat.

Now Jackie and I sit on our little thrones and sail up and down the mountains to Highway 101. With our backs leaned up nicely against the windows and our legs full out on the seats, we look down on the dumb boys riding along in their cramped little spaces.

Sometimes I wonder why the big boys don't just shove us off our seats. Could it be because we're Orville's favorites? Still, Jackie

and I give him plenty of trouble, 'specially when he has to spend time breaking up our fights. Maybe he favors us to keep on the good side of my stepfather, for whom he works.

I'm also baffled over how scared the big boys act around him, how they snap to when Orville tells them to shut up and sit down. I wonder if they know something about Orville that Jackie and I don't know.

After a long week of riding the bus and listening to boring teachers, we welcome the weekend. On Sunday, we round up Stardust and Scout and trot off for a ride in the hills.

It's almost dark when we're back. Jackie turns Scout toward her house and I point Stardust toward mine. At my house, there's no lamplight in the windows. Al and Ruby must be down at the bar.

Riding up to the bar, I see our pickup parked in front. I get off Stardust and unbuckle her bridle. When I pull the bit out of her mouth, she licks her lips and wanders off into the gloom of the fading light. She'll eventually hook up with Brownie, and Jackie and I will track them down again when we want to ride them. For now they're on their own.

Bridle in hand, I climb the wide wooden stairs and push my way through the dirty swinging doors, bracing myself against the assault of a thick cloud of cigarette smoke.

Looking down, I note the pockmarked floor, holes left by trails of tired loggers trudging in with their cork boots to swill a drink or two after a long day in the woods. They're called cork boots, but I've never seen any cork on them, only nails. The nails sticking out of the soles easily dig into the bark of the timber and keep men from slipping. Loggers say they never get nailed to a log. They swear the boots save many a man's life, especially in running out of the way of a falling tree. If he slips and falls, he's pancake for sure.

No matter how well the cork boots work in the woods, they get the men in trouble at home. Almost every day, "Get the hell out of here with your damn boots!" is a war whoop coming from little gray shanties all around the Thorn Valley. The women don't

mind the mud and dust so much, but they don't want their floors all eaten up with nail holes.

Tonight Orville is at his usual place behind the redwood bar. As usual, he's serving drinks with a big grin. A couple of loggers are draped over the cracked maroon covers on the bar stools.

I catch Orville's eye. "Seen my mother?"

With a wider grin he tips his head toward the door leading to the living quarters. "She's in the back with Norma."

The juke box is playing, so I station myself by the wall and settle down to listen to a little music. I'm sure glad the bar has a gas-run generator so it has electricity. I like to listen to the western songs when I'm here.

I start to relax when I notice an old guy pushing his way through the swinging doors. I've never seen him before. He's shabby and dirty, his body shriveled and feeble, like men get when they quit logging and devote themselves to Muscatel wine. On top of his head his hair is sparse and slimy, a few strands of it crawling down over his bloodshot eyes. This guy really needs a drink. I imagine his parched throat as he inches his way to the bar. The heartbreaking sound of the "Tennessee Waltz" accompanies his pitiful shuffle.

At the bar, he whispers something to Orville. He probably wants a free drink. I expect Orville will give the fellow one on the house.

Instead, Orville's good-natured smile fades into a twisted grimace. In a flash, he springs over the bar, grabs the old geezer, and punches him full in the face. I flinch as the old guy falls flat on his back, landing right in front of me, blood from his mouth dripping to the floor.

Orville towers over him, fists clenched as he raises his big cork boot over the helpless old face. The nails gleam like daggers! I cower in terror as Orville's intention hits me.

Sure enough, the boot smashes down, making a horrible crunching sound. I try to scream, "Stop!" but my throat is frozen. The boot keeps on stomping up and down. Up and down. The nails turn from silver to an angry red. I feel each blow as if it

were my own face being ground up. I don't want to watch, but I can't pull my eyes away. The old man's nose collapses and his face becomes a giant, raw hamburger.

When done, Orville reaches down and slings the old man over his shoulder as if he were just a sack of broken trash. He carries him across the barroom and slams him through the big swinging doors. My ears ring with the pounding of flesh as Orville kicks the old fellow down the stairs. I gag and almost throw up. I suddenly realize why Orville's pretty wife always has bruises around her eyes.

As I lean against the wall, trembling and breathing hard, I wonder if the old man is still alive. We have no police or doctors in Thorn. And no one in Thorn cares about old winos. I care. But I'm too scared to go outside. And what could I do? After all, I'm just a little girl.

Just then, the big doors swing open and Orville comes back into the barroom. He saunters across the floor and takes up his station as bartender. His cockeyed grin is back on his face and he becomes again the big friendly guy liked by everybody in town.

I remember he's the guy who gently separates Jackie and me when we battle on the bus, the one with the steady look, the quiet reassurance, the easygoing guy we all like and admire. But this other Orville, the one with the grimace and stomping cork boots over a helpless old man's face, now I know he's also there.

A few minutes later Ruby and Al appear from the back room where they've been visiting Mike and Norma. They beckon for me to join them and we head out of the bar. Walking down the steps, I shut my eyes and hold Ruby's hand. Nothing is said. The old man must have crawled away. I don't say a word about what happened. I can't. I also want to protect Ruby from knowing what I'd seen. I somehow feel shame at having witnessed it.

When I get to bed, I can't sleep. I keep seeing the blood and my bus driver stomping the old guy's face. I dread Monday, tomorrow.

In the morning the bus pulls up to my stop right on time. Orville opens the door, the usual big smile on his face. My stomach

Among the Silent Giants

quivers as I climb up the steps. I manage to mumble a weak hi and hurry on down to a seat near the back of the bus. I want to be as far away from him as I can. When Jackie gets on the bus, I'm going to warn her that we have to quit causing trouble. There's no telling what Orville might do if we make him mad.

In the safety of my seat, I study the back of Orville's tousled head. I don't know why I thought he was different from the rest of the loggers. If the truth be known, most of them are a rough and brutal bunch and in some ways they're like wild animals, only partly tamed. Although friendly animals can seem harmless, they can turn back to their savage nature when you least expect it.

I remember the story my grandmother told me about a woman who tried to tame a wild deer. She fed the deer every day and she even named him Jimmy. After a few months of giving him food, she thought the deer was harmless. Then one day, she took a handful of vegetables out to the backyard and the deer reared over her. His razor-sharp hoofs came down on her head making deep bloody gashes in her face. She was scarred for life.

Although I've no holes or gashes in my face, there's some invisible part, deep inside of me, that feels wounded and torn, and I'm afraid I will wear that scar forever.

21. Leaving Whitethorn

Al has sold the Whitethorn Lumber Company! Since then, at times I feel like I'm having a pleasant dream; other times the idea of leaving Whitethorn feels like a darned nightmare.

Al has wanted to sell for years, but I didn't think he would ever find someone to buy up here. Most people know this country is beginning to run out of trees and it won't be long until they're all gone. Without trees, who will want a sawmill? The guy who bought it must be a city slicker, or he thinks there's oil under the log pond.

Al sold his half of the bar to the man, as well as land and the small shacks he rents out on it. The leftovers from the seven hundred acres, mostly with slashings, he gave away to people he liked.

"Better than paying taxes on 'em," he said.

The minute the mill was sold, Ruby and Al took off to a town called Santa Rosa to buy a small ranch for raising chickens and livestock. They've been gone for a week now; in the meantime, I'm staying here at Jackie's house.

I've had many different feelings about the move. On the one hand I'm looking forward to it as a big, new adventure. I'm also soured on loggers and the fierce life here in Whitethorn. I can't forget that awful night at the Whitethorn Bar, when our good-natured bus driver Orville ground his cork boots into a poor old

geezer's face and probably killed him. Since then, I hate getting on the school bus and the long daily ride to Miranda.

On the other hand, it will be strange living somewhere else. I belong here. I've made my mark here exploring miles of endless country. I know where the big trout are hiding under the log jams in the Mattole River. I know how to spot cow flops with big fat worms under them. I can hunt small and big game, prepare, and cook them. I can track. I can follow my horse, Stardust's, hoof prints telling me which direction she has taken and how long ago she made them. I'm worried I'll be leaving the best part of me right here in the mountains. And the part I'll miss the most is Jackie. I'm Batman and she's my Robin. How can I leave it all?

Jackie is so upset she doesn't even bring it up. There are no other girls she likes here. Most of them are not very smart, and they don't like to read or run in the woods. Jackie's mother promised to let her come and stay with me every summer, but we know it won't be the same. I wonder if she'll be able to keep a whole seat for herself riding the school bus without me.

As I stand warming myself by the kitchen stove, I keep an eye on Jackie drying the dishes in her usual slow-as-molasses way. There's still no speeding her up. I smile as I watch her endlessly wiping the dishes with one end of her dish towel, the other end draped over her shoulder.

Turning my head, I look out the kitchen window and watch the pouring rain. I love the way it rains here in Whitethorn. Once a storm starts, you can count on it lasting for days or even weeks. And what a great show it delivers. Great sheets of rain swagger across the valley like silver soldiers marching in a grand parade.

I look for the streetwalkers Jackie's mother is always so upset about. I still can't figure out why she thinks they're sinners. They just look like run-of-the-mill teenagers to me. But if she thinks they're going to hell, it must be so. I don't spot any streetwalkers on the road this rainy morning.

Instead, an old pickup suddenly plows through the downpour, churning full tilt up the muddy road. Every time it hits a pothole,

mud flies in all directions. When it gets closer, I can make out Al and Ruby in our faithful old GMC.

"My mother and Al are back. I'm going home!" I holler to Jackie. Not waiting for her answer, I race right out of the house and tear through the rain for home.

I rush up the steps and into the house, dripping water all over the kitchen floor. Ruby is standing in the middle of the room, grinning like a dog eating yellow jackets.

"We found the most wonderful little ranch you ever saw," she sings out. "It's in a small town called Windsor, just a few miles from Santa Rosa. It has fruit trees in bloom and a big two-story house. It's absolutely beautiful." She takes a couple of spins in the middle of the kitchen floor. "It even has a pasture for Stardust with grass a foot tall."

"A foot tall!" I repeat in awe. "Does the ranch have a barn?"

"Not only does it have a barn for a horse, it has a long chicken coop that can hold hundreds of chickens. We're going into the egg business!" She begins strutting around the kitchen, arms flapping, clucking like a big redheaded hen.

"If they're laying eggs, we won't need a rooster!" I shout, hopping up and down. "I'd hate to have another ornery rooster like that old cock outside chasing me around the yard."

"We'll give him away, or make chicken soup out of him."

"I vote for the soup." Serves him right, sneaking up on me all those times, pounding my legs with his big ole spurs.

Ruby has said nothing about my grandma. I wouldn't want to leave her behind. "What about Grandma?" I ask.

"She's coming too. The new place has three bedrooms, room for all of us."

"Yea! Grandma is coming with us."

Later when I'm alone, I'm again not so sure about it all. The move seems unreal, a fuzzy, scary dream of a blurry train whizzing by. I want to hop on, but I'm scared of the destination. It sounds grand, but how can I be sure? Everything will be fenced in. I bet they won't let me shoot a gun, and I'll probably have to wear a dress to school. Worse yet, I'll have to face it all without Jackie.

In the evening, Ruby and I are sitting by the living room stove, drinking coffee and listening to the heavy rainstorm battering the house. A bright coal-oil lamp sits on the small table beside us. I'm "hanging my nose" like we always say about Grandma when she's feeling blue. Taking a sip of my well-sugared coffee, I ask Ruby to tell me more about our new place.

"We bought it from an old couple who sailed from Italy when they were first married. It has seven acres of land with five or six acres of it planted in grapes. There's a real little stone winery on it with a grape press and lots of wine barrels to store wine." A sly smile appears on her face. "There's an old secret in the big garage."

I perk up. "A secret?"

"Yep."

"What is it?" I can't imagine what kind of a secret could be in a garage.

"There's a hidden room at the back of the garage."

This sounds right out of the Hardy Boys books my father, George, gave me last year. My mind swirls around reasons for a hidden room. Could there be a dead body buried in it, or is there some kind of treasure?

Ruby takes a sip of her coffee and follows it with a drag on her cigarette. "Many years ago, it was against the law to make alcoholic drinks. The people we bought the ranch from built an extra wall and a secret door in the back end of the garage where they hid their barrels of wine from the law."

The lure of a secret room raises my spirits. When Jackie comes to visit in the summer we can use it as a hiding place. On second thought, if Al and Ruby make a bunch of wine, they might do more drinking.

"We won't have to build fires there," Ruby continues. "All we have to do is turn a knob on the heater and it lights up. Won't that be nice? No more chopping wood and carrying it into the house."

"I sure won't miss carrying the wood."

"Better yet, we'll have electricity! No more coal-oil lamps. All we have to do is turn on a switch. We'll also have our own well and indoor running water all year-round. You won't have to take baths in a washtub because there's a great big bathtub with lots of hot running water. Best of all, there'll be no more trips to the outhouse. There's an indoor toilet you can flush. Everything folks call 'modern conveniences'—we'll have them now."

"Everything at the turn of a switch," I add, wondering about this new life coming up, everything so easy and comfortable. "What about school?"

"It's only a few minutes away, and the school bus will stop right in front of the house to take you there. No more long rides to Miranda. And will you be surprised when you meet the twelve-year-old girl living next door! Guess what her name is?"

"Jackie?" I ask, astonished.

"Yep. Jackie."

It's too good to be true, even a girl named Jackie the same age as me. I wonder if she's in the eighth grade. But even if she is, she won't ever take the place of my Jackie.

"When are we leaving?" I ask in a quiet voice, even with so much to look forward to.

"In a week or two, as soon as we're packed." Her dreamy smile tells me she's already in Windsor.

By the next morning I decide to look on the bright side and start rounding up gunny sacks. As I pile them in the middle of the kitchen floor, Grandma raises her eyebrows and gives me a big frown.

"What in the world are you doing with all those dirty sacks?"

"I'm going to make a blanket for Stardust."

"With those dirty old sacks?"

"Yes. It's going to be a long, cold ride in the back of the pickup. She's going to have a baby and needs a nice blanket to keep her warm."

"But they're filthy!" She gives a big sigh and shakes her head.

"Stardust won't care. I'll just sew them together the way they are. Saves me the trouble of heating water and washing them."

"All I gotta say, young lady, is you're gonna have to learn some new manners in the new place we're going to."

The coming days are all a bustle of packing the stuff we're taking with us. I hardly have time to think any further on where I'm going or what I'm leaving behind. I'm in the kitchen reaching for the three small irons we heat on the stove for ironing when Ruby shakes her head.

"We don't need those. We'll have an electric iron, and all we have to do is plug it into the wall."

I put them back on the stove instead of packing them in a cardboard box. I think they're kind of cute, but if she doesn't want them, I'm too busy to raise a fuss.

Later in the afternoon, a lost-looking Jackie comes trudging up the driveway.

"Hi," I say. Any excitement about moving starts fading away again. She's dressed in our uniform of jeans, denim jacket, and a five-inch hunting knife on her belt. I look at her blonde hair and pretty blue eyes. Her usual twinkle is gone. We've been friends since third grade. We even wish we were sisters. What am I going to do without her? I look away and start talking about Stardust's blanket.

Finally, after droning on about the blanket and nothing else left to say, I ask her, "How about going down to the falls?"

She mumbles, "Okay," and follows behind as I walk down my driveway, cross the road, and hit the little trail leading to the Mattole River.

The falls are a magical place. Today the water is almost at flood stage from the hard winter rains. The schools of salmon seem to have passed because we can't see a single one. The water is roiled with a tan mixture of runoff that's captured by the river and flushed on down to the ocean.

Late February or early March is usually the time Jackie and I take our first swim. We like to think we're the first kids to swim in the river every year. Wearing only our underpants, we paddle in

the water until our lips start turning blue. As a rule, it ordinarily takes just a few minutes in the deep cold before we have to get out of the water.

As we stand on the bank looking at the swollen falls, Jackie says," Let's take our first swim of the year right now."

"I don't think we should. The water is too deep and swift. We might drown."

Quietly we watch the tumbling brown water. This is probably our last visit to the falls. I wish we could have at least taken this first, and last, swim in the river together.

I feel tears welling up and turn to hide them. Jackie and I have stayed four nights a week at her house or mine since third grade. I've suffered through her bed-wetting, and she's put up with my taking my chicken to bed with us. Letting my thoughts run on, the tears are pushing through even harder. I'm scared I'm going to start bawling like a baby right in front of Jackie if I keep on.

To get a hold of myself, I remind myself that this is not good-bye forever. She's going to stay with me during the summers, and it's already February, and she'll be coming in June. That's only four months from now.

I have to think about the good times I'm going to have at our new house. Stardust will have bunches of grass to eat, and she'll have her half-Arabian foal in April. I remember how glad I was when I rode her down to Briceland last year and bred her to that fancy Arabian stallion. I look forward to the fun I'm going to have training the baby.

When we get back to my house, Jackie doesn't look at me. Instead she turns to go home. "See you later," she says in a tight voice.

On a cool and cloudy morning at the end of February, we're all gathered in our driveway, all packed and loaded except for Stardust. I slip the burlap-sack blanket on her and it fits like a charm.

"I think it's an outrage to cover that poor horse with gunny sacks. We're going to look foolish." Grandma can't help one last complaint.

I ignore her and start leading Stardust over to where Ruby is backing the pickup to a bank. She won't even have to jump to get in because the bank is the same height as the pickup's bed. She trots along right up to the pickup and then stops dead, refusing to go in.

"Come on, Stardust, you're going to a place that has grass as high as your knees." Her long ears flip straight up, and the next time I walk her to the pickup, she goes right in. I tie her to the board in the front of the bed.

Just before I get into the pickup, I look up for the last time at the top of the redwood tree where the buzzards are perched. Staring at them for a minute, I decide to wave good-bye. As usual, they don't wave back. They're probably glad I'm leaving. No more gunshots at dawn or coal-oil bombs going off in the night.

My Aunt Maude and Uncle Gene are driving Grandma in their car along with the boxes of stuff we need. We don't have to take much with us. The Italian family who sold us the ranch is leaving all their furniture, a lot of other stuff, and even an old Model T Ford pickup in the garage.

Ruby, Al, and I go ahead in the pickup with Stardust. Thank heavens she's going to have a dry trip. Maude, Gene, and Grandma follow in their car. Since Al likes to blow pipe smoke in my face when I take a deep breath between sentences, I make up my mind to be quiet on this trip.

I gaze at the Whitethorn brush as we drive along the Whitethorn Road for the last time. We pass the bar where my neck got caught in the clothesline and where Orville stomped the old geezer's face with his cork boots. I'm not going to miss the fighting.

I look over to the left side of the road where Jackie and I used to cross the river to get to each other's house. The path to the river won't run as deep without us traveling on it every day. I squeeze back a tear.

Now we pass the Whitethorn school. What a bunch of stupid things we did there, like running poor Mr. Smith out of our sixth-grade classroom forever.

Up ahead is the tiny white Pentecostal Church. How many hours I sat there with Jackie and her family, bored to tears. Of course things did get lively when somebody started speaking in tongues or rolling on the floor, or when the whole church rang out in song. From church people, I also learned a lot about how to be good and live a better life without smoking, drinking, and fighting.

We come to the main part of town, still not much since we first arrived. Without a glance, Ruby drives right by the small grocery store and the post office.

Continuing to stare out the window, I look up at the hills where Jackie and I used to run and laugh just for the heck of it. What a great, wild life I'm leaving! A movie Ruby and I saw in Eureka comes to my mind. It was about Tarzan leaving his home in the jungle and going to a great big city with tall buildings. It made me sad.

The Whitethorn brush slowly disappears as we get farther and farther away. Every time we hit a pothole, I can hear Stardust's hooves clanking. It must be hard for her to keep her balance on our rough old road.

How will my life be with a bunch of city slickers? We didn't like them much when they happened to come up to Whitethorn. We didn't want strangers coming in with all their fancy talk, knowing nothing about the woods. I loved it here with the mighty mountains and the trees that grow so high into the sky. But there's no going back. Thank heavens my grandmother and Stardust are coming with me.

Afterword

My mother, Ruby, and I remained the best of friends until the day she died at the age of ninety. Having bought my first horse on my ninth birthday, she continued to take great interest and pride in sharing my subsequent lifelong involvement with horses. As a grandmother, Ruby was much loved and sought after by her many grandchildren and great-grandchildren. Her good nature and sense of humor made her the center of attention of her entire family. For many years, she enjoyed working as a psychiatric technician at the Sonoma Developmental Center in Eldridge, CA.

About the Author

Born in Eureka, CA, Sharon Porter Moxley is a retired, award-winning school psychologist. She has also spent many years riding, breeding, and later showing, training, and racing horses. One of her mares was a national champion Appaloosa racehorse. *Among the Silent Giants* is written with Susan Dregéy, retired social worker and former editor and feature writer. They live in Santa Rosa, CA.

Grandpa Guy Doers

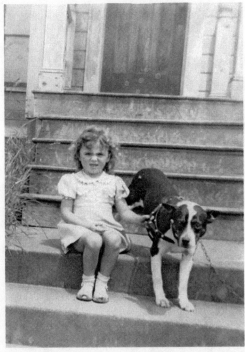

Sharon, age four, and her dog, Mutt, sitting in front of her house in Eureka

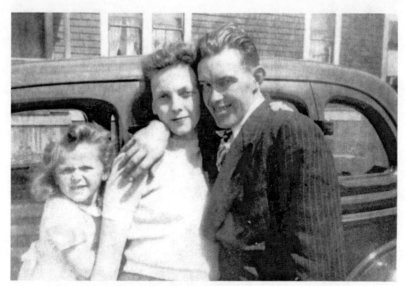

Sharon, Mother Ruby, and Maude's husband, Gene, in Eureka

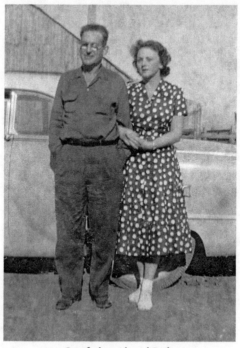

Stepfather Al and Ruby

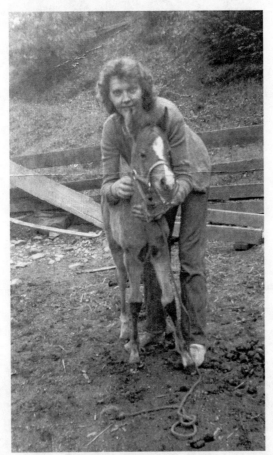

Aunt Maude and filly in Bull Creek

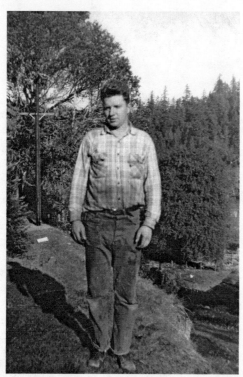

Uncle Allan Doers after hard day's work in Bull Creek

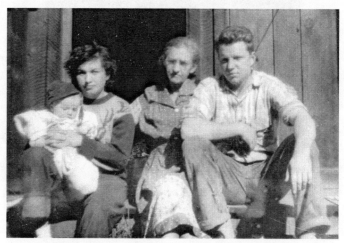

Aunt Pearl with baby Lyle, Grandma Blanche Doers, and Uncle Allan sitting on stairs of shed in Whitethorn

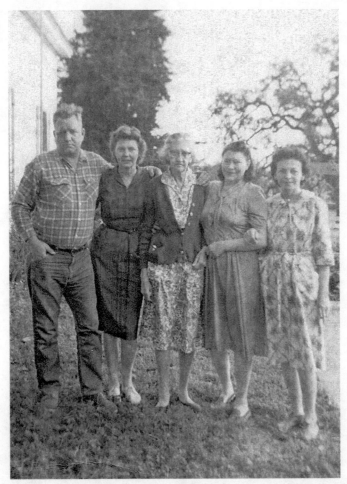

Uncle Allan, Aunt Maude, Grandma Blanche, Aunt Doris, and Mother Ruby

Endnotes

1. In the 1850s, the Lolangkok Sinkyone Indians stole a bull from a homesteader and cooked it beside a nearby creek. The homesteaders retaliated by massacring three hundred Indians. From that time on the area was called Bull Creek.
2. Today, Eureka is a beautiful, historic port town that was an important hub of the logging industry in Northern California. My harsh view of the town was colored by my nighttime childhood experiences of huddling for many hours in cars, waiting for my family to come out of the waterfront bars they frequented.
3. In 2008, I journeyed to Rockefeller Redwood Forest. I had read in the paper that the death rate of old-growth trees had almost doubled due to global warming. This terrible destruction was apparently happening all over the United States. Surely my wonderful old flatiron tree would stand forever. But when I arrived, I found my old friend on the ground, broken into several pieces, large sharp bristles jutting from its gaping wounds. I was grief-stricken. It had stood tall for two thousand years. How could it have died in my lifetime? It had become a symbol of my childhood's most treasured memories. Now it was fallen and dead, all quiet around its broken

corpse. The quiet wasn't the same as the deep silence I remembered. This soundless sleep spoke of death, a great sacrifice to civilization.

4. Bull Creek was swallowed by the great floods of 1955 and 1964. By then, my family and I had long moved to Sonoma County. However, my Aunt Maude, who lived in Bull Creek during those years, recounted that even the graveyard was wiped out. She said corpses washed out along with the town and the living. Everyone was amazed at how well preserved the bodies were, she said, and "people who had not seen each other for years became reacquainted." In the end, it made no difference if the living or the dead passed down that bloated creek. Bull Creek and its people are now gone forever. Today, only a new graveyard marks its spot. The adjacent ten thousand acres of old-growth redwoods, part of Humboldt Redwood State Park, survived the floods and continue to stand tall today. This section of the park is now called Rockefeller Redwood Forest in honor of John D. Rockefeller Jr., who donated two million dollars in the early part of the twentieth century to protect these ancient giants from the loggers' axe.

5. Whitethorn, Shelter Cove, and other small communities found on the thirty-five-mile stretch from the mouth of the Mattole River to the Sinkyone Wilderness are considered part of the Lost Coast. The Lost Coast got its name when the builders of Highway 1 were unable to complete its course from Southern California to Northern California. The mountains along the thirty-five-mile stretch of coastline were too rugged to build a highway.

6. My stepfather's story about the fate of the Chinese in Eureka in 1885 is verified and detailed in *Driven Out: The Forgotten War against Chinese Americans* by Jean Pfaelzer, New York: Random House (2007), 121–25.

7. In 1860, a secret group of Humboldt County folks slaughtered about one hundred fifty Indians, mostly women and children, on Indian Island in Humboldt Bay. *Two Peoples, One Place* by Ray Raphael and Freeman House, Eureka: Humboldt County Historical Society (2007), 164–65.

CPSIA information can be obtained at www.ICGtesting.com
Printed in the USA
LVOW121556070912

297891LV00003B/1/P

7. In 1860, a secret group of Humboldt County folks slaughtered about one hundred fifty Indians, mostly women and children, on Indian Island in Humboldt Bay. *Two Peoples, One Place* by Ray Raphael and Freeman House, Eureka: Humboldt County Historical Society (2007), 164–65.